SHOW ME HOW

SHOW

DEREK FAGERSTROM, LAUREN SMITH & THE SHOW ME TEAM

ME HOW

500 THINGS YOU SHOULD KNOW
INSTRUCTIONS FOR LIFE FROM THE EVERYDAY TO THE EXOTIC

COLLINS DESIGN
An Imprint of HarperCollins Publishers

show me how to…

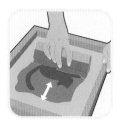

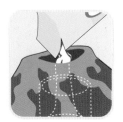

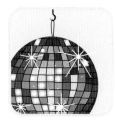

arts

crafts

tips

make

eat

 ## drink

 cooking
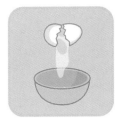

 baking

cocktails

 coffee and tea

 wine

 clothing

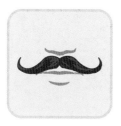
 hair

makeup

flirting

dating

nest

grow

wedding

plumbing

home decor

electricity

plants

pets

parenting

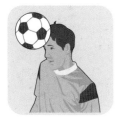

sports

wellness

266 graft a citrus tree
267 prune a rosebush
268 plant bulbs at the right depths
269 transplant seedlings
270 grow from plant clippings
271 create a japanese zen garden
272 design a french parterre garden
273 plant an edible garden
274 foster a succulent garden
275 repel backyard pests
276 attract friendly critters
277 make a suet snack for birds
278 set up a beekeeping station
279 build an ant farm
280 milk a goat
281 bottle-feed a lamb
282 groom a horse
283 feed a chilean-rose tarantula
284 determine a box turtle's gender
285 give a parrot a bath
286 build a koi pond
287 hug a hedgehog
288 pick up a rabbit

289 brush a pup's teeth
290 read a dog's body language
291 greet a new dog
292 feed a pooch a pill
293 collar my dog correctly
294 decipher a cat's body language
295 deflea herbally
296 befriend a scared kitty
297 feed a cat a pill
298 clip a cat's claws
299 bathe a baby
300 cook up yummy baby food
301 hang a high-contrast mobile
302 pack a well-stocked diaper bag
303 swaddle a wee one
304 burp a baby
305 massage a colicky baby
306 diaper a tiny tot
307 teach a kid to ride a bike
308 banish imaginary monsters
309 remove gum from a child's hair
310 convince a child to eat veggies
311 serve a banana-octopus snack

thrive

312 select the right golf club
313 perfect my swing
314 navigate a golf course
315 throw a four-seam fastball
316 nail a free throw
317 deliver a killer tennis serve
318 pitch in pétanque
319 assume the basic 4-4-2
320 score a goal with a 4-3-3
321 win the midfield with a 3-5-2
322 go on the defensive with a 4-5-1
323 understand soccer penalties
324 head a soccer ball
325 defend a soccer goal
326 understand my vitamins

327 pick a calorie-burning activity
328 visualize serving sizes
329 heal with acupressure points
330 make my desk ergonomic
331 soothe a first-degree burn
332 stop a nosebleed
333 treat a beesting
334 pull out a splinter
335 remove an object from my eye
336 pack a first-aid kit
337 stop bleeding
338 bandage a nasty wound
339 tie a tourniquet
340 perform cpr
341 save a choking victim

342 splint a lower-leg injury
343 wrap a sling
344 deliver a baby in a taxi
345 perform a breast self-exam
346 breast-feed an infant
347 save a choking baby
348 meditate for inner peace
349 relax in a finnish sauna
350 pamper with a hot-stone massage
351 heal with reiki
352 do a simple tai chi move
353 strike a basic yoga pose
354 train to run long distance

355 stretch before a workout
356 strengthen and tone my core
357 firm up my lower body
358 exercise my upper body
359 do the front crawl
360 paddle the backstroke
361 swim the breaststroke
362 dive like an olympian
363 recover from falling in skis
364 ski down a slope
365 shred downhill on a snowboard
366 carry my skis
367 climb a ski slope with my gear

first aid

 go

368 choose my perfect destination
369 know the time everywhere
370 fold her clothes for travel
371 fold his clothes for travel
372 choose the best airplane seat
373 stay limber on an airplane
374 combat jet lag
375 identify toilets everywhere
376 find the ladies' room
377 find the men's room
378 use a squat toilet
379 freshen up with a bidet
380 play korean gonggi
381 indulge in a hookah ritual
382 hang out in a hammock
383 share authentic yerba mate
384 patch a blown-out bike tire
385 fix a flat bike tire with money
386 use bike hand signals for safety
387 shimmy up a rock chimney
388 rappel down a sheer rock face
389 leap from a cliff
390 right a capsized kayak
391 clear water from a scuba mask

392 understand the parts of a boat
393 decipher crucial nautical flags
394 triumph over seasickness
395 tie basic sailing knots
396 stand up on a surfboard
397 do a killer duck dive
398 rip some gnarly surf maneuvers
399 jump-start my car's battery
400 fix my car's flat tire
401 bait and cast my fishing hook
402 build a roaring campfire
403 toast grilled cheese on a stick
404 make a delicious s'more
405 open wine without a wine key
406 mount an elephant
407 mount a camel
408 mount a horse
409 compose a memorable photo
410 take a steady shot
411 create professional effects
412 parade in rio's carnaval
413 drench myself in holi's color
414 run with the bulls in pamplona
415 create a day of the dead altar

travel

culture

leisure

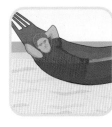

navigation

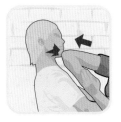

self defense

wilderness

tricks

pranks

stunts

tools

index

a note from derek and lauren

8 invent clay oddities

As long as either one of us can remember, we've always loved collecting and sharing obscure, eclectic, and occasionally (somewhat) useful knowledge. Our passion for learning has even inspired a great monthly tradition where we get together with friends to teach each other how to do cool, sometimes slightly ridiculous things—everything from making our own jam (delicious!) to twisting balloon animals (dazzles children and coworkers alike!). These days, we own a fun little shop where we encourage people to do all sorts of curious things, like make duct-tape wallets, crochet little creatures, and build musical instruments. So we were thrilled when the Show Me Team asked us to pitch in and help bring this fantastic book into the world—a world that so clearly needs simple, step-by-step instructions for crafting clay monsters (#8), making rugs from old grocery bags (#238), and escaping from panthers (#434).

238 craft a plastic-bag throw rug

In fact, we bet that before reading this note from us, you'd already flipped through the book a few times and learned some neat tricks. If you're like Derek and really want to cover your bases, read it straight through, cover to cover. If you prefer to focus on improving certain areas of your life in a more organized fashion like Lauren, let your interests guide you from topic to topic. Or better yet, invite some friends over and explore the book together. **Show Me How** is designed to educate, amuse, and occasionally astound. So if each time you pick it up you also pick up a few skills—or simply feel inspired to get out there and learn a new weird or wonderful thing—then we've done our job.

434 evade a panther attack

DEREK loves tending to his bees (#278, #333), teasing out a tune on his saw (#469), and indulging in his obsessions with coffee (#126–130) and camping (#404). He's thrilled that his work on **Show Me How** has improved his knot-tying skills (#395), and he anxiously awaits the opportunity to test out his newly acquired ability to correctly hug a hedgehog (#287).

LAUREN is a born crafter, and can while away hours knitting (#48), embroidering (#50), or doing paper crafts (#18). She's always looking for an excuse to bust out the ol' tool box, and is determined to install dimmer switches (#239) in every room of the house. And though she is fearless when it comes to hanging wallpaper (#221), she never, never, never wants to fight a shark (#452)—but she's glad she knows how if the need ever arises!

make a delicious s'more 404

rock out on the musical saw 469

hug a hedgehog 287

set up a beekeeping station 278

pour a latte leaf 130

tie basic sailing knots 395

do basic embroidery 50

install a dimmer switch 239

fend off a shark 452

hang wallpaper seamlessly 221

do a knit stich 48

craft a paper penguin 18

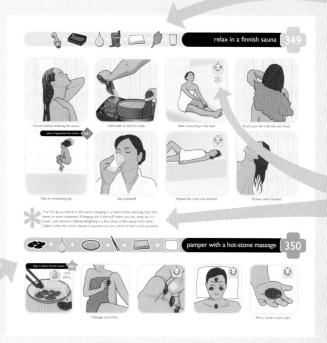
Show Me How is a new and different type of book—one in which virtually every piece of essential information is presented graphically. In most cases, the pictures do, indeed, tell the story. Every so often, however, it may be useful to understand how special information is portrayed.

CROSS REFERENCES Sometimes one thing just leads to another. Follow the links for related, helpful, or otherwise interesting information.

skip a stone across water 461

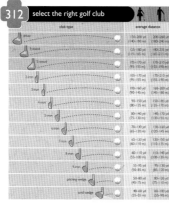

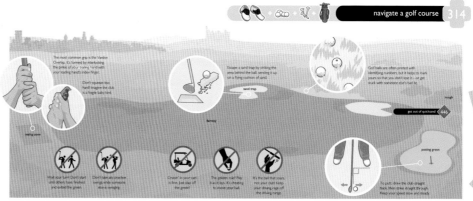

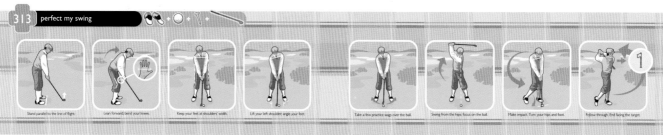

TOOLS The toolbar pictures everything you'll need to perform the depicted activity. Having a hard time deciphering an item? Turn to the tools glossary at the back of the book.

MORE INFORMATION If there's something crucial you need to know in order to do an activity—or a really cool fact—look for the text marked with an ✱.

ZOOMS Called out in a circle near or within a given frame, zooms highlight important information on detailed activities—or crucial "don'ts."

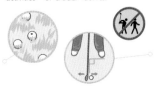

MATHEMATICS Handy "angle" icons help you do it right . . . or at least from the right direction! And if it's a matter of ratio? Look for icons like 3:1 to let you know how to get the perfect mix. When exact measurements matter, find them called out right in the box.

 8–16 fl oz (240–475 ml)

ICON GUIDE Throughout the book, a plethora of icons helps guide you through critical aspects of time, degree, safety, and more. Here are the icons you'll encounter in the pages that follow.

 Danger! Avoid this if you're not trained. (Or if you don't want to get into trouble!)

 (2–3 min) Check out the timer to learn how much time a relatively short task takes.

 Phew—fumes! Open a window before performing this activity.

 The calendar shows how many days, weeks, or months an activity requires.

 Call 9-1-1 to seek professional help if you find yourself in this situation.

 Look to the thermometer to learn the proper temperature for a given action.

 ×2 Repeat the depicted action the designated number of times.

 Just how hot, you ask? Cook over low, medium, or high heat, respectively.

 copy me! This page serves as a pattern. Photocopy or scan it, blowing it up as necessary, then follow the instructions.

 The meat thermometer lets you know when something is thoroughly cooked.

A NOTE TO READERS The depictions in **Show Me How** are presented for entertainment value only. Please keep the following in mind if attempting any of these activities:

- **RISKY ACTIVITIES** Certain activities in this book are not just risky but downright nutty. Before attempting any new activity, make sure you are aware of your own limitations and have adequately researched all applicable risks. (And just don't do #493. Really.)

- **PROFESSIONAL ADVICE** While every item has been carefully researched, **Show Me How** is not intended to replace professional advice or training of a medical, culinary, sartorial, veterinary, mixological, athletic, automotive, or romantic nature—or any other professional advice, for that matter.

- **PHYSICAL AND HEALTH-RELATED ACTIVITIES** Be sure to consult a physician before attempting any health- or diet-related activity, or any activity involving physical exertion, particularly if you have a condition that could impair or limit your ability to engage in such an activity. Or if you don't want to look silly (see #471).

- **ADULT SUPERVISION** The activities in this book are intended for adults only, and they should not be performed by children without responsible adult supervision. Many of them shouldn't really even be performed by adults if they can possibly help it (see #433).

- **BREAKING THE LAW** The information provided in this book should not be used to break any applicable law or regulation. In other words, when in New York City, don't try #500.

2 hang a tire swing

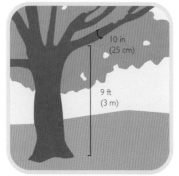

Pick a sturdy, high branch.

10 in (25 cm)

9 ft (3 m)

Drill three holes for drainage.

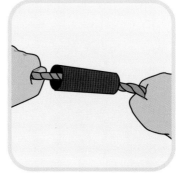

Tubing keeps the rope from fraying.

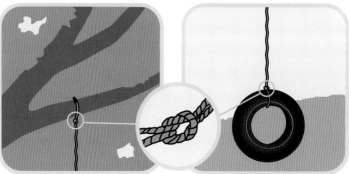

Secure with a square knot.

Hang with the holes at the bottom.

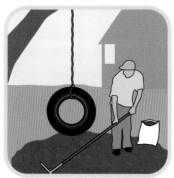

Mulch makes for softer landings.

3 press pretty flowers

Place on newspaper; fold.

Let set.

Mount on acid-free paper.

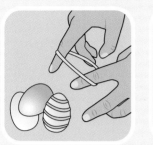 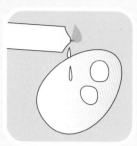

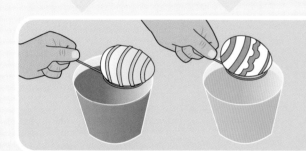

Peep!

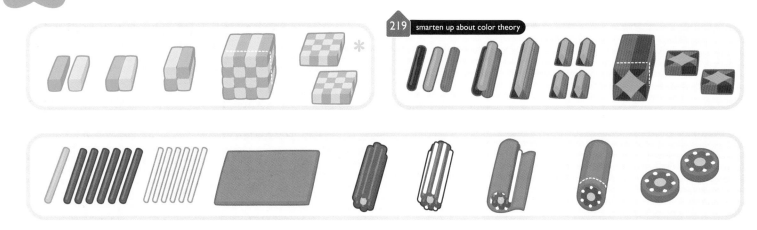

219 smarten up about color theory

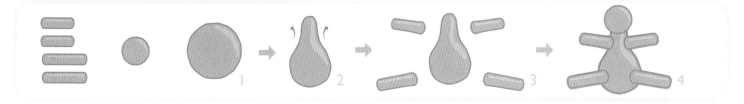

7 mold clay animals

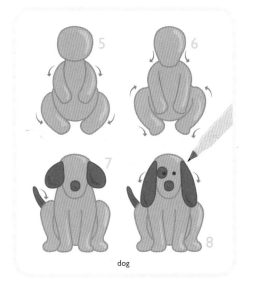

dog

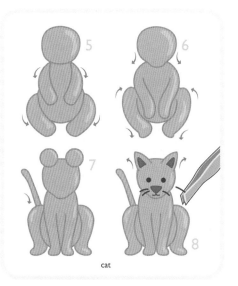

cat

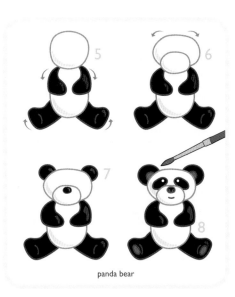

panda bear

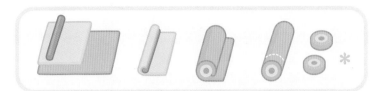

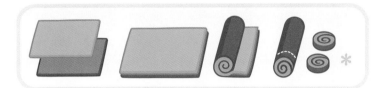

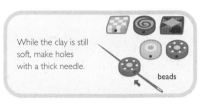

While the clay is still soft, make holes with a thick needle.

beads

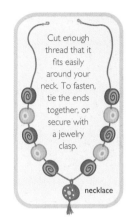

Cut enough thread that it fits easily around your neck. To fasten, tie the ends together, or secure with a jewelry clasp.

necklace

1 Loop, knot, and feed the thread through the bead.

2 Tie another knot, fray the fringe, and trim the excess.

pendant

Liven up your creations with beaded details—like eyes, knobs, feet, or antennae—and experiment with multiple layers and colors. How about "x-ray vision" eyes for your alien, a window for your spaceship, or a spiral cyclops eye for your monster?

make crop circles 477

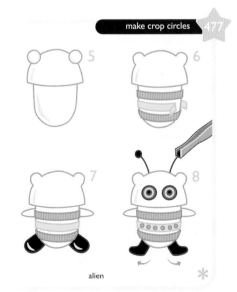

alien

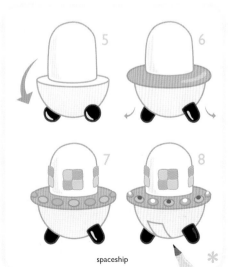

spaceship

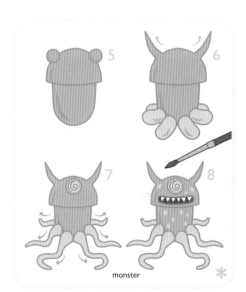

monster

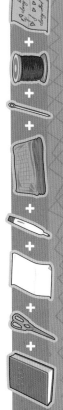

9 sew a spooky voodoo doll

Trace onto fabric.

Adorn with your enemy's hair.

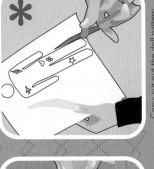

Copy, cut out the doll pattern.

Stuff with incriminating items.

Collect personal effects.

Partially sew the pieces together.

Pick an enemy.

Cut out a front and back.

* To make your own voodoo doll, simply trace this pattern, or photocopy it at whatever size you wish. (Warning: life-sized dolls, though effective, are often difficult to conceal.)

10 use my voodoo doll

To inflict pain (or pleasure) on your chosen victim (or the object of your affections), decorate the doll with symbols that correspond to your desires. Then choose a pin and prick the doll in the appropriate symbol. It helps to chant as you cast your spell—just remember to use your powers wisely. Hex away!

wealth
power
success
pleasure
pain
spirituality
love

ward off evil with a gris-gris

Someone working some voodoo on you? Fill this satchel with no more than 13 objects—like stones, herbs, or dirt from a graveyard—and use it to keep malevolent forces at bay. If you're female, wear it on your left; if you're male, pin it on your right.

love

money

enemy nearby

travel

protection

enlightenment

danger

fertility

goal

252 protect with a brigid's cross

Pin to the inside of your shirt.

Gather and tie closed.

Fill with an odd number of items.

Cut out a square of red felt.

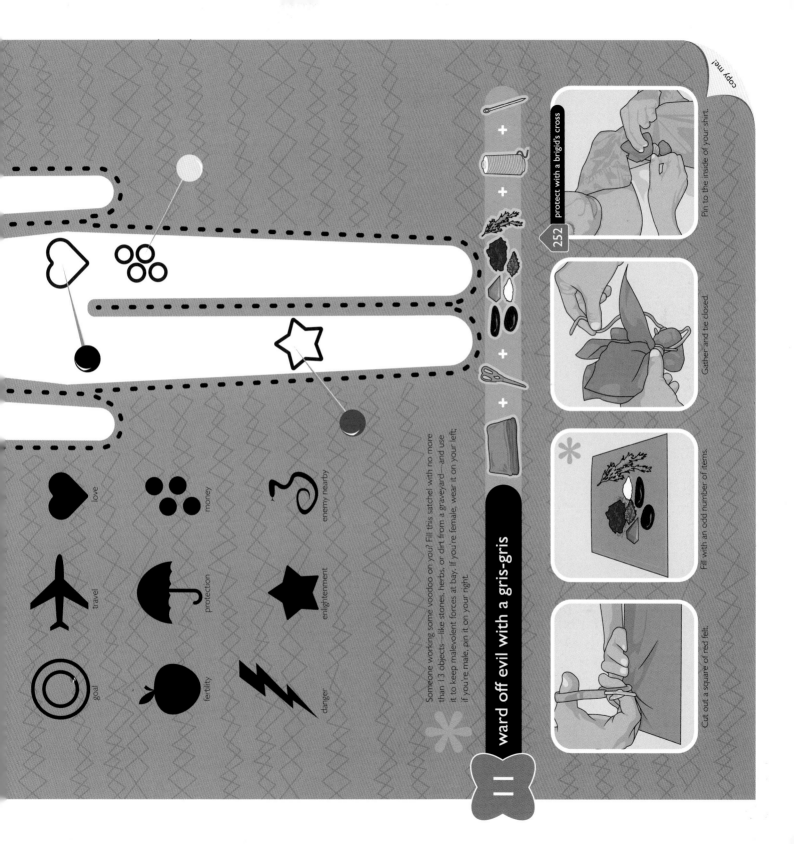

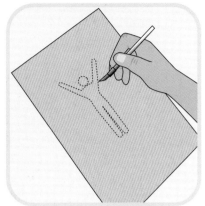

Design and cut out a personal tag.

Remove the bag's bottom.

Sneak to your destination in dark clothes.

Exit nonchalantly.

Paint with the juice.

Pass to a worthy confidant.

Apply glue to the edges of the pages.

Insert a cardboard separator; let dry.

Cut and remove the pages.

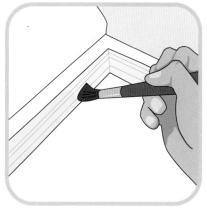

Coat the interior pages with glue.

Insert a cardboard separator; let dry.

Fill with secret items.

Cut open the rubber bands.

Tie each to the cloth.

Find a stone—and a target!

16 fold a sixteen-point star

It's easy to modify this merry decoration. Add more points to increase its size, or use many different colors for a more festive look.

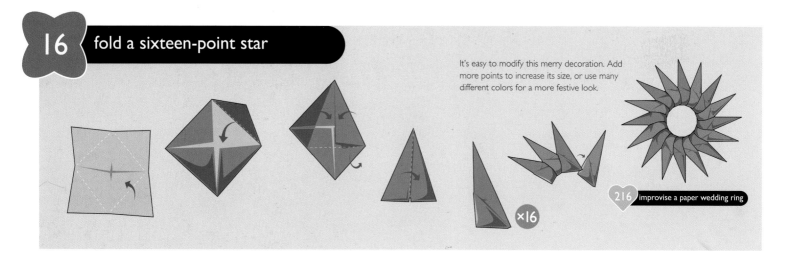

×16

216 improvise a paper wedding ring

17 construct an origami box

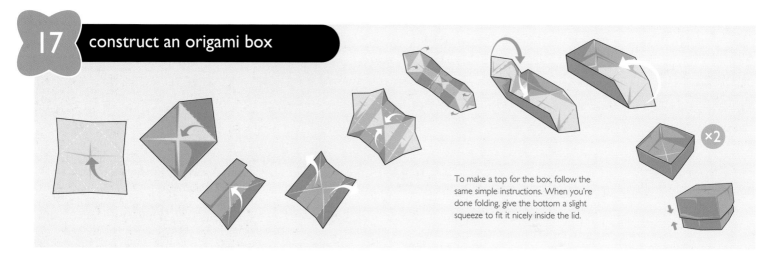

To make a top for the box, follow the same simple instructions. When you're done folding, give the bottom a slight squeeze to fit it nicely inside the lid.

×2

18 craft a paper penguin

Fold this little guy just right, and he'll stand all on his own! Slightly spread the folded "feet" to support his weight.

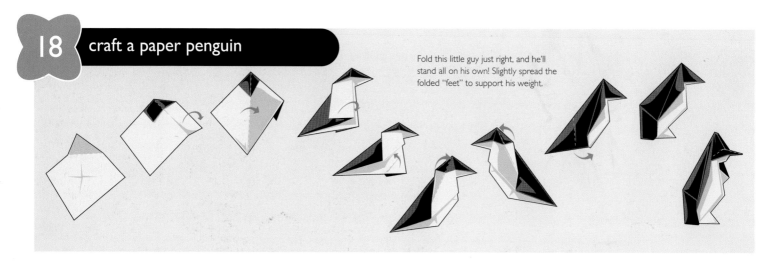

Copy onto a transparency.

Squeegee with emulsion.

Repeat on the back. Let dry.

Secure the transparency.

Add the glass.

Expose under a 250-watt bulb.

Rinse thoroughly.

Lay the frame on paper.

Squeegee with paint.

befriend a scared kitty 296

Lift the frame.

For best results, be sure to pick a design that packs a graphic punch—one without fussy details or lettering that might reverse in the silk-screening process.

Simplify multiple tones into bold, high-contrast shapes.

Use halftone dots to show gradual shifts in tone.

Stay clear of overly thin lines, which clog and smear easily.

Avoid very large areas of solid color where ink might pool.

Print colors one at a time. Layer them for cool effect.

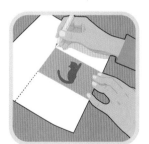

Trace a cover to size pages.

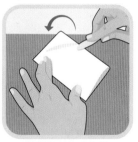

Fold the pages in half.

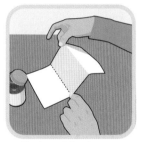

Overlap and glue the pages.

Glue inside the covers.

21 make a compact disc-o ball

 + + + +

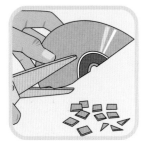

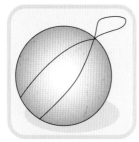

Wrap twice; knot.

Glue to the craft ball.

Continue around the ball.

464 moonwalk in style

Hang, and get busy dancing.

22 shape a retro record bowl

 + +

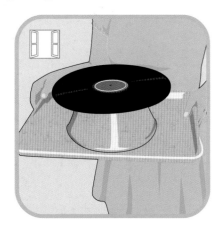

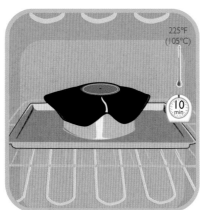

225°F (105°C)
10 min

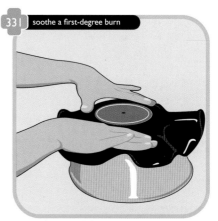

331 soothe a first-degree burn

Gently mold the record over the bowl.

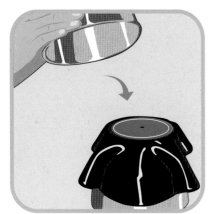

Press with a slightly larger bowl.

10 min

Let set.

The Infoettes

Overturn and use as a decorative bowl.

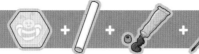

 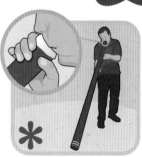

build a pvc-pipe didgeridoo — 23

Heat until pliant.

Mold a "snake."

Wrap around the opening.

Seal your lips to it and blow.

The didgeridoo's quirky droning sound is all owed to a trick called circular breathing. When the didgeridooist's lungs are almost empty, he stores his last breath in his cheeks, then slowly blows it out as he inhales through his nose. This way, air keeps circulating—and creating that cool, warbly rhythm!

craft a playing-card wallet — 24

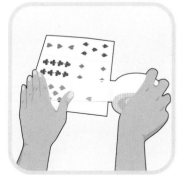

Tape the cards into a solid panel.

"Laminate" the back.

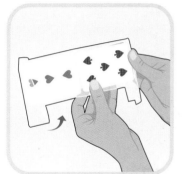 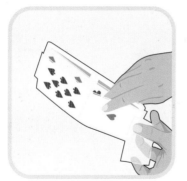 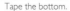 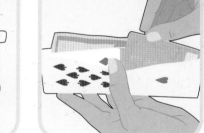

Fold the four cards; tape the sides.

Tape the two-card "pocket."

Tape the bottom.

1. Open a ring.

2. Hang two rings; cinch closed.

3. Repeat to make a chain.

4. Fasten two chains.

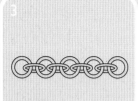

5. Create and attach three panels. ×2

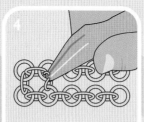

6. Gather the interior edges. ×2

7. Connect to make a seam. ×2

8. Adjoin all pieces.

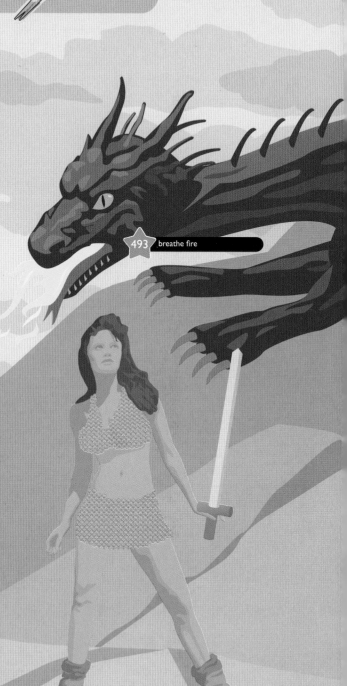

493 breathe fire

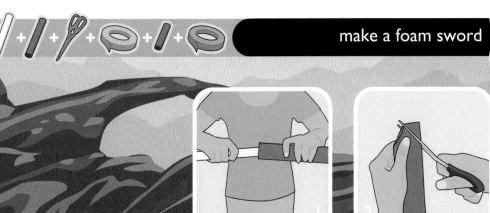
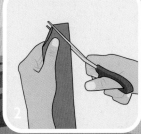

Sheath the pipe with foam.

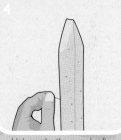

Trim the foam into a point.

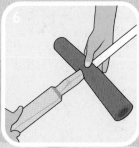

Cover with duct tape.

Holes make the sword softer.

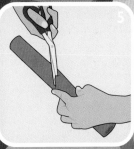

Make a hole in the short foam.

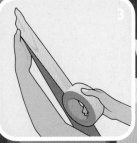

Slide onto the bare pipe end.

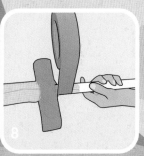

Cover the crossbar with tape.

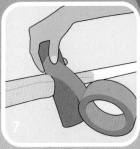

Wrap the exposed handle.

27 tell time with a potato clock

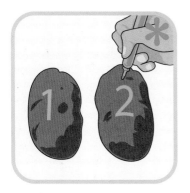

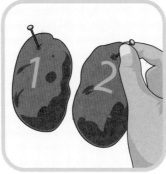

Add the galvanized nails.

Stick in the copper wires.

Remove the battery-compartment lid.

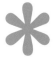 Taters may make surprising batteries, but they aren't the only unlikely items that can power a small digital clock—practically anything will conduct enough electricity. Try citrus, bananas, avocados, or even soda. Just remember to keep the galvanized nails and the copper wires as far away from each other as possible: it's the distance between them that generates power.

28 power a spinning machine

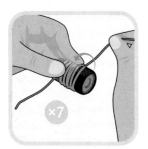

Wrap the electrical wire.

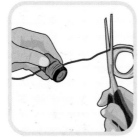

Trim; remove the battery.

Loop through the coil.

Strip the plastic coating.

Coat the ends in nail polish.

Attach the battery.

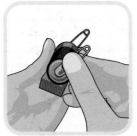

Add the safety pins.

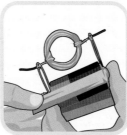

Add the coil; tape together.

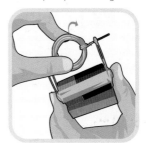

Give it a spin.

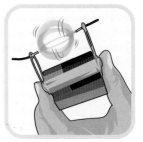

Watch it go!

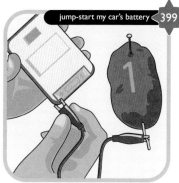

jump-start my car's battery `399`

Connect the copper wire to the clock.

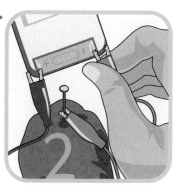

Link the nail to the clock.

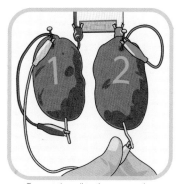

Connect the nail to the copper wire.

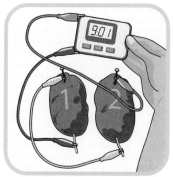

Set the clock to the proper time.

fit out a foxhole radio `29`

These clever radios were first invented by soldiers seeking a connection with the outside world during World War II. Some of the components (like the blued razor blade and the crystal earphone) might take some tracking down online or at a specialty hardware store.

4

To lengthen your wire, twist on a second one.

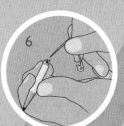

5

Expose the wire's other end—it acts as an antenna.

6

Insert the safety pin into the pencil's lead.

Connect all elements with the wire. Wrap it around the tacks; push the tacks into the board.

3

×120

2

Thread the wire through a hole in the tube, then wrap it around the tube.

7

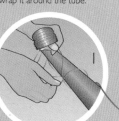

1

Move the pencil along the blued razor blade until you pick up a transmission. It may take a little jiggering to get it just right.

Wrap the wire around the safety pin and the earphone's receptor.

To ground the radio, wrap the magnet wire around a water pipe or a similar item.

8

A crystal earphone lets you tune into radio stations in your area.

Tape paper inside the box.

Cut a hole opposite it.

Cover with foil. Prick.

Cut a space for your head.

Adjust so you can see the eclipse.

 A solar eclipse is a truly amazing sight, but it could be your last if you look directly at it! The tiny hole in this box projects the eclipse's image onto the paper screen, sparing your eyes from harsh direct light. The longer the box, the larger the image.

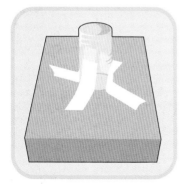 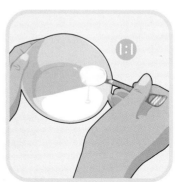

Tape a newspaper cone to the can.

Mix flour and water to make a paste.

Paste the paper strips to the cone.

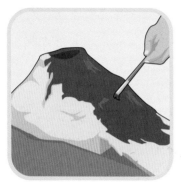 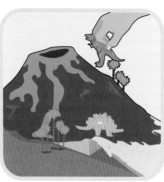 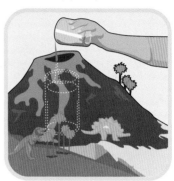

After the volcano dries, paint it.

Fill the can halfway with baking soda.

Add vinegar and food coloring.

A terrarium is a magical, miniature world, encapsulated for you to enjoy. This tropical version brims with plants that like misty environments, while desert-themed terrariums feature heat-craving succulents. (It's best to leave desert terrariums uncovered to let excess moisture evaporate.)

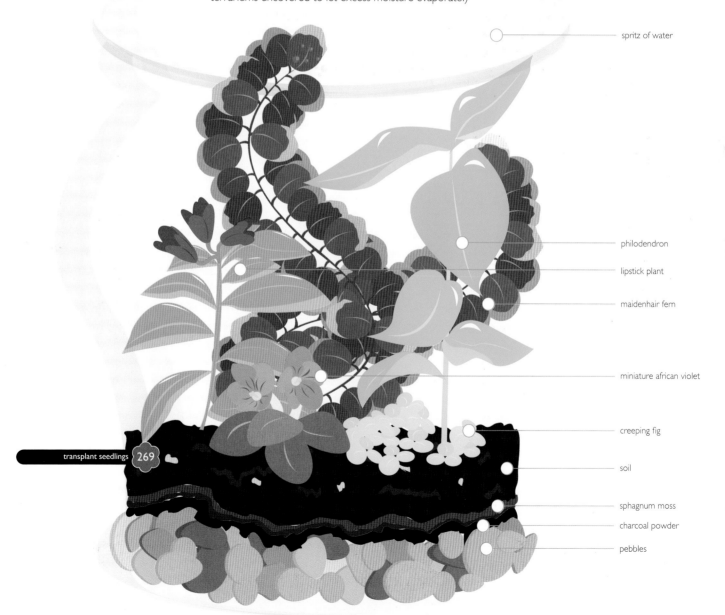

spritz of water

philodendron

lipstick plant

maidenhair fern

miniature african violet

creeping fig

soil

sphagnum moss

charcoal powder

pebbles

transplant seedlings 269

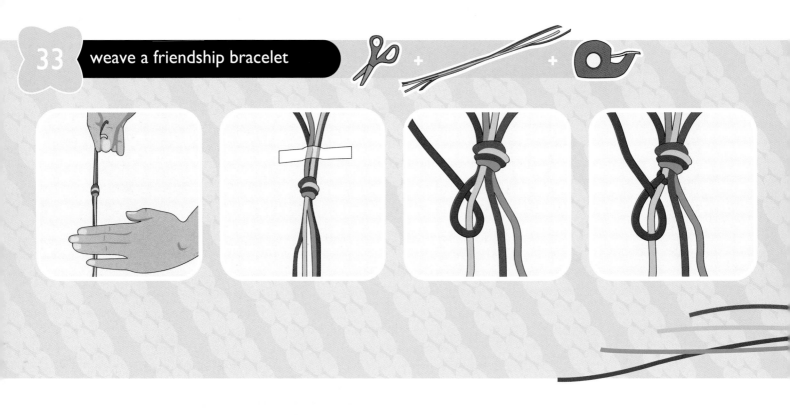

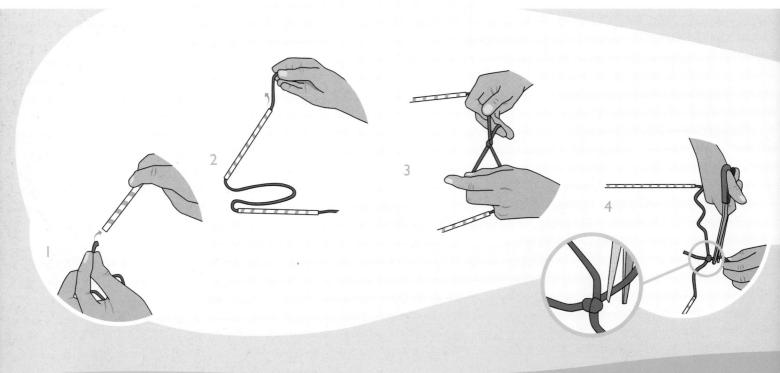

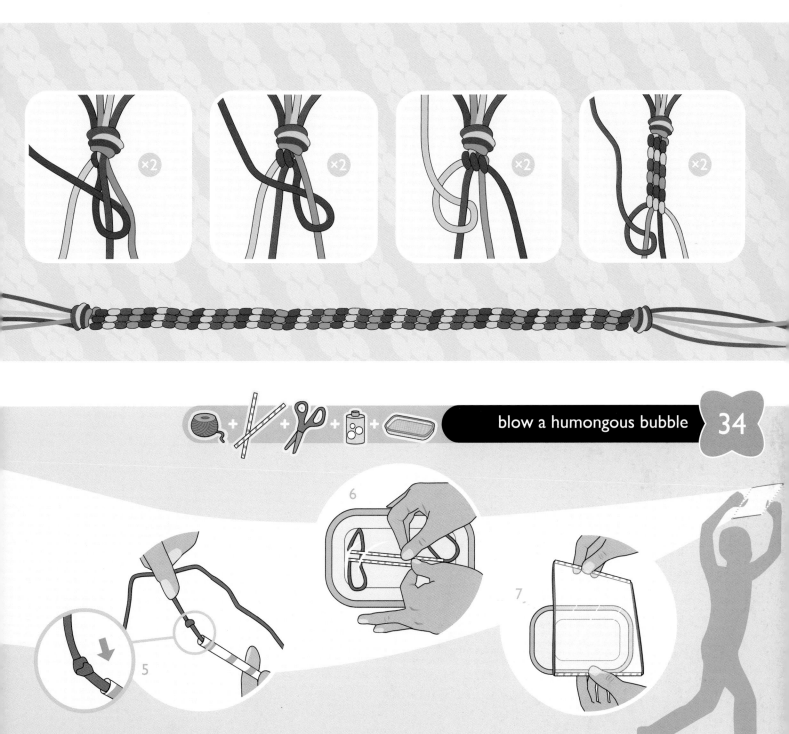

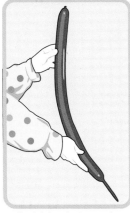

Don't inflate the bottom tip.

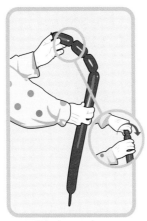

Twist three sections.

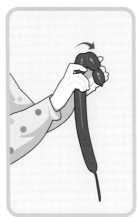

Bend back two sections.

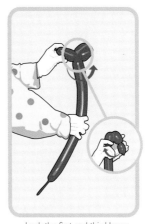

Lock the first and third loops.

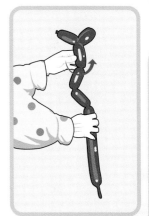

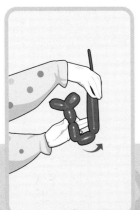

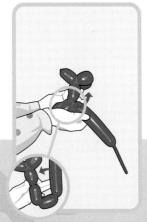

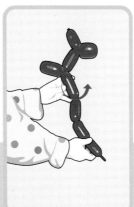

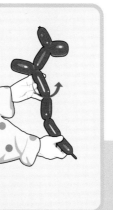

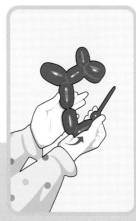

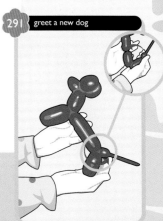

291 greet a new dog

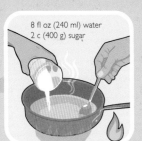

8 fl oz (240 ml) water
2 c (400 g) sugar

Dissolve the sugar in water.

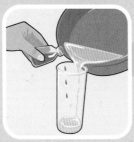

Mix the syrup and coloring.

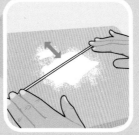

Wet the stick; coat in sugar.

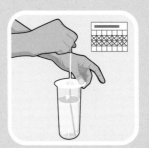

Cover. Insert the stick.

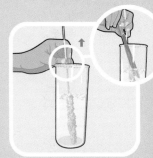

Cut out the stick, if needed.

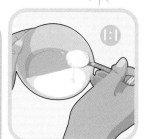

Mix the flour and water.

Add paper cones and strips.

Let dry. Pop the balloon.

Make two holes.

String through the two holes.

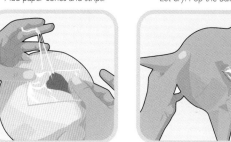

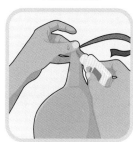

Hang, and have a swing at it!

tell time with a potato clock 27

Carve away the background.

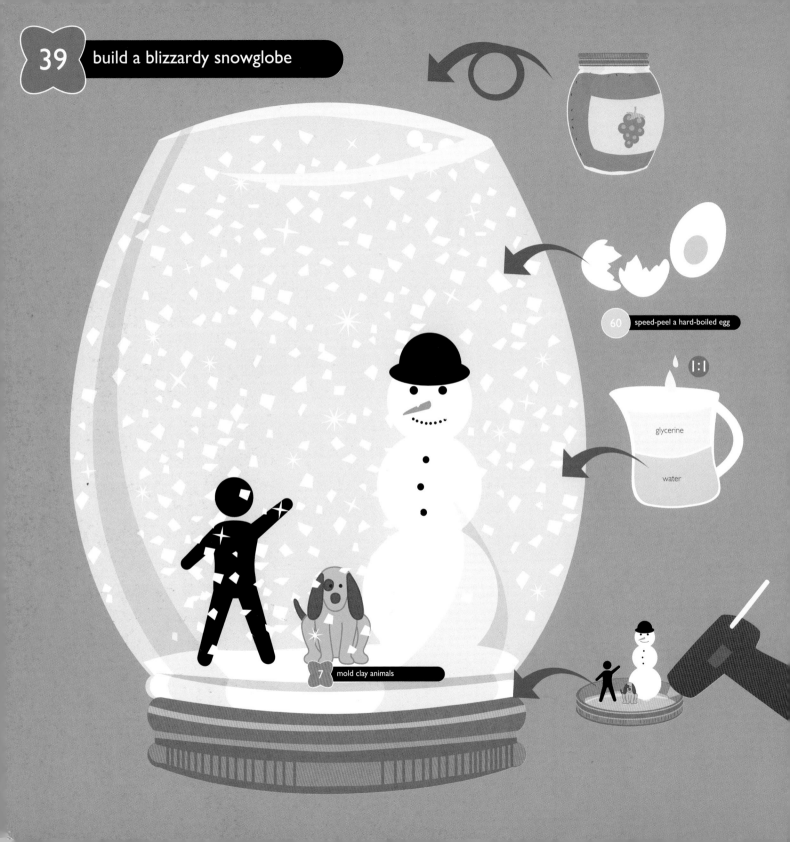

60 speed-peel a hard-boiled egg

I:I

glycerine

water

7 mold clay animals

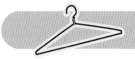
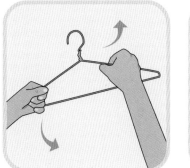

Stretch the hanger into a circle.

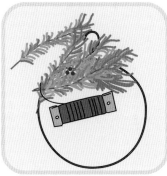

Layer the greenery.

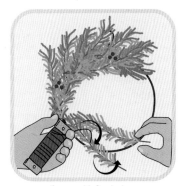

Secure with floral wire.

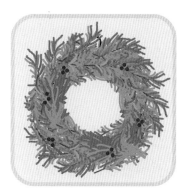

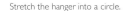
graft a citrus tree 266

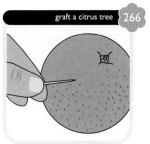

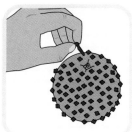

Roll in seasonal spices.

Let cure.

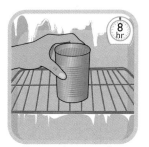

Freeze so the can stays firm.

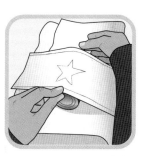

Nail holes along the design.

Hot water melts the ice.

Add a small candle. Light.

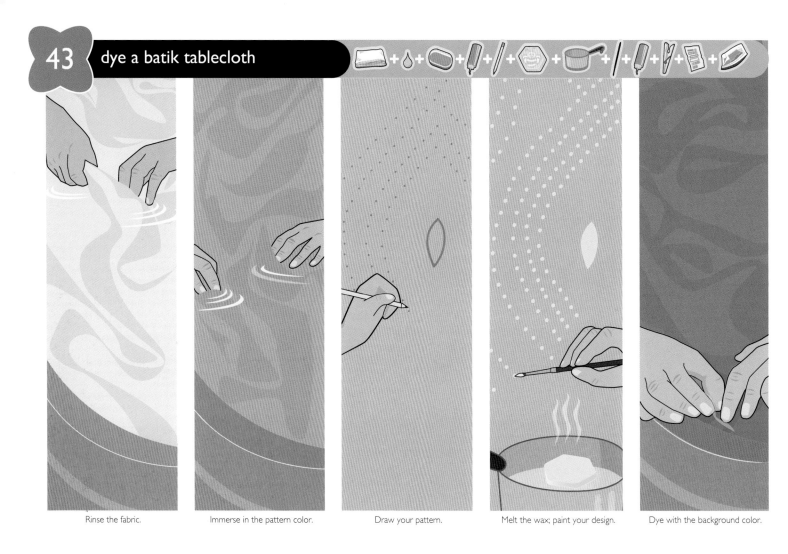

43 dye a batik tablecloth

Rinse the fabric.

Immerse in the pattern color.

Draw your pattern.

Melt the wax; paint your design.

Dye with the background color.

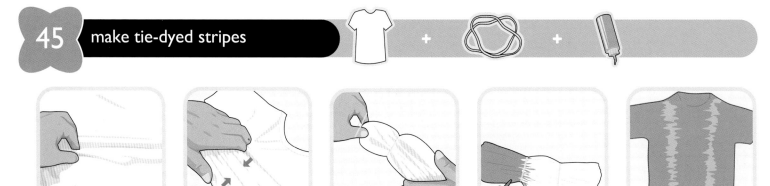

45 make tie-dyed stripes

Pinch the center.

Rinse and wear.

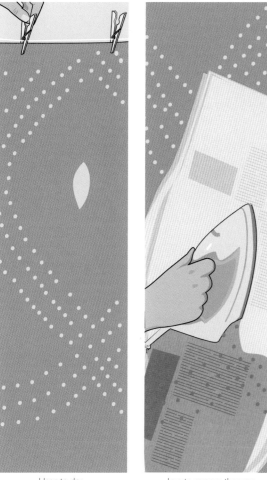

Hang to dry.

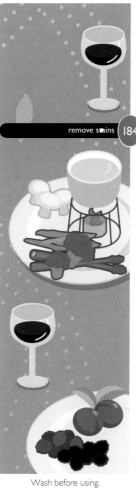

Iron to remove the wax.

remove stains 184

Wash before using.

Called sido dadi, this Indonesian design is a good omen. It translates to "you should be as you wish."

Only the most dignified wear the satrio wibowo, which is characterized by its all-over diamond print.

Once worn by royalty, the symmetrical kawung pattern balances energy, power, and other forces.

The purang rusak print was at one time a favorite of the sultan's family. Its wavy lines are considered lucky.

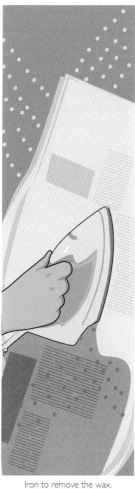

tie-dye a groovy spiral 46

Pinch the center.

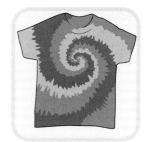

Rinse and wear.

47 cast on

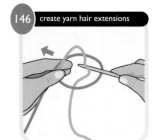

146 create yarn hair extensions

Put the needle in a slipknot.

Pull through the loop.

Loop around the needle.

Pull the yarn over the needle.

Pull to tighten.

48 do a knit stitch

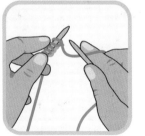

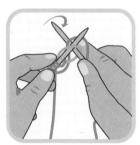

Put the right needle in back.

Loop around the needle.

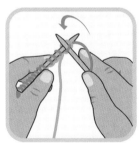

Put the back needle in front.

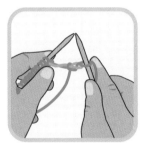

Slip off the left needle.

49 purl perfectly

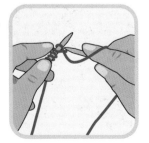

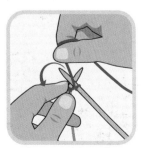

Put the right needle in front.

Loop around the needle.

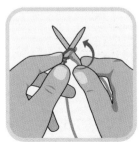

Put the front needle in back.

185 wash a sweater by hand

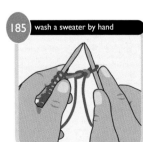

Slip off the left needle.

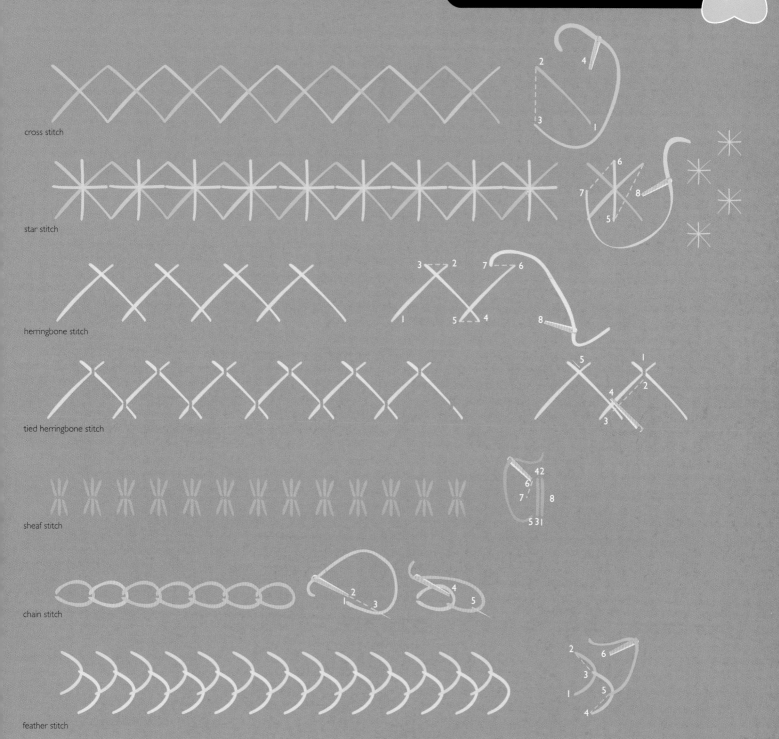

cross stitch

star stitch

herringbone stitch

tied herringbone stitch

sheaf stitch

chain stitch

feather stitch

rock

feather

morning star

stitch native bead designs

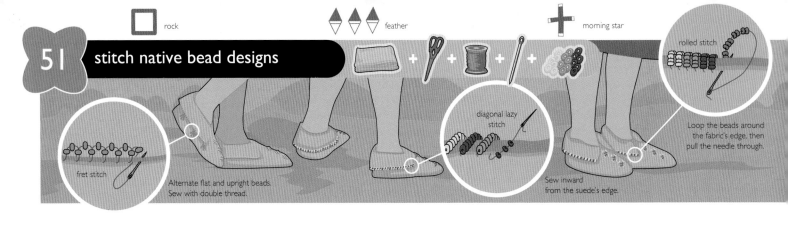

rolled stitch

fret stitch

Alternate flat and upright beads.
Sew with double thread.

diagonal lazy
stitch

Sew inward
from the suede's edge.

Loop the beads around
the fabric's edge, then
pull the needle through.

measure my feet for moccasins

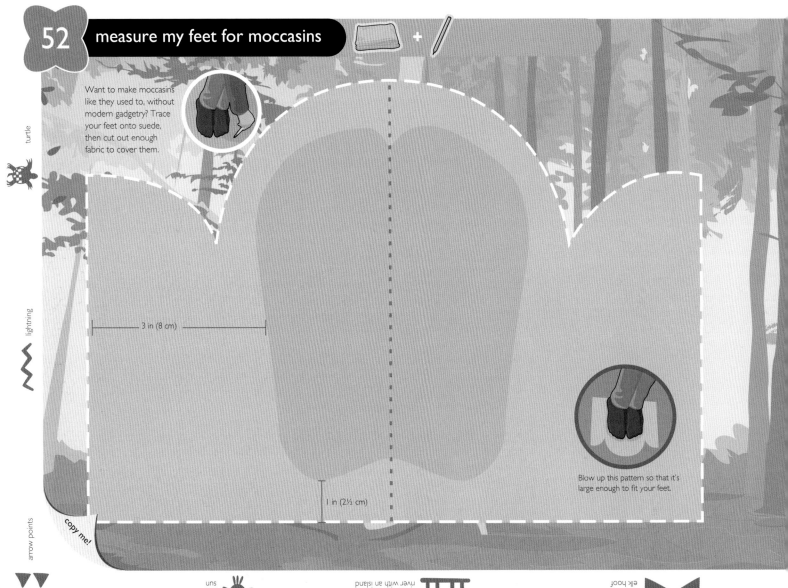

Want to make moccasins
like they used to, without
modern gadgetry? Trace
your feet onto suede,
then cut out enough
fabric to cover them.

turtle

lightning

arrow points

copy me!

3 in (8 cm)

1 in (2½ cm)

Blow up this pattern so that it's
large enough to fit your feet.

sun

river with an island

elk hoof

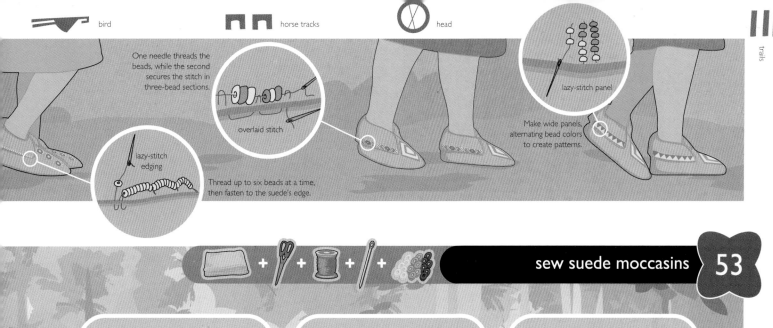

bird

horse tracks

head

trails

One needle threads the beads, while the second secures the stitch in three-bead sections.

overlaid stitch

lazy-stitch edging

Thread up to six beads at a time, then fasten to the suede's edge.

lazy-stitch panel

Make wide panels, alternating bead colors to create patterns.

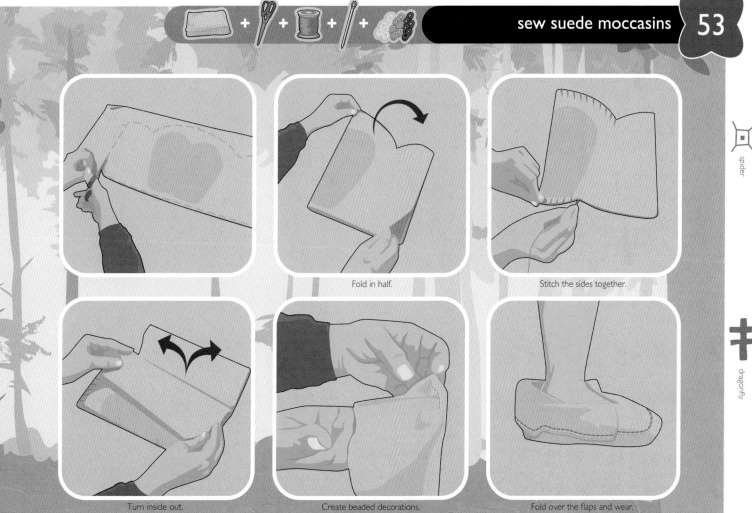

sew suede moccasins 53

Fold in half.

Stitch the sides together.

Turn inside out.

Create beaded decorations.

Fold over the flaps and wear.

spider

dragonfly

tipi

crayfish

thunderstorm

star

eat

54 open a pomegranate

 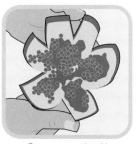

Cut along the rind sections.

Open; remove the pith.

55 dice a mango

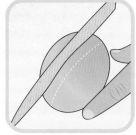

Cut on both sides of the pit.

Discard the pit.

Flip the half inside out.

Scrape fruit from the skin.

56 pit an avocado

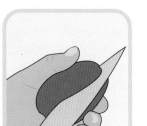 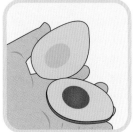 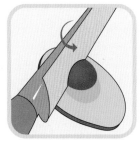

262 grow an avocado tree

Tap into the pit; twist it out.

Scoop out the meat.

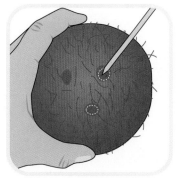

Make holes in two of the soft spots.

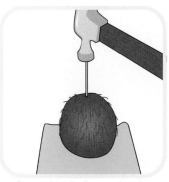

Deepen the holes. Remove the nails.

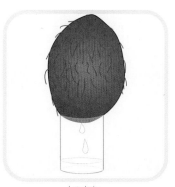

Let drain.

8–16 fl oz
(240–475 ml)

Separate the meat from the shell.

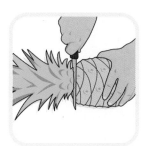

Cut off the top and bottom.

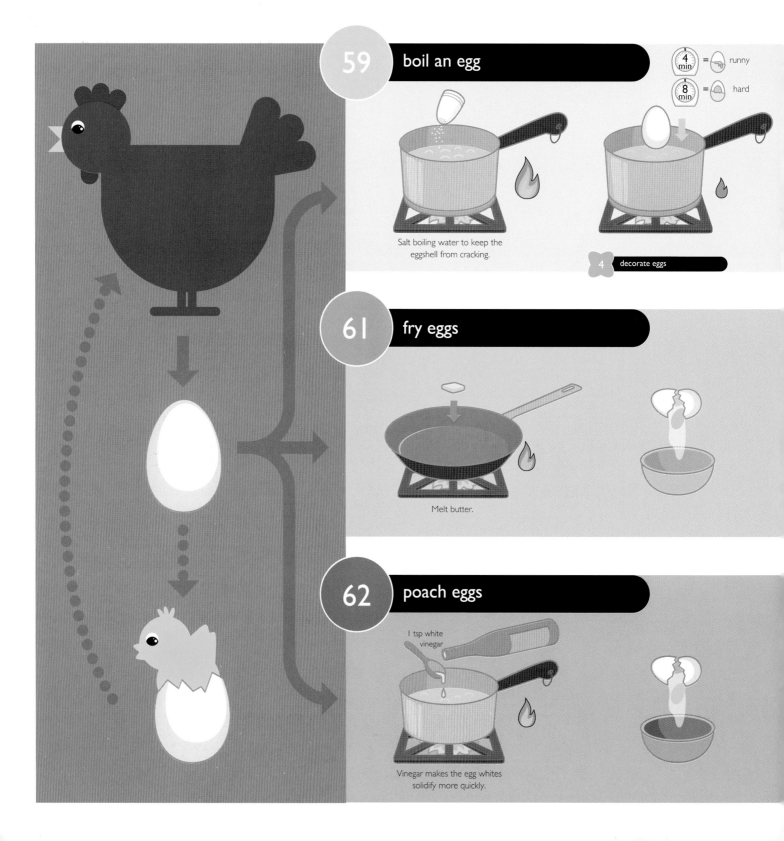

59 boil an egg

4 min = runny
8 min = hard

Salt boiling water to keep the eggshell from cracking.

4 decorate eggs

61 fry eggs

Melt butter.

62 poach eggs

1 tsp white vinegar

Vinegar makes the egg whites solidify more quickly.

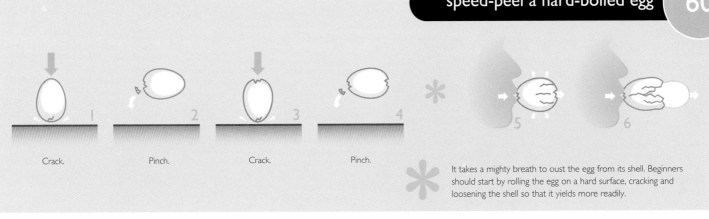

Crack. Pinch. Crack. Pinch.

It takes a mighty breath to oust the egg from its shell. Beginners should start by rolling the egg on a hard surface, cracking and loosening the shell so that it yields more readily.

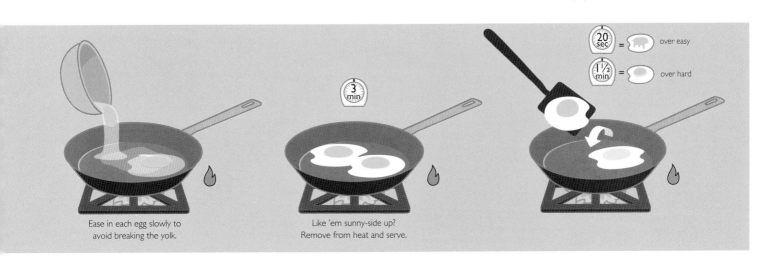

20 sec = over easy
1½ min = over hard

3 min

Ease in each egg slowly to avoid breaking the yolk.

Like 'em sunny-side up? Remove from heat and serve.

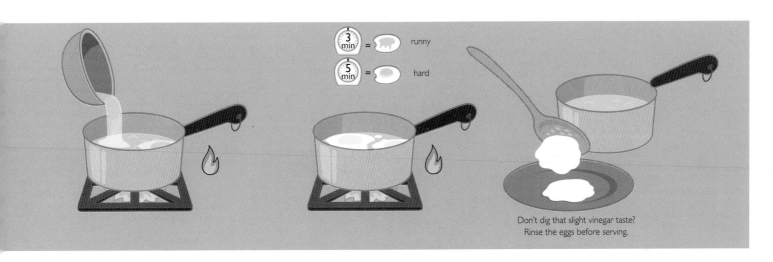

3 min = runny
5 min = hard

Don't dig that slight vinegar taste? Rinse the eggs before serving.

63 roll a taqueria-style burrito

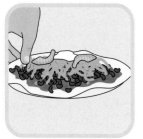
Start with a warm tortilla.

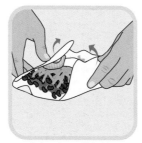
Gather the tortilla's sides.

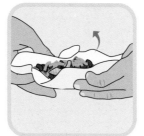
Fold the top and bottom.

Roll, wrapping the top flap.

Tuck any loose ends.

64 fry tortilla chips

Cut the tortillas into sixths.

Pour plenty of corn oil.

375°F (190°C)

Fry, turning occasionally.

2–3 min

Let cool. Blot with towels.

Sprinkle with salt.

65 prepare guacamole

56 pit an avocado

×4

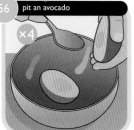

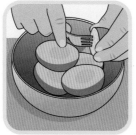
Spritz lime juice.

Dice the cilantro.

Mince the onion.

Combine; mash together.

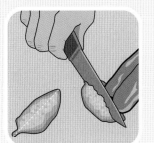

Cut into quarters.

Remove the ribs and seeds.

This simple, feisty condiment delivers a festive kick to any plate. Dice the ingredients, mix them together, and refrigerate for an hour. Serve as a spicy snack at a casual party, or alongside your favorite Mexican dishes.

1 onion

juice of 1–2 limes

6 large tomatoes

1 tsp salt

3 chile peppers

12 sprigs cilantro

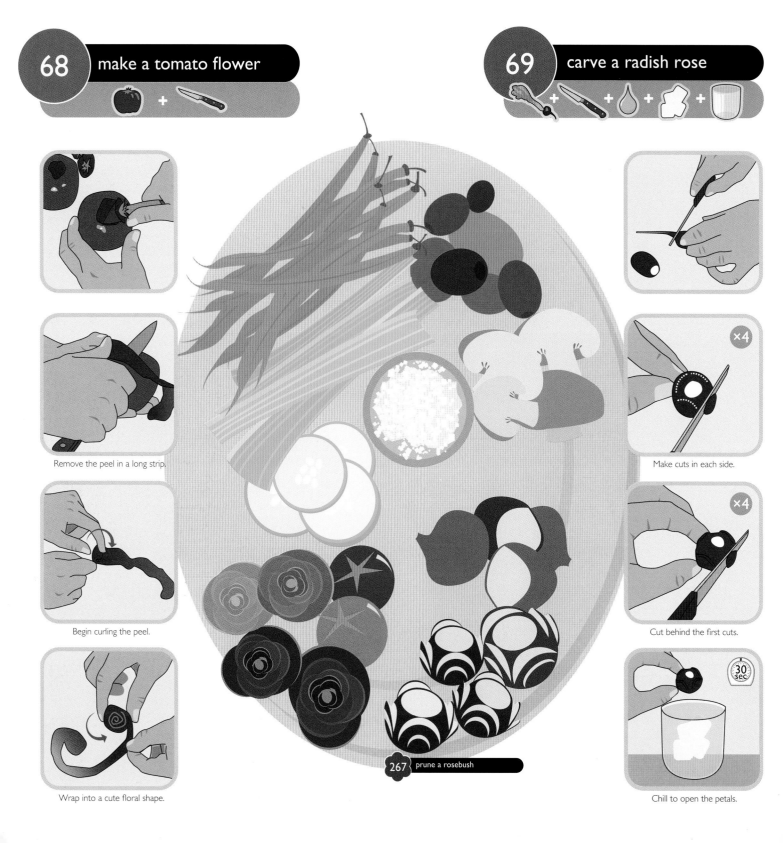

Remove the peel in a long strip.

Begin curling the peel.

Wrap into a cute floral shape.

Make cuts in each side.

×4

Cut behind the first cuts.

×4

Chill to open the petals.

30 sec

267 prune a rosebush

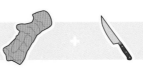

Cut away from your hands.

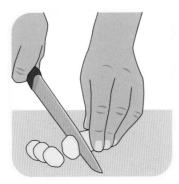

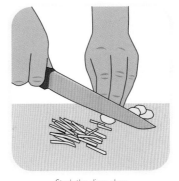
Stack the discs; chop.

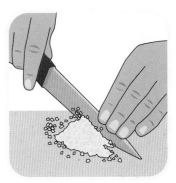
Rock the knife back and forth.

Rotate, charring each side.

Steam to loosen the skin.

Peel off the skin.

Remove the stem.

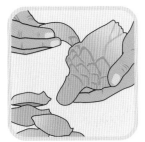
Peel off the outer leaves.

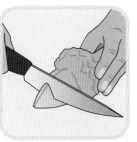
Slice off the top one-third.

Peel the stem; rub with lemon.

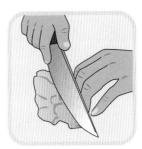
Cut into quarters.

Discard the fibrous choke.

73 derust a cast-iron pan

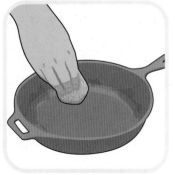

Rub vigorously with fine steel wool.

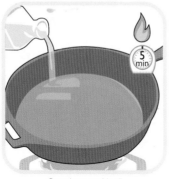

5 min

Coat the pan with oil.

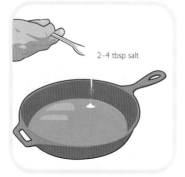

2–4 tbsp salt

Add salt to create a paste.

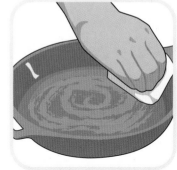

Scrub with paper towels, then rinse.

74 make a nonstick rolling pin

Stretch out a nylon stocking.

Insert a rolling pin.

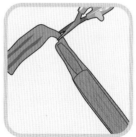

Use on a floured surface.

75 sharpen and polish a knife

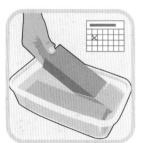

Soak the whetstones.

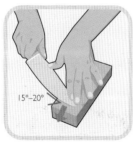

15°–20°

Push the knife forward.

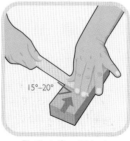

15°–20°

Flip the knife; pull it back.

15°–20°

Switch stones and repeat.

15°–20°

catch a fish bare-handed 426

* To keep herb sprigs fresh, submerge their stems in a glass of water and refrigerate. Basil is the only exception—it tends to brown in the fridge.

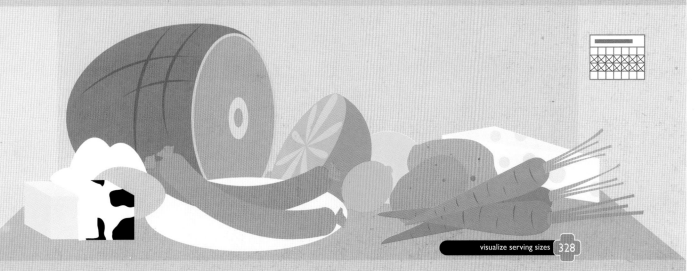

visualize serving sizes 328

77 use chopsticks

Place at the thumb's base.

Pinch against the forefinger.

Keep the bottom chopstick still.

* Chopsticks may seem intimidating. Just remember never to pass food with them—that's how grieving Japanese families receive the ashes of their loved ones during funerals.

tamago (egg) nigiri

hamachi (yellowtail) nigiri

tako (octopus) nigiri

78 wrap temaki sushi

Layer rice on the seaweed.

Leave a gap at the top.

Smear a line of wasabi.

Add ingredients.

Press to the seaweed.

Tighten into a roll.

ikura (salmon roe) nigiri

sake (salmon) nigiri

maguro (tuna) nigiri

ebi (shrimp) nigiri

maguro (tuna) temaki

shoyu (soy sauce)

 + +

Tuck the loose end.

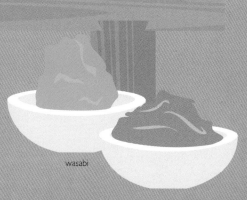

wasabi

gari (pickled ginger)

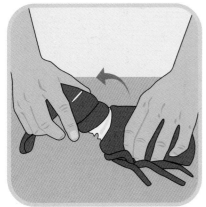

Twist the tail off of the body.

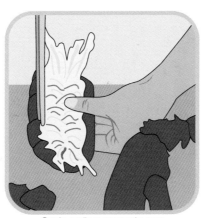

Cut the cartilage; remove the meat.

Remove the intestinal vein.

Pull the body from the chest shell.

Halve the chest shell. Extract the meat.

Crack the claws; remove the meat.

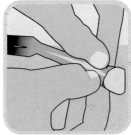

Pull the shell loose.

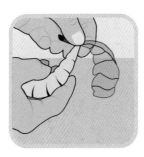

Cut along the vein.

Pull out the intestine.

Cut or pull away the apron.

Lift off the top shell.

Reserve fat from the shell.

Remove the gills.

Pull off the jaws.

Pull out the intestine.

Twist off the claws and legs.

Cut into quarters.

Extract the meat.

Crack the claws.

 Wait, don't throw out the fat! Called "crab butter," this soft yellow substance has a savory, slightly salty taste that makes a delicious addition to butter or sauces.

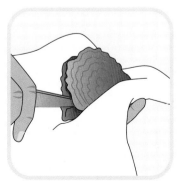

Break the shell's hinge.

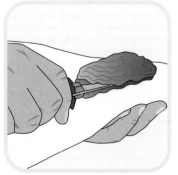

Detach the muscle from the top shell.

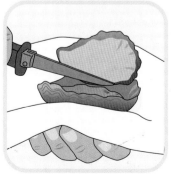

Discard the top shell.

Loosen the oyster.

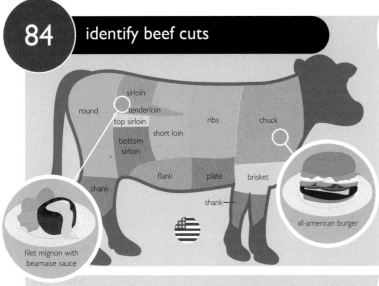

sirloin
round
tenderloin
top sirloin
short loin
bottom sirloin
ribs
chuck
flank
plate
brisket
shank
shank
steak and kidney pie

filet mignon with beamaise sauce

all-american burger

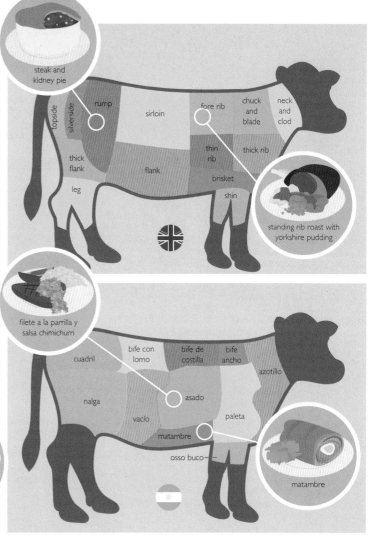

topside
silverside
rump
sirloin
fore rib
chuck and blade
neck and clod
thick flank
thin rib
thick rib
flank
brisket
leg
shin

standing rib roast with yorkshire pudding

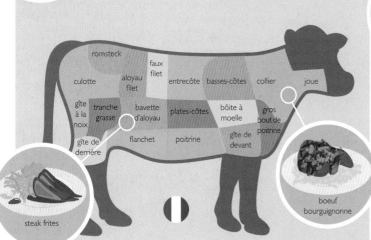

romsteck
faux filet
culotte
aloyau filet
entrecôte
basses-côtes
collier
joue
gîte à la noix
tranche grasse
bavette d'aloyau
plates-côtes
bôite à moelle
gros bout de poitrine
gîte de derrière
flanchet
poitrine
gîte de devant

steak frites

boeuf bourguignonne

filete a la parilla y salsa chimichurri

cuadril
bife con lomo
bife de costilla
bife ancho
azotillo
nalga
asado
vacío
paleta
matambre
osso buco
matambre

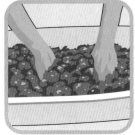
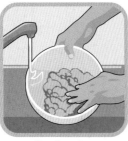

Mix the meat and spices.

Rinse the casings.

Lubricate the stuffer.

Ease on the casing.

Tie off the end.

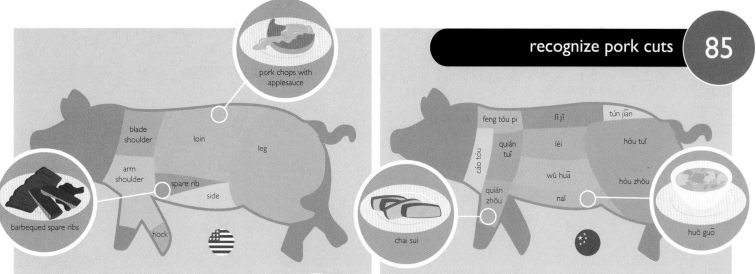

USA (top-left diagram):

pork chops with applesauce

blade shoulder

loin

leg

arm shoulder

spare rib

side

barbequed spare ribs

hock

China (top-right diagram):

feng tóu pi

lǐ jǐ

tún jiān

cǎo tóu

quián tuǐ

lèi

hòu tuǐ

wǔ huā

hòu zhǒu

quián zhǒu

naǐ

chai sui

huǒ guō

Spain (bottom-left diagram):

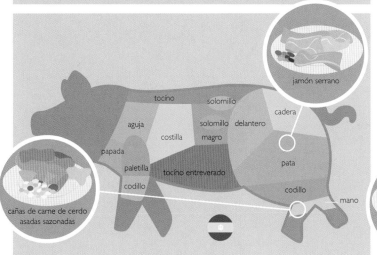

tocíno

solomillo

aguja

solomillo

delantero

cadera

costilla

magro

papada

pata

paletilla

tocíno entreverado

codillo

codillo

mano

jamón serrano

cañas de carne de cerdo asadas sazonadas

Germany (bottom-right diagram):

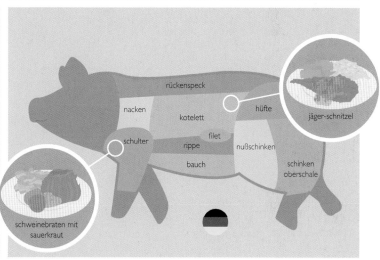

rückenspeck

nacken

kotelett

hüfte

schulter

filet

rippe

nußschinken

bauch

schinken oberschale

jäger-schnitzel

schweinebraten mit sauerkraut

Feed into the processor.

Pinch the sausage.

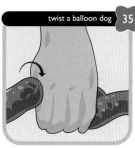

Twist clockwise.

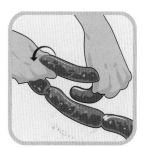

Switch with each link.

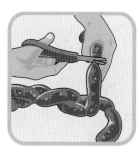

Separate before cooking.

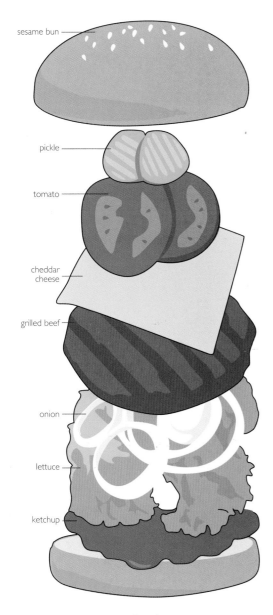

sesame bun

pickle

tomato

cheddar
cheese

grilled beef

onion

lettuce

ketchup

classic burger

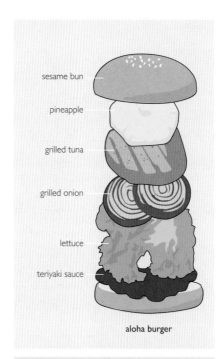

sesame bun

pineapple

grilled tuna

grilled onion

lettuce

teriyaki sauce

aloha burger

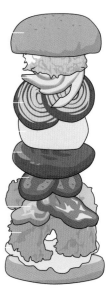

whole wheat bun

sprouts

avocado

grilled onion

provolone cheese

grilled portobello

tomato

bell pepper

lettuce

mustard

'shroom burger

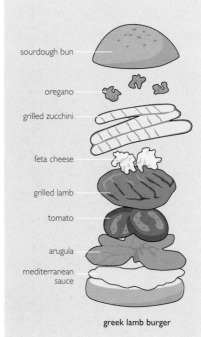

sourdough bun

oregano

grilled zucchini

feta cheese

grilled lamb

tomato

arugula

mediterranean
sauce

greek lamb burger

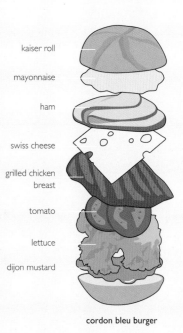

kaiser roll

mayonnaise

ham

swiss cheese

grilled chicken
breast

tomato

lettuce

dijon mustard

cordon bleu burger

Trim the excess fat.

To prevent curling, score the sides.

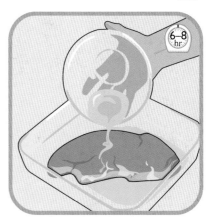

Pour marinade, then refrigerate.

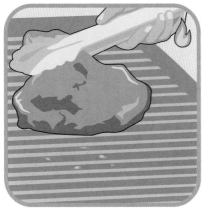

Place on a preheated grill.

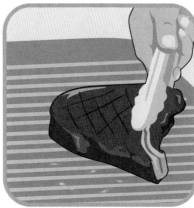

Flip. Rotate to make a crosshatch design.

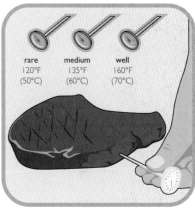

rare	medium	well
120°F	135°F	160°F
(50°C)	(60°C)	(70°C)

Test for doneness.

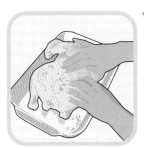

Rub with butter and spices.

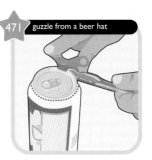

471 guzzle from a beer hat

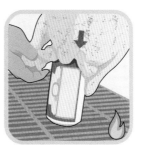

Add your favorite spices.

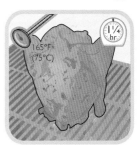

Ease onto the can.

165°F
(75°C)

1¼ hr.

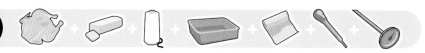

Remove the giblets.

Spread butter over the skin.

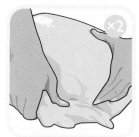
Tuck each wing.

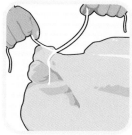
Tie the drumsticks together.

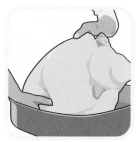
Place breast side up.

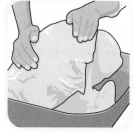
Cover the breast with foil.

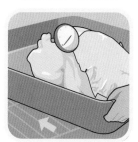

Baste every 45 minutes.

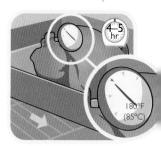
Uncover for the last hour.

4–5 hr
180°F (85°C)

Ancient Romans first came up with this fun luck-building tradition, and it now goes on as a friendly competition at Thanksgiving tables across the United States. The long and short of it? Two people lock their pinkies around the wishbone (which is the collarbone) and try to break off the longest piece—and gain some good fortune.

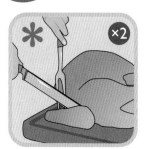
Slice off the wings.

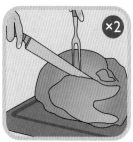
Remove the legs.

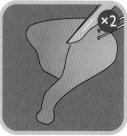
Sever the drumstick.

Carve parallel to the bone.

Carve the breast in slices.

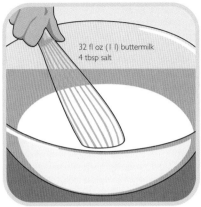

32 fl oz (1 l) buttermilk
4 tbsp salt

Whisk the buttermilk and salt.

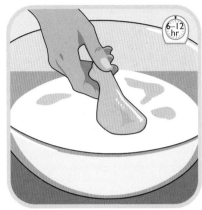

6–12 hr

Submerge the chicken pieces; refrigerate.

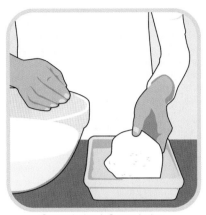

Coat each piece in flour and spices.

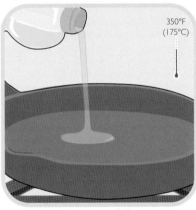

350°F (175°C)

Heat plenty of oil.

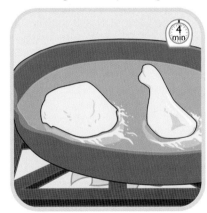

4 min

Fry each side until golden brown.

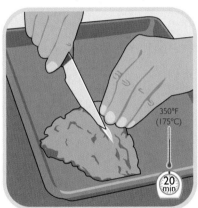

350°F (175°C)

20 min

Bake, then check for doneness.

Let the drippings separate.

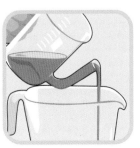

Pour the juices from the fat.

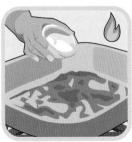

Add flour and butter.

10 min

Add juices and stock; whisk.

Check for desired thickness.

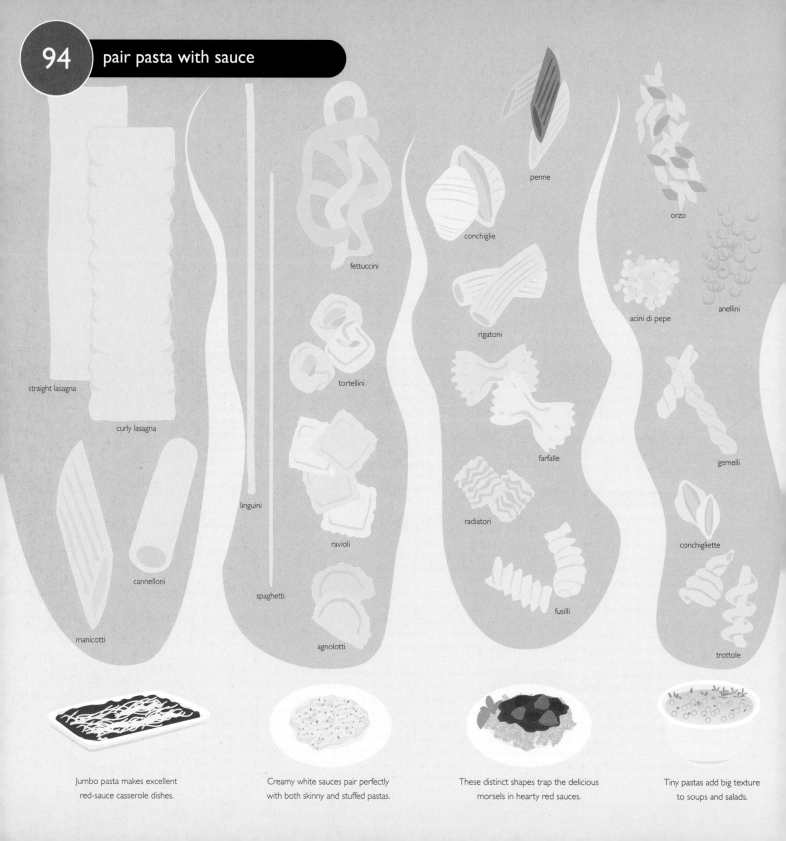

straight lasagna

curly lasagna

fettuccini

conchiglie

penne

orzo

tortellini

rigatoni

acini di pepe

anellini

linguini

ravioli

farfalle

gemelli

radiatori

conchigliette

cannelloni

spaghetti

fusilli

manicotti

agnolotti

trottole

Jumbo pasta makes excellent
red-sauce casserole dishes.

Creamy white sauces pair perfectly
with both skinny and stuffed pastas.

These distinct shapes trap the delicious
morsels in hearty red sauces.

Tiny pastas add big texture
to soups and salads.

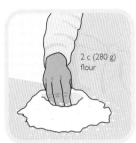

2 c (280 g) flour

Make a well in the flour.

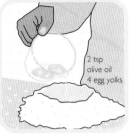

2 tsp olive oil
4 egg yolks

Add the egg-oil mixture.

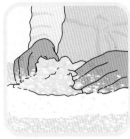

Draw in the flour.

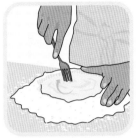

Roll the dough into a ball.

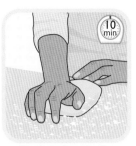

Knead on a floured surface.

Divide into fourths.

Flatten each into a disc.

 74 make a nonstick rolling pin

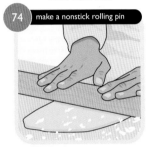

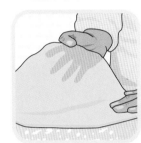

Flip and roll again.

Check for translucence.

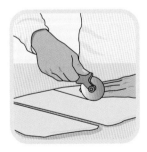

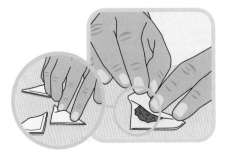

Spread; let dry.

Add filling; wet the edges.

98 fold a galette

Fold over the edges.

Brush with an egg wash.

Sprinkle with sugar.

*An egg wash is a mixture of egg yolk and water. It covers pastries and breads with a slight glaze, and seals in scrumptious flavors.

99 shape a baguette

436 throw an effective punch

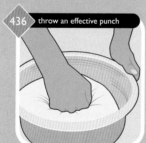

Let the dough rise.

Punch to release gases.

100 braid challah bread

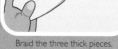

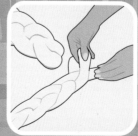

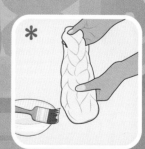

Braid the three thick pieces.

Make a skinny braid.

Stack; brush with egg wash.

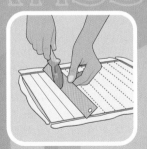
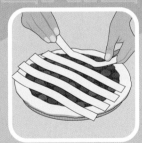
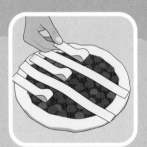
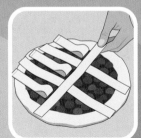

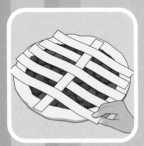
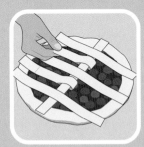
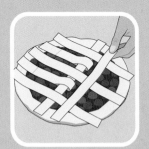

Continue until covered.

read a dog's body language 290

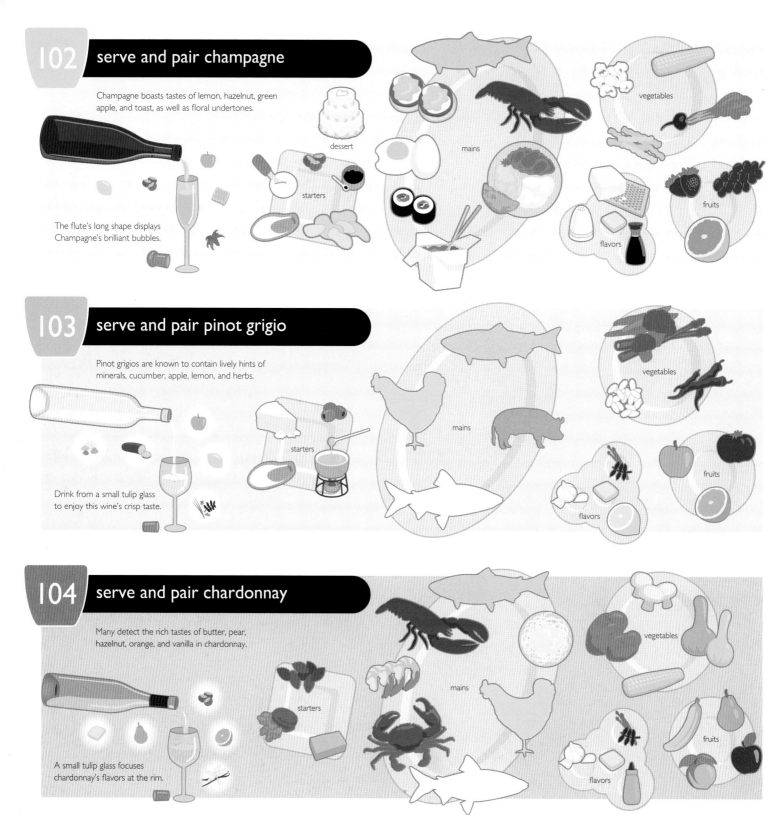

102 serve and pair champagne

Champagne boasts tastes of lemon, hazelnut, green apple, and toast, as well as floral undertones.

The flute's long shape displays Champagne's brilliant bubbles.

dessert

starters

mains

vegetables

flavors

fruits

103 serve and pair pinot grigio

Pinot grigios are known to contain lively hints of minerals, cucumber, apple, lemon, and herbs.

Drink from a small tulip glass to enjoy this wine's crisp taste.

starters

mains

vegetables

flavors

fruits

104 serve and pair chardonnay

Many detect the rich tastes of butter, pear, hazelnut, orange, and vanilla in chardonnay.

A small tulip glass focuses chardonnay's flavors at the rim.

starters

mains

vegetables

flavors

fruits

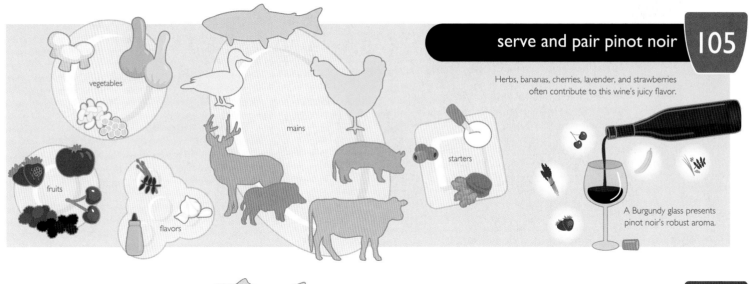

serve and pair pinot noir 105

Herbs, bananas, cherries, lavender, and strawberries often contribute to this wine's juicy flavor.

vegetables

mains

fruits

flavors

starters

A Burgundy glass presents pinot noir's robust aroma.

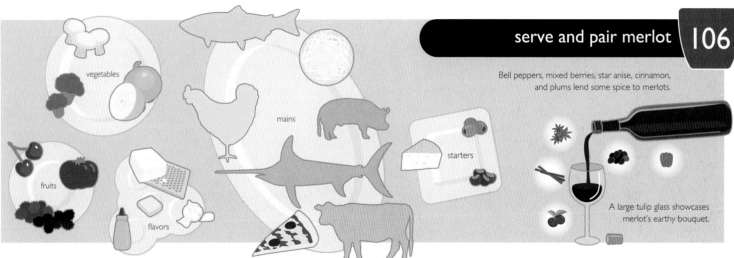

serve and pair merlot 106

Bell peppers, mixed berries, star anise, cinnamon, and plums lend some spice to merlots.

vegetables

mains

fruits

flavors

starters

A large tulip glass showcases merlot's earthy bouquet.

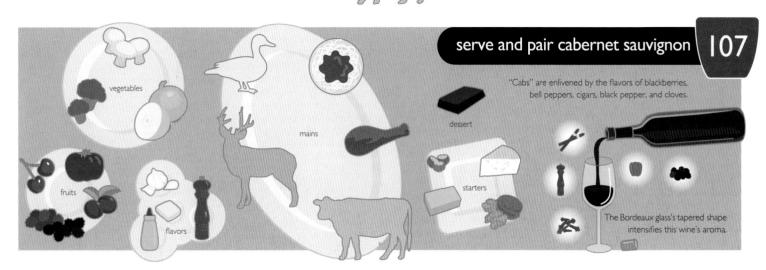

serve and pair cabernet sauvignon 107

"Cabs" are enlivened by the flavors of blackberries, bell peppers, cigars, black pepper, and cloves.

vegetables

mains

dessert

fruits

flavors

starters

The Bordeaux glass's tapered shape intensifies this wine's aroma.

108 open a bottle of wine

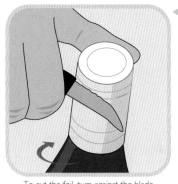
To cut the foil, turn against the blade.

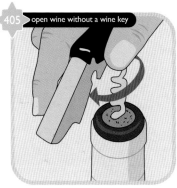
405 open wine without a wine key
Twist the worm halfway into the cork.

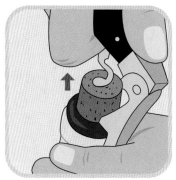
Place the lever on the rim; pull.

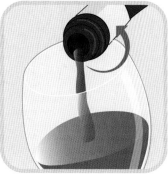
Twist slightly to prevent drips.

109 remove cork bits from wine

Inspect for loose cork bits.

Place a filter over the glass.

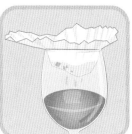
Push the cork back; pour.

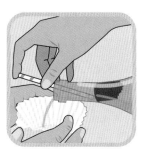

110 evaluate a wine

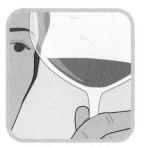
Note the color and clarity.

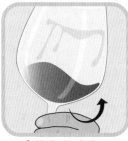
Swirl; observe the legs.

Inhale its aroma.

Fill one-third of your mouth.

Swish the wine thoroughly.

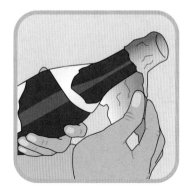
Wipe away excess moisture.

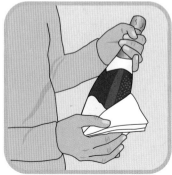

Untwist the wire; remove the cage.

Locate where the seam meets the lip.

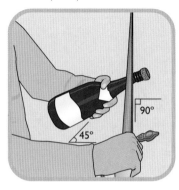

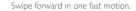
Swipe forward in one fast motion.

The spray washes away any shards.

 This flamboyant trick was first popularized by Napoleon's soldiers. The secret? The bottle's intersecting seams create a weak spot that ruptures readily under pressure, impressing—and sometimes dousing!—all in attendance.

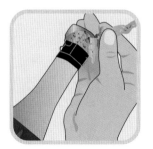

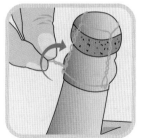

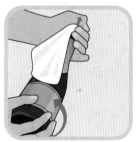
To open, rotate the bottle.

Fill in stages to avoid spills.

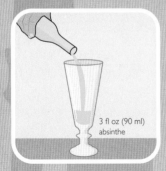

3 fl oz (90 ml)
absinthe

Put sugar on an absinthe spoon.

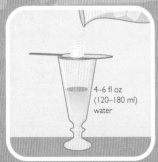

4–6 fl oz
(120–180 ml)
water

Dilute to taste.

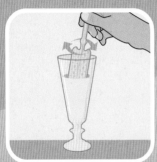

140 identify men's facial hair styles

In this Czech variation on a French theme, the sugar cube is dipped in absinthe and set ablaze. (Don't get too carried away—absinthe's high alcohol content makes it very flammable.) After the sugar melts, dilute the drink, then serve it promptly to the nearest wild-eyed bohemian. Na zdraví!

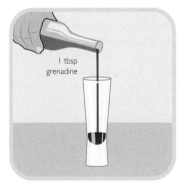

1 tbsp
grenadine

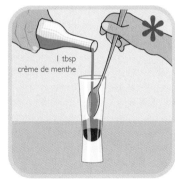

1 tbsp
crème de menthe

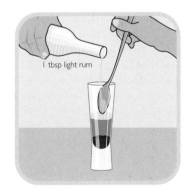

1 tbsp light rum

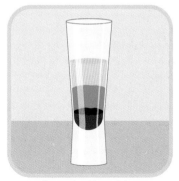

Serve as is, without stirring.

 The pousse-café is famous for its distinctive layers, and it has gravity to thank for it! To keep the liqueurs stacking just right, pour them in order of most to least dense. Trickle them over the back of a spoon to prevent them from mixing as they settle.

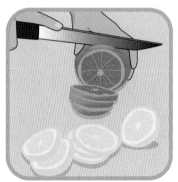

Slice fruit of your choosing.

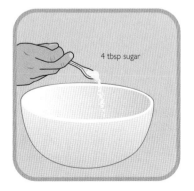

4 tbsp sugar

2 fl oz (60 ml)
brandy

25 fl oz (750 ml)
wine

10 fl oz (300 ml)
orange juice

16 fl
club soda

Refrigerate or serve immediately.

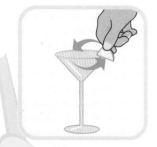

Twist in sugar or salt.

strawberry margarita
2 fl oz (60 ml) silver tequila
1 fl oz (30 ml) lime juice
8 strawberries, hulled
1 strawberry garnish
salt for the rim

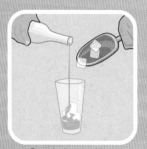

bloody mary
2 fl oz (60 ml) vodka
4 fl oz (120 ml) tomato juice
1 tbsp lime juice
¼ tsp pepper
1 pinch salt
¼ tsp ground cumin
2 dashes Worcestershire sauce
2 dashes hot sauce
1 celery stalk garnish
1 lime wedge garnish

mai tai
3 tbsp dark rum
2 tbsp light rum
2 tbsp triple sec
1 tbsp apricot brandy
2 tbsp lime juice
2 tbsp simple syrup
1 dash of orgeat syrup

sidecar
1½ fl oz (45 ml) brandy
1 tbsp triple sec
1 tbsp maraschino liqueur
1 tbsp lemon juice
sugar for the rim

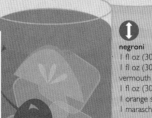

shake roll blend

Some drinks like a rousing shake, some prefer to be rolled gently
from side to side (or stirred), and others still want to go for a spin
in a blender. Let this guide turn you into a stellar mixologist.

negroni
1 fl oz (30 ml) gin
1 fl oz (30 ml) sweet
vermouth
1 fl oz (30 ml) Campari
1 orange slice garnish
1 maraschino cherry garnish

manhattan
2½ fl oz (75 ml) whiskey
1½ tbsp sweet vermouth
2 dashes Angostura bitters
1 maraschino cherry garnish

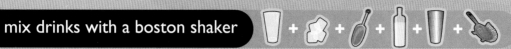

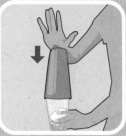
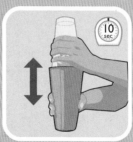

Pour the liquor; add ice. Tap to create a seal. Invert; shake thoroughly. Tap to break the seal. Secure the strainer; pour.

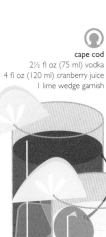

cape cod
2½ fl oz (75 ml) vodka
4 fl oz (120 ml) cranberry juice
1 lime wedge garnish

long island iced tea
1 tbsp gin
1 tbsp light rum
1 tbsp silver tequila
1 tbsp vodka
1 tbsp triple sec
1 fl oz (30 ml) lemon juice
1 tbsp simple syrup
5 fl oz (150 ml) cola
1 lemon wedge garnish

tequila sunrise
2½ fl oz (75 ml) silver tequila
4 fl oz (120 ml) orange juice
1½ tsp grenadine
1 pineapple wedge garnish

singapore sling
2 fl oz (60 ml) gin
1 tbsp Bénédictine
1 tbsp cherry brandy
1 fl oz (30 ml) lemon juice
1 tbsp simple syrup
2 fl oz (60 ml) club soda
1 lemon wedge garnish

cut a pineapple 58

cuba libre
2½ fl oz (75 ml) light rum
1 fl oz (30 ml) lime juice
6 fl oz (180 ml) cola
1 lime wedge garnish

tom collins
2 fl oz (60 ml) gin
1 tbsp lemon juice
1 tbsp simple syrup
5 fl oz (150 ml) club soda
1 lemon wedge garnish
1 maraschino cherry garnish

tie a cherry stem in my mouth 193

mojito
6 mint leaves, muddled
1½ tbsp simple syrup
1 tbsp lime juice
2 fl oz (60 ml) light rum
2 fl oz (60 ml) club soda
2 lime wedge garnishes

white russian
2 fl oz (60 ml) vodka
1 fl oz (30 ml) coffee liqueur
1 fl oz (30 ml) light cream

piña colada
2 fl oz (60 ml) light rum
6 fl oz (180 ml) pineapple juice
2 fl oz (60 ml) coconut cream
1 pineapple wedge garnish
1 maraschino cherry garnish

caipirinha
2 lime wedges, muddled
1 tbsp simple syrup
2 fl oz (60 ml) cachaça

use a muddler 119

Grind until smooth.

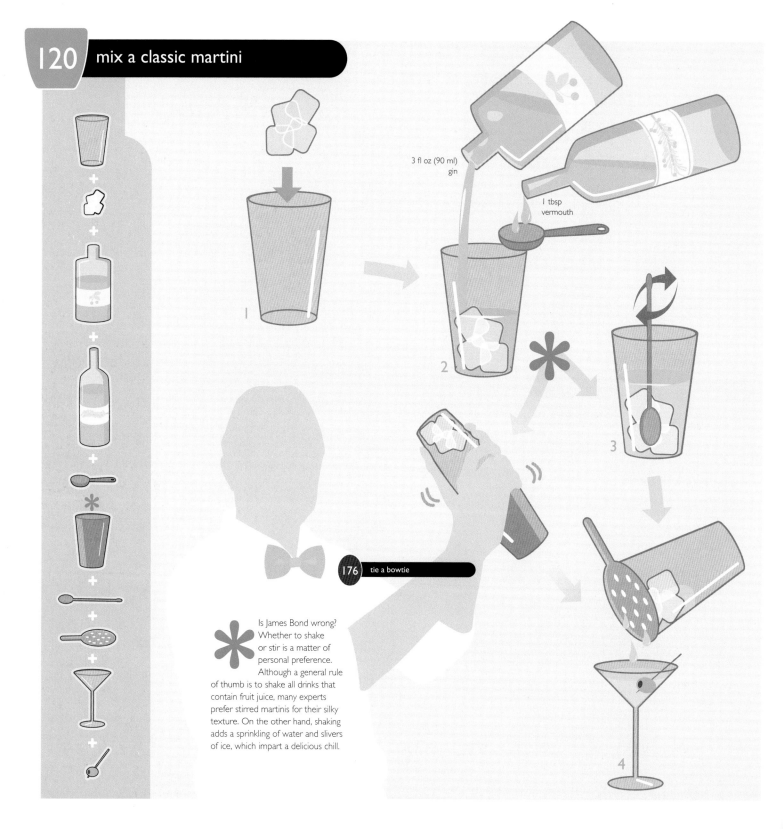

3 fl oz (90 ml) gin

1 tbsp vermouth

1

2

3

4

176 tie a bowtie

Is James Bond wrong? Whether to shake or stir is a matter of personal preference. Although a general rule of thumb is to shake all drinks that contain fruit juice, many experts prefer stirred martinis for their silky texture. On the other hand, shaking adds a sprinkling of water and slivers of ice, which impart a delicious chill.

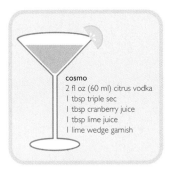

cosmo
2 fl oz (60 ml) citrus vodka
1 tbsp triple sec
1 tbsp cranberry juice
1 tbsp lime juice
1 lime wedge garnish

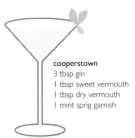

cooperstown
3 tbsp gin
1 tbsp sweet vermouth
1 tbsp dry vermouth
1 mint sprig garnish

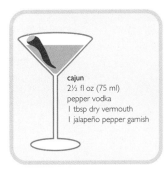

cajun
2½ fl oz (75 ml)
pepper vodka
1 tbsp dry vermouth
1 jalapeño pepper garnish

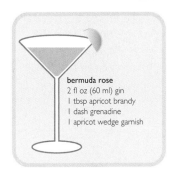

bermuda rose
2 fl oz (60 ml) gin
1 tbsp apricot brandy
1 dash grenadine
1 apricot wedge garnish

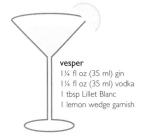

vesper
1¼ fl oz (35 ml) gin
1¼ fl oz (35 ml) vodka
1 tbsp Lillet Blanc
1 lemon wedge garnish

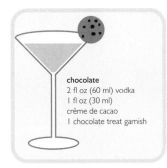

chocolate
2 fl oz (60 ml) vodka
1 fl oz (30 ml)
crème de cacao
1 chocolate treat garnish

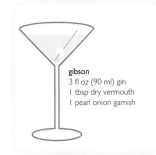

gibson
3 fl oz (90 ml) gin
1 tbsp dry vermouth
1 pearl onion garnish

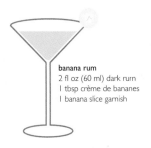

banana rum
2 fl oz (60 ml) dark rum
1 tbsp crème de bananes
1 banana slice garnish

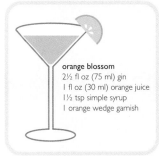

orange blossom
2½ fl oz (75 ml) gin
1 fl oz (30 ml) orange juice
1½ tsp simple syrup
1 orange wedge garnish

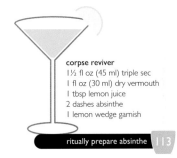

corpse reviver
1½ fl oz (45 ml) triple sec
1 fl oz (30 ml) dry vermouth
1 tbsp lemon juice
2 dashes absinthe
1 lemon wedge garnish

ritually prepare absinthe 113

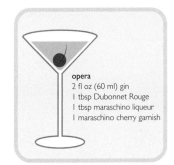

opera
2 fl oz (60 ml) gin
1 tbsp Dubonnet Rouge
1 tbsp maraschino liqueur
1 maraschino cherry garnish

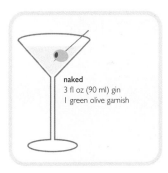

naked
3 fl oz (90 ml) gin
1 green olive garnish

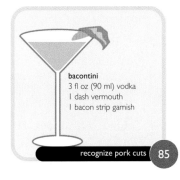

bacontini
3 fl oz (90 ml) vodka
1 dash vermouth
1 bacon strip garnish

recognize pork cuts 85

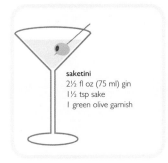

saketini
2½ fl oz (75 ml) gin
1½ tsp sake
1 green olive garnish

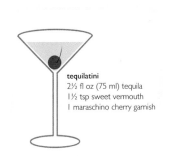

tequilatini
2½ fl oz (75 ml) tequila
1½ tsp sweet vermouth
1 maraschino cherry garnish

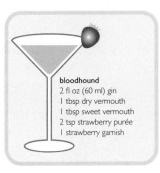

bloodhound
2 fl oz (60 ml) gin
1 tbsp dry vermouth
1 tbsp sweet vermouth
2 tsp strawberry purée
1 strawberry garnish

1

Boil water.

2

Rinse to warm the teapot.

3

Boil water for the tea.

478 prepare a tea-leaf reading

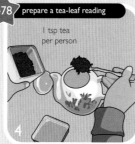

4

1 tsp tea
per person

Add black Indian tea leaves.

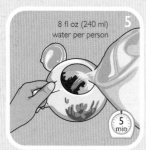

5

8 fl oz (240 ml)
water per person

5 min

Let steep.

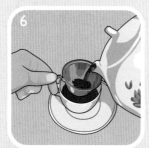

6

Strain.

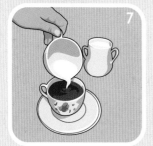

7

Add milk and sugar, if desired.

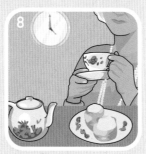

8

Enjoy with scones.

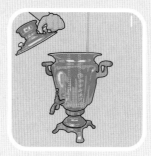

1

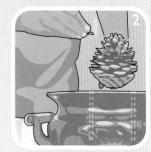

2

Lit pinecones boil the water.

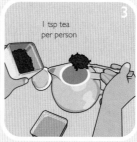

3

1 tsp tea
per person

Add black Indian tea leaves.

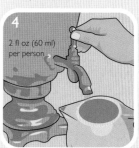

4

2 fl oz (60 ml)
per person

Add boiling water.

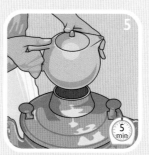

5

5 min

Steep on top of the samovar.

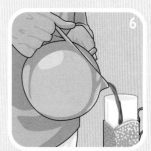

6

Pour into the podstakannik.

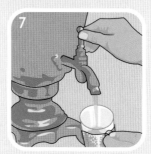

7

8

Dilute to taste.

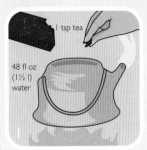

I tsp tea

48 fl oz
(1½ l)
water

Add tea to the boiling water.

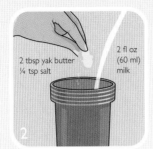

2 tbsp yak butter
¼ tsp salt

2 fl oz
(60 ml)
milk

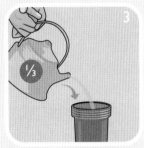

⅓

Pour one-third into the churn.

2–3
min

Churn vigorously.

½

Transfer half back to the pot.

⅓

Repeat until all is churned.

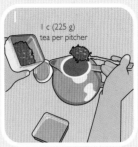

I c (225 g)
tea per pitcher

Add spiced Thai tea leaves.

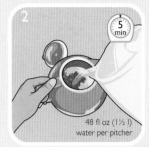

5
min

48 fl oz (1½ l)
water per pitcher

Brew until bright orange.

Pour through the cloth strainer.

I c (200 g)
sugar

Chill to the desired coolness.

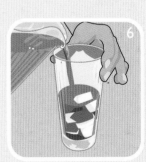

8 fl oz (240 ml)
condensed milk

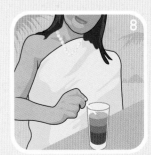

understand espresso drink ratios

Frothed milk or steamed milk, whole milk or half-and-half? If the drinks menu of your local café makes your head spin, study up on these simple recipes.

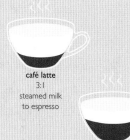

café latte
3:1
steamed milk
to espresso

café au lait
1:1
steamed milk
to espresso

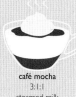

café mocha
3:1:1
steamed milk
to espresso to
drizzle of
chocolate syrup

americano
5:1
hot water
to espresso

café breva
3:1
steamed half-and-half
creamer to espresso

cappuccino
1:1:1
frothed milk
to steamed milk
to espresso

espresso con panna
1:1
espresso to dollop
of whipped cream

irish coffee
1:1
whiskey to coffee
2 tbsp sugar
2 tbsp cream

espresso
1 espresso

macchiato
4:1
espresso
to steamed milk

pick a caffeinated drink

Need to get wired for an all-nighter, or turn in early for a decent night's sleep? Use this comparison chart to pick a drink with the caffeine amount that's right for you.

Your basic cup of coffee
(8 fl oz/240 ml) contains
a whopping 135 mg
of caffeine.

=

brewed tea
8 fl oz (240 ml) =
70 mg of caffeine

=

energy drink
8 fl oz (240 ml) =
70 mg of caffeine

=

espresso
1 fl oz (30 ml) =
45 mg of caffeine

=

green tea
8 fl oz (240 ml) =
35 mg of caffeine

=

iced tea
8 fl oz (240 ml) =
15 mg of caffeine

=

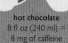

hot chocolate
8 fl oz (240 ml) =
8 mg of caffeine

 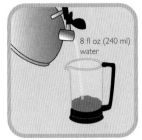 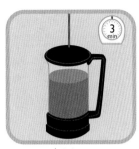 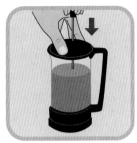 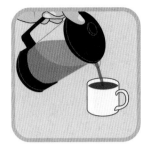

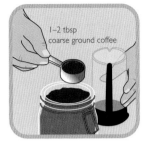

1–2 tbsp
coarse ground coffee

8 fl oz (240 ml)
water

Add boiling water.

3 min

Let steep.

Press evenly on the plunger.

Secure the lid; pour.

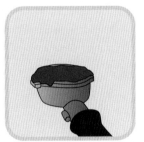 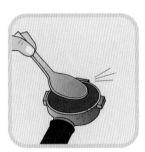 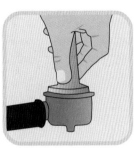 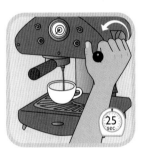

Fill with fresh grounds.

Smooth off the excess.

Tamp until tight.

Align the basket and cup.

25 sec

Pull the shot.

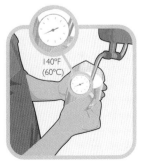 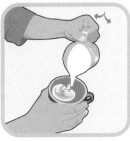

140°F
(60°C)

Steam milk for one cup.

Swirl; bang if bubbles arise.

Pour. Wiggle your wrist.

Draw through the design.

131 open a beer with another beer

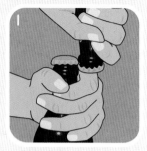

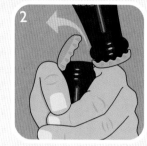

Hook the lids together.

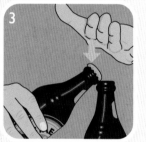

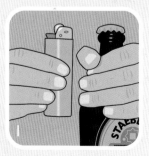

Thrust downward.

132 open a beer with a lighter

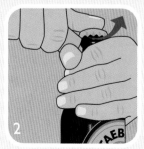

Use as lever.

133 serve beer in the right glass

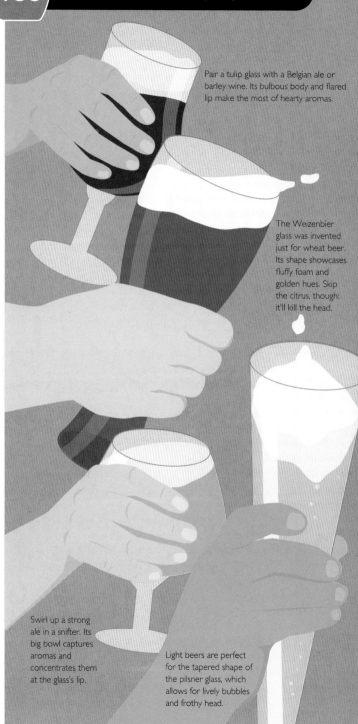

Pair a tulip glass with a Belgian ale or barley wine. Its bulbous body and flared lip make the most of hearty aromas.

The Weizenbier glass was invented just for wheat beer. Its shape showcases fluffy foam and golden hues. Skip the citrus, though: it'll kill the head.

Swirl up a strong ale in a snifter. Its big bowl captures aromas and concentrates them at the glass's lip.

Light beers are perfect for the tapered shape of the pilsner glass, which allows for lively bubbles and frothy head.

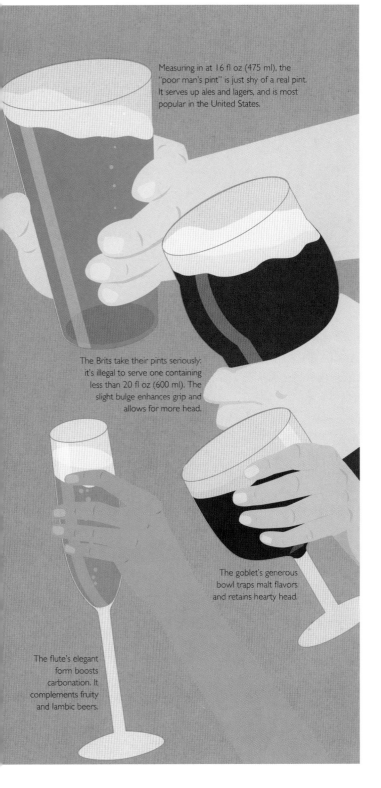

Measuring in at 16 fl oz (475 ml), the "poor man's pint" is just shy of a real pint. It serves up ales and lagers, and is most popular in the United States.

The Brits take their pints seriously: it's illegal to serve one containing less than 20 fl oz (600 ml). The slight bulge enhances grip and allows for more head.

The goblet's generous bowl traps malt flavors and retains hearty head.

The flute's elegant form boosts carbonation. It complements fruity and lambic beers.

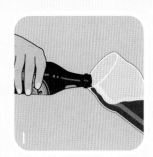
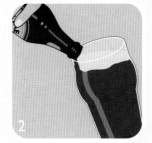

Pour slowly.

Right the glass as it fills.

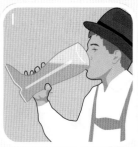

When a bubble forms . . .

vanquish a case of hiccups 474

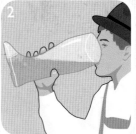

. . . rotate to avoid spillage.

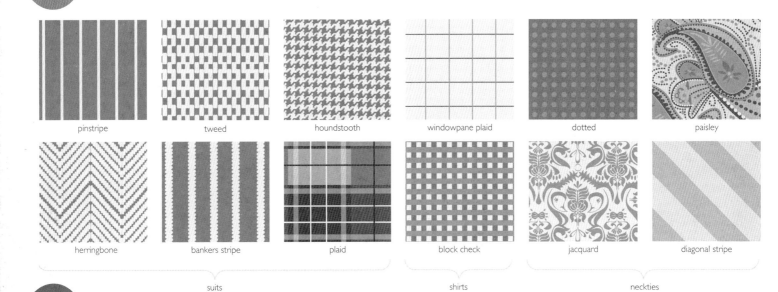

pinstripe	tweed	houndstooth	windowpane plaid	dotted	paisley
herringbone	bankers stripe	plaid	block check	jacquard	diagonal stripe

suits shirts neckties

137 pick a suit for each season

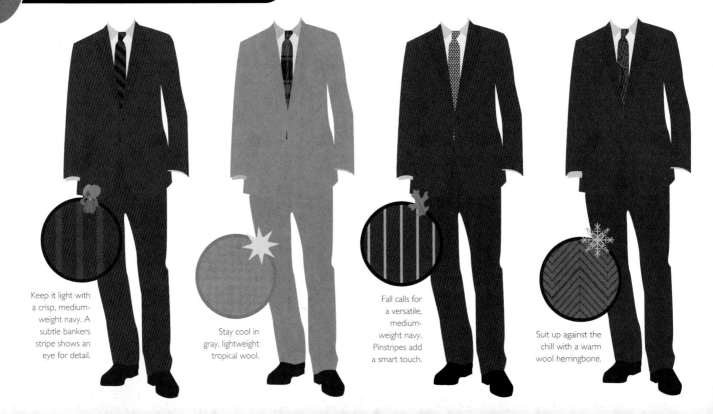

Keep it light with a crisp, medium-weight navy. A subtle bankers stripe shows an eye for detail.

Stay cool in gray, lightweight tropical wool.

Fall calls for a versatile, medium-weight navy. Pinstripes add a smart touch.

Suit up against the chill with a warm wool herringbone.

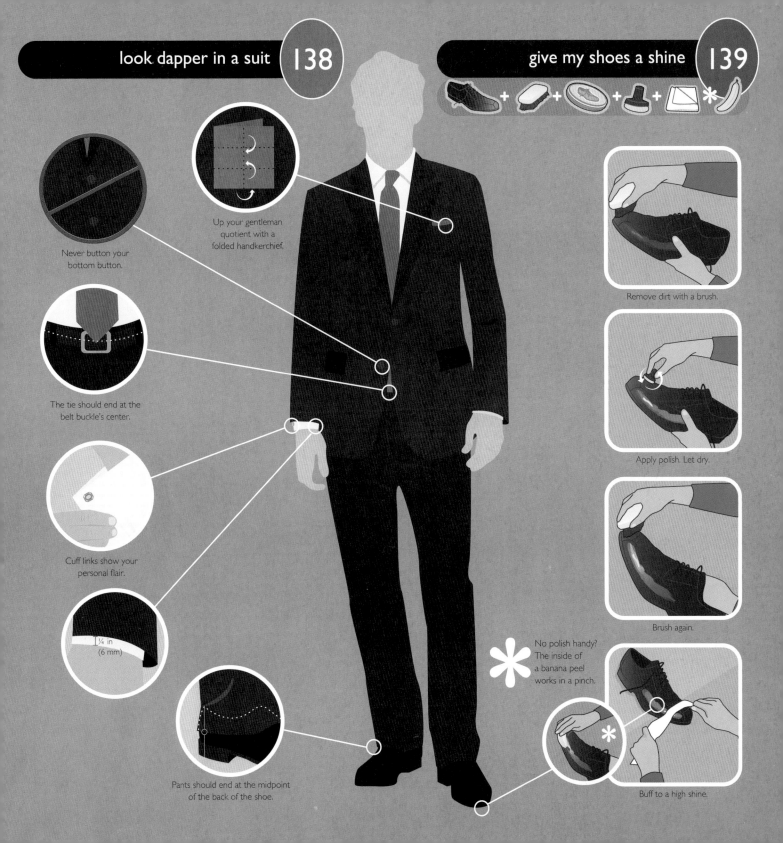

Never button your bottom button.

Up your gentleman quotient with a folded handkerchief.

The tie should end at the belt buckle's center.

Cuff links show your personal flair.

¼ in (6 mm)

Pants should end at the midpoint of the back of the shoe.

Remove dirt with a brush.

Apply polish. Let dry.

Brush again.

***** No polish handy? The inside of a banana peel works in a pinch.

Buff to a high shine.

Which 'stache is right for you—a horseshoe or a fu manchu? Enlarge this guide with a photocopier, cut out the mustaches, and try them on for size.

pyramid lilibrow pencil toothbrush lamp shade chevron english

walrus petit handlebar handlebar imperial face spanner

copy me!

french fork bishop circle beard neck beard chin curtain

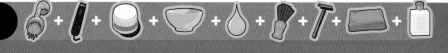

 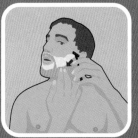

Start with a warm shower. Trim the beard, if needed. Dip in cream; froth in water. Spread in a circular motion. Shave with the grain.

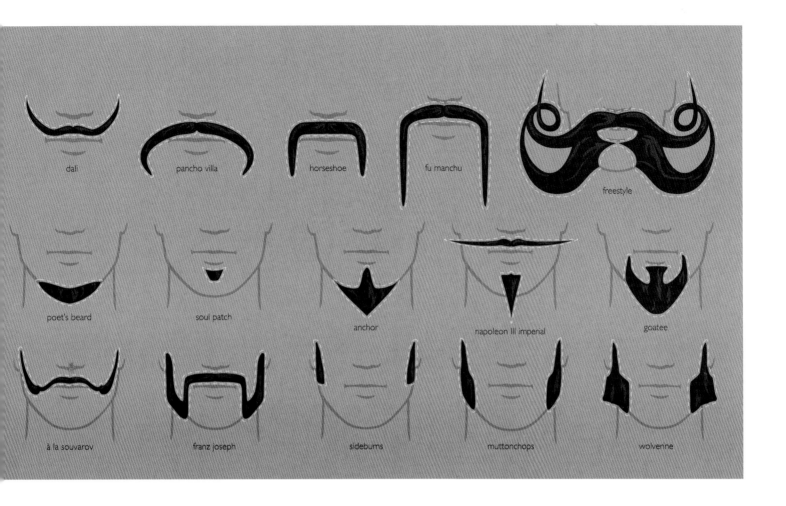

dali pancho villa horseshoe fu manchu

freestyle

poet's beard soul patch anchor napoleon III imperial goatee

à la souvarov franz joseph sidebums muttonchops wolverine

Rinse every few strokes.

Shave with the grain.

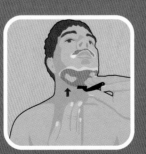 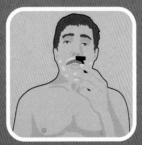

Suck in; shave above the lip.

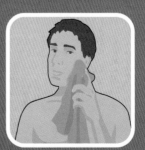

Rinse; pat dry.

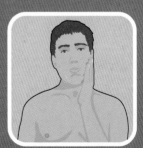

Slap with a little aftershave.

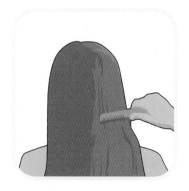

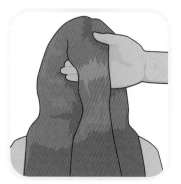

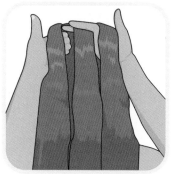

Gather three sections.

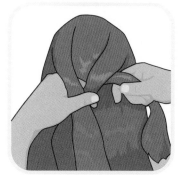

Begin braiding.

100 braid challah bread

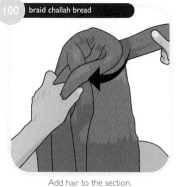

Add hair to the section.

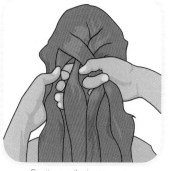

Continue gathering as you go.

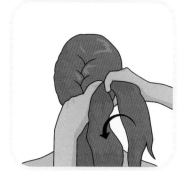

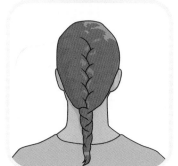

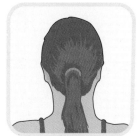

Start with a low ponytail.

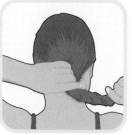

Twist it into a loop.

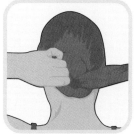

Pull any excess through.

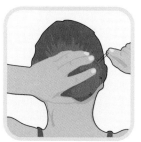

Secure with pins.

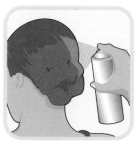

Spray lightly.

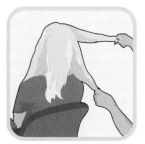

Create four sections.

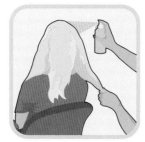

Spray with setting lotion.

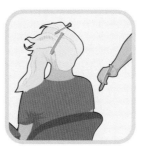

Clip the sections not in use.

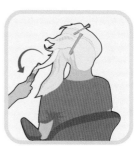

Curl each section.

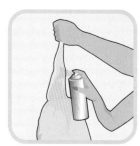

Spray heavily with hairspray.

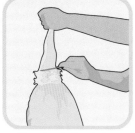

Tease from bottom to top.

Pin the sections; continue.

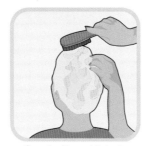

Smooth with a paddle brush.

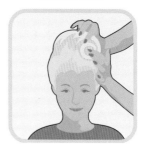

Craft a swirl in the front.

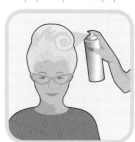

Finish with more hairspray.

fashion fabulous fingerwaves 145

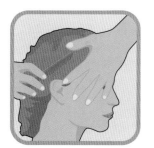

Put setting lotion in wet hair.

Wiggle to make waves.

To set, pinch the waves.

Secure with clips as you go.

Continue until complete.

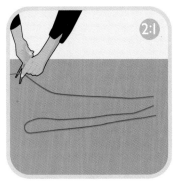

Cut two lengths of yarn.

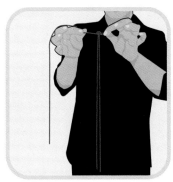

Tie the short yarn to the center.

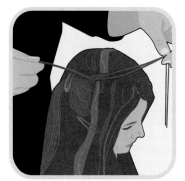

Tie the long yarn to a strand.

Align one string with the strand; braid.

Knot the end.

Tie on a charm, if desired.

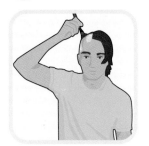

Shave except for the top.

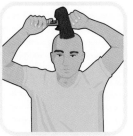

Backcomb the hair.

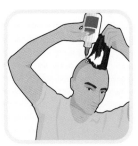

Apply glue generously.

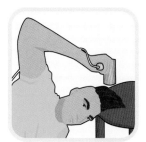

Blow-dry against a surface.

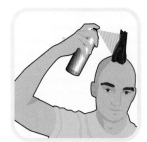

Spray to hold.

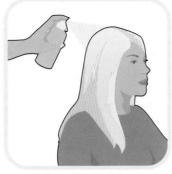
Spray with setting lotion.

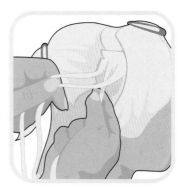
Make a path for the cornrow.

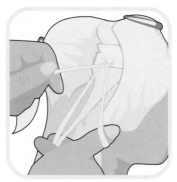
Braid close to the scalp.

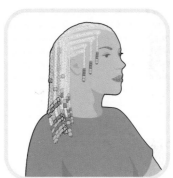
Add hair to the middle strand.

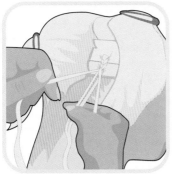
Continue, picking up hair as you go.

If the hair is long, extend the braid.

shape clay beads 5

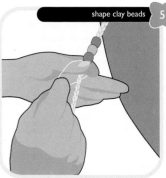
Finish with beads and a clear elastic.

Divide the hair into sections.

Comb each section.

Backcomb each section.

Twist each; secure the ends.

3 months

Maintain with beeswax.

1 Start with a base of white makeup.

Go gangrene with splotches of green makeup.

3 Line your eyes for that undead look.

Coat your lips in red "blood."

308 banish imaginary monsters

151 stir up fake blood

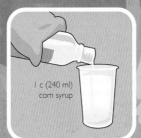

1 c (240 ml) corn syrup

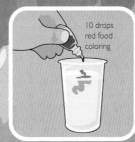

10 drops red food coloring

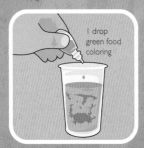

1 drop green food coloring

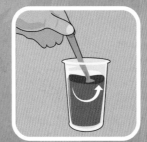

152 fake an exposed bone

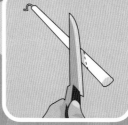

Cut the desired bone length.

Attach with liquid latex.

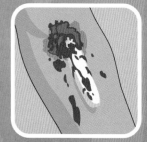

Secure with more latex.

Add fake blood and bruising.

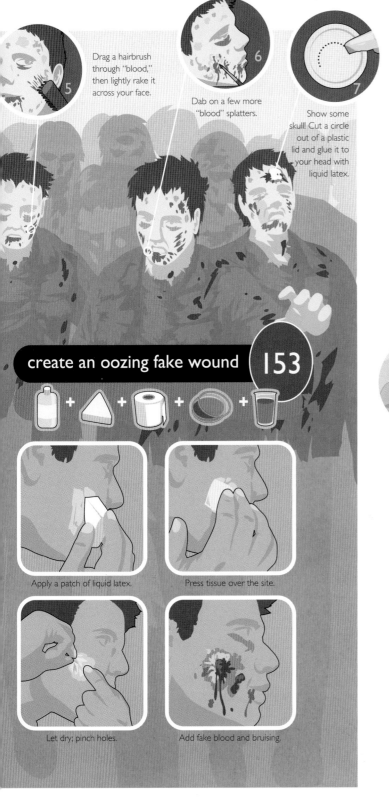

Drag a hairbrush through "blood," then lightly rake it across your face.

Dab on a few more "blood" splatters.

Show some skull! Cut a circle out of a plastic lid and glue it to your head with liquid latex.

create an oozing fake wound 153

Apply a patch of liquid latex.

Press tissue over the site.

Let dry; pinch holes.

Add fake blood and bruising.

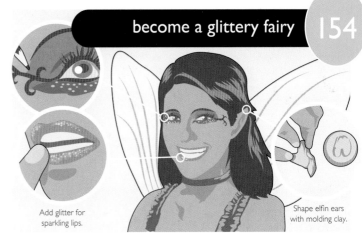

become a glittery fairy 154

Add glitter for sparkling lips.

Shape elfin ears with molding clay.

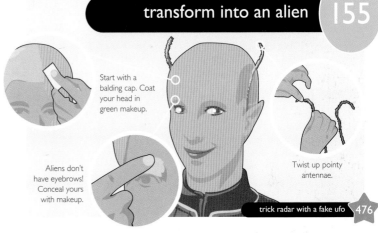

transform into an alien 155

Start with a balding cap. Coat your head in green makeup.

Aliens don't have eyebrows! Conceal yours with makeup.

Twist up pointy antennae.

trick radar with a fake ufo 476

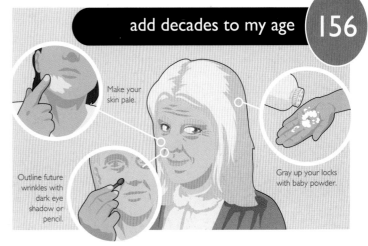

add decades to my age 156

Make your skin pale.

Outline future wrinkles with dark eye shadow or pencil.

Gray up your locks with baby powder.

157 thread my eyebrows

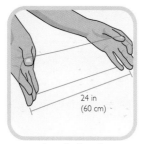 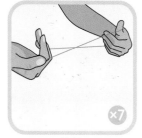 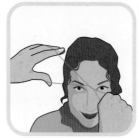 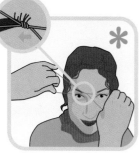 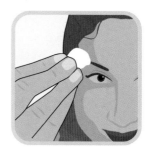

Loop the thread.

Twist.

Place to the right of the hair.

Widen one side of the loop.

Swab with toner.

 How does it work, exactly? By opening one hand and closing the other as you move the string along the brow, you capture stray hairs and pull them out. Careful—it may pinch at first!

158 apply and remove false eyelashes

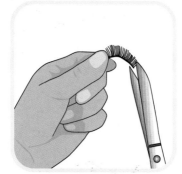 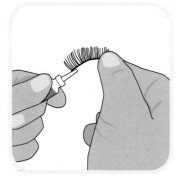 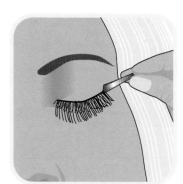 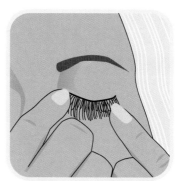

Trim the eyelash to match your eye.

Apply glue to the back.

Place along the lash line.

Hold in place while it dries.

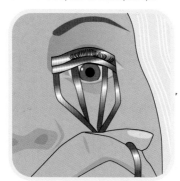 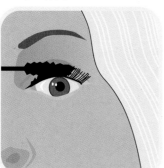 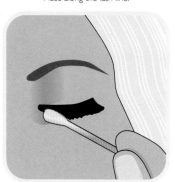 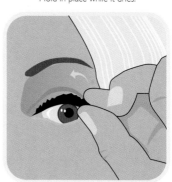

Curl the fake and real lashes together.

Apply mascara.

Petroleum jelly loosens the glue.

To remove, gently pull loose.

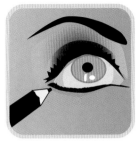

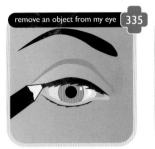
remove an object from my eye 335

Line the top lid.

Brush on a highlighter color.

Apply the medium shadow.

Blend the darkest shade.

Line the lower lashes.

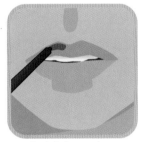

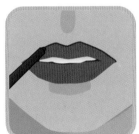

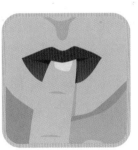

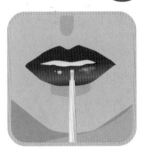

Apply lip liner as a base.

Define the lips' outline.

Apply lipstick with a brush.

Suck your finger to blot.

Dab gloss in the center.

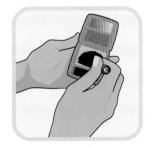

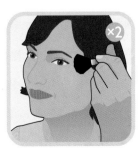

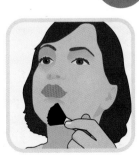

Tap off the excess.

Smile; apply to the cheeks.

Sweep toward the temples.

Brush around the jawline.

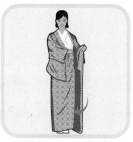

Fold the left over the right.

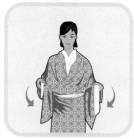

Tie on the koshi himo.

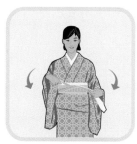

Tie on the datejime.

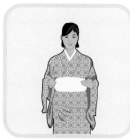

Position the obi makura.

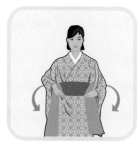

Wrap the obi.

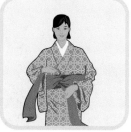

Tie the two ends together.

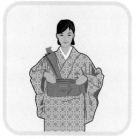

Fold across the waist.

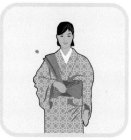

Cinch at the center.

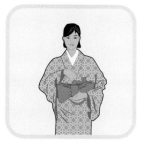

Tie with the excess.

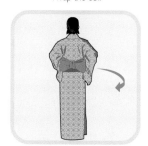

Slide the obi to the back.

163 decode kimono styles

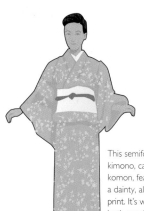

This semiformal kimono, called a komon, features a dainty, all-over print. It's worn by both married and unmarried women.

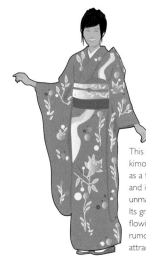

This highly formal kimono is known as a furisode, and is worn by unmarried women. Its graceful, flowing sleeves are rumored to attract suitors.

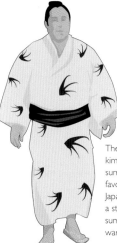

The cotton yukata kimono is a casual summertime favorite among the Japanese. It's also a staple in young sumo wrestlers' wardrobes.

Worn by married women at formal events (like weddings), the kurotomesode kimono is always black, and patterned only beneath the waist.

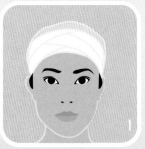

Cover your hair.

Apply a white foundation.

Create an erotic "W" shape.

 Red face paint is typically worn by maiko, or geisha in training. These young women, who are customarily under the age of 21, vigorously train in the gei (dancing, singing, and the art of polite conversation) before they are allowed to entertain at events as full-fledged geisha.

Apply blush.

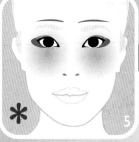

Rim the eyes and brows in red.

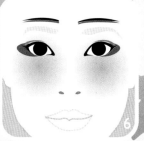

Don the wig and hair ornaments.

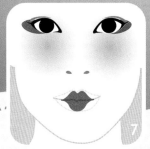

Paint bow-shaped lips.

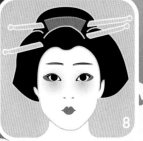

Emphasize with black eyeliner.

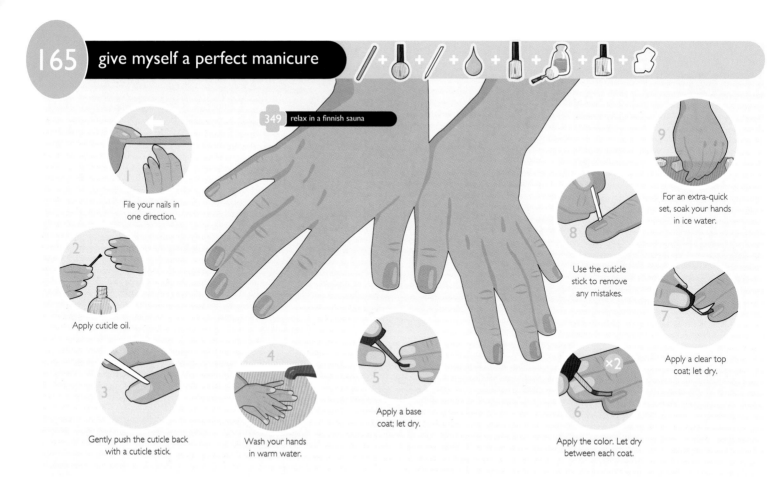

165 give myself a perfect manicure

349 relax in a finnish sauna

1. File your nails in one direction.

2. Apply cuticle oil.

3. Gently push the cuticle back with a cuticle stick.

4. Wash your hands in warm water.

5. Apply a base coat; let dry.

6. Apply the color. Let dry between each coat. ×2

7. Apply a clear top coat; let dry.

8. Use the cuticle stick to remove any mistakes.

9. For an extra-quick set, soak your hands in ice water.

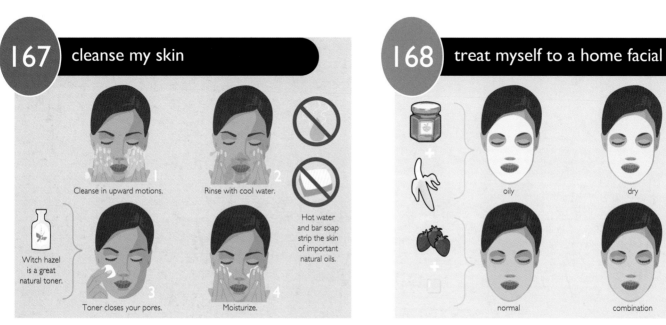

167 cleanse my skin

1. Cleanse in upward motions.

2. Rinse with cool water.

Hot water and bar soap strip the skin of important natural oils.

Witch hazel is a great natural toner.

3. Toner closes your pores.

4. Moisturize.

168 treat myself to a home facial

oily

dry

normal

combination

Cut the nails straight across.

File in one direction.

¼ c (55 g) epsom salt

Treat your feet to a luxurious soak.

Apply cuticle oil.

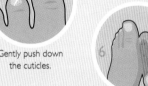

Gently push down the cuticles.

Rub down any calluses.

Finish with a clear top coat.

×2

Apply the color. Let dry between each coat.

Insert a separator.

Wipe down each nail to remove excess oils.

Moisturize your feet.

Use papaya as an inexpensive, at-home exfoliant.

Cover with a gentle exfoliant.

Brush in circular motions.

Avoid the tender under-eye area.

Rinse with cool water.

Soothe with a moisturizer.

Sleep on two pillows.

Treat the under-eye area with cucumber.

Hydration keeps skin fresh and rejuvenated.

Use sunscreen daily.

Use an alpha-hydroxy cream.

Smoking ages the skin.

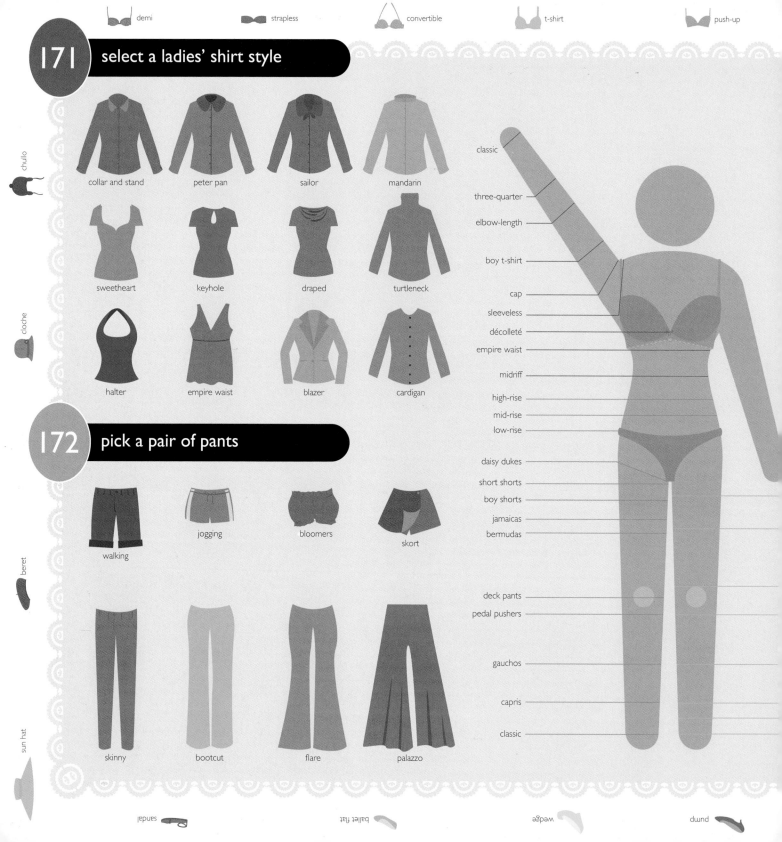

demi strapless convertible t-shirt push-up

171 select a ladies' shirt style

- collar and stand
- peter pan
- sailor
- mandarin
- sweetheart
- keyhole
- draped
- turtleneck
- halter
- empire waist
- blazer
- cardigan

172 pick a pair of pants

- walking
- jogging
- bloomers
- skort
- skinny
- bootcut
- flare
- palazzo

chullo

cloche

beret

sun hat

classic
three-quarter
elbow-length
boy t-shirt
cap
sleeveless
décolleté
empire waist
midriff
high-rise
mid-rise
low-rise
daisy dukes
short shorts
boy shorts
jamaicas
bermudas
deck pants
pedal pushers
gauchos
capris
classic

sandal ballet flat wedge pump

identify dress and skirt shapes 173

avoid being a fashion don't 174

identify dress and skirt shapes

fit and flare

sheath

slip dress

shift

column

princess

mermaid

empire waist

micromini

schoolgirl

bubble

flip

sarong

mini

pencil

tube

midi

tea

princess

maxi

a-line

handkerchief

fishtail

peasant

avoid being a fashion don't

Do pair a sexy top and sandals with a long skirt.

Don't wear denim on denim!

Do look sleek in a strappy tank and wide-legged trousers.

Do top off a miniskirt and knee-high boots with a chunky sweater.

Don't emphasize baggy pants with a boxy shirt.

Don't look frumpy in a long skirt and turtleneck.

Do pair boot-cut jeans with boots!

Don't overdo it with too many patterns.

Don't expose too much skin.

Do cap off skinny jeans with a flowing, empire-waist top.

Do balance a flared skirt with a fitted jacket.

175 rock the chelsea knot

Fold the scarf in half.

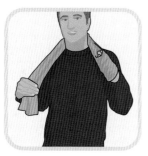

395 > tie basic sailing knots

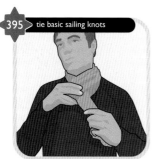

Bring through the loop.

176 tie a bowtie

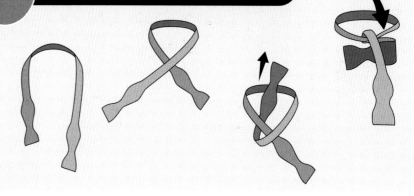

177 tie a traditional windsor knot

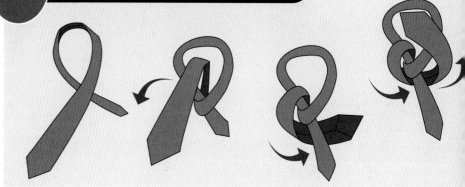

178 lace my shoes with flair

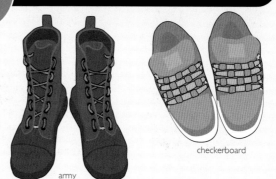

army

checkerboard

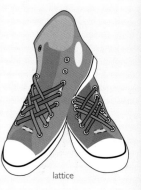

lattice

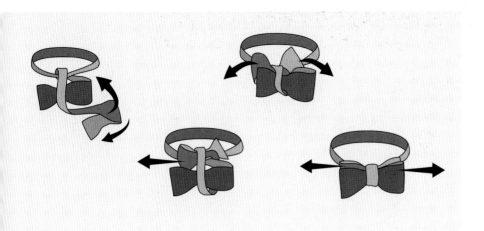

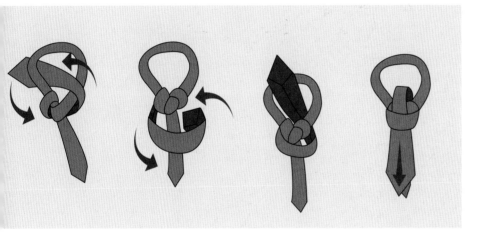

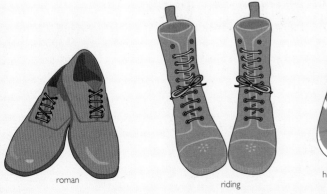

roman

riding

hidden knot

Fold the scarf into a triangle.

Wrap; tie in the back.

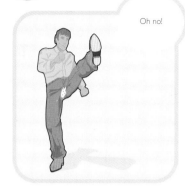

Oh no!

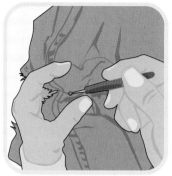

Open the area with a seam ripper.

Cut out a paper pattern.

Place onto the desired fabric.

Cut out; fold over the edges.

Sew onto the jeans' exterior.

Hi-ya!

High-kick without apprehension.

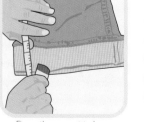

Figure the amount to hem.

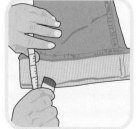

Fold half under; pin.

Sew along the old hem.

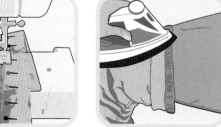

Turn inside out; press.

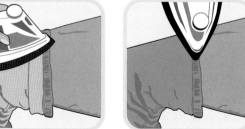

Turn right side out; press.

 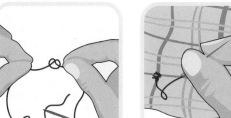
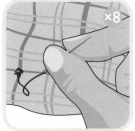

Thread the needle; knot.

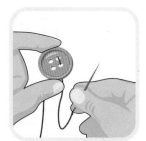

Anchor the stitch.

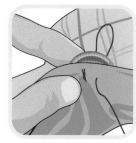

Attach the button.

Sew, but not too tightly.

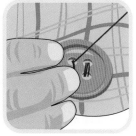

Repeat on the other holes.

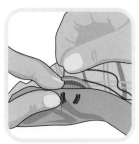

Bring the needle through.

Push through the stitches.

Knot against the fabric.

Cut off the legs.

Open the inseam and crotch.

Trim both sides' excess.

Glue the back.

Glue the front; let dry.

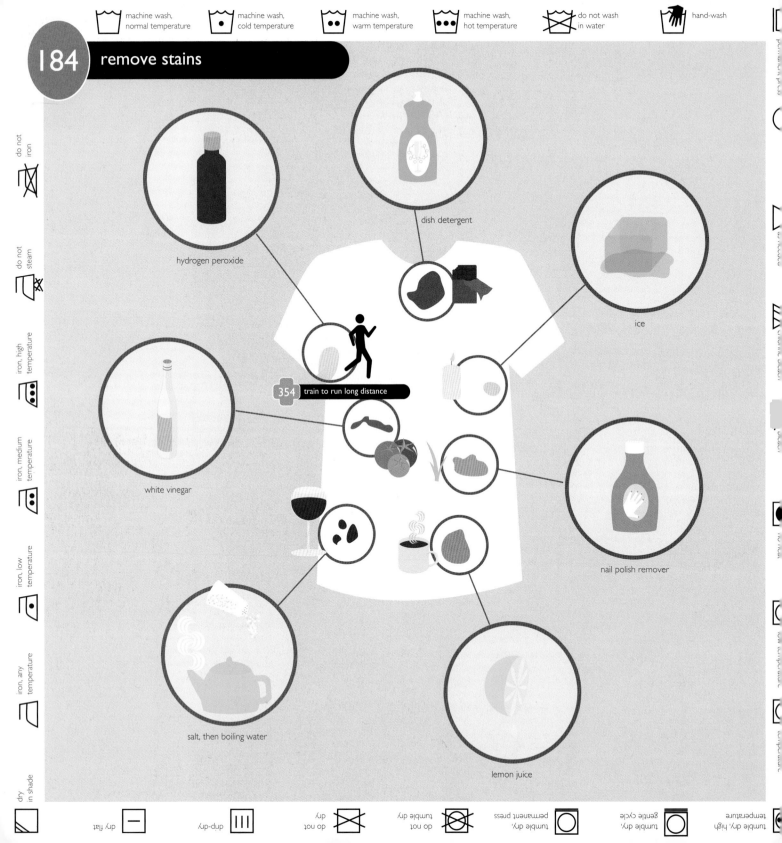

machine wash, normal temperature

machine wash, cold temperature

machine wash, warm temperature

machine wash, hot temperature

do not wash in water

hand-wash

do not iron

do not steam

iron, high temperature

iron, medium temperature

iron, low temperature

iron, any temperature

dry in shade

hydrogen peroxide

dish detergent

ice

white vinegar

354 train to run long distance

nail polish remover

salt, then boiling water

lemon juice

dry flat

drip-dry

do not dry

do not tumble dry

tumble dry, permanent press

tumble dry, gentle cycle

tumble dry, high temperature

Add detergent to water.

Get the sweater sudsy.

Rinse out the soap.

Roll in a towel; squeeze.

Lay flat to dry.

Whoops—did you shrink your sweater? Simply tack the wet sweater to a board, stretching it until it dries and returns to its normal size and shape.

Dampen as you go.

Iron the back of the collar.

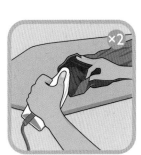

Iron the inside of the collar.

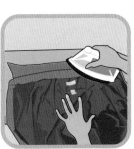

Open the cuffs; iron inside.

Iron the sleeves and cuffs.

Iron the shoulders.

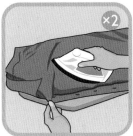

Iron a front panel.

Move to the back; iron.

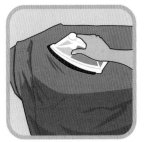

Iron the other front panel.

Iron between the buttons.

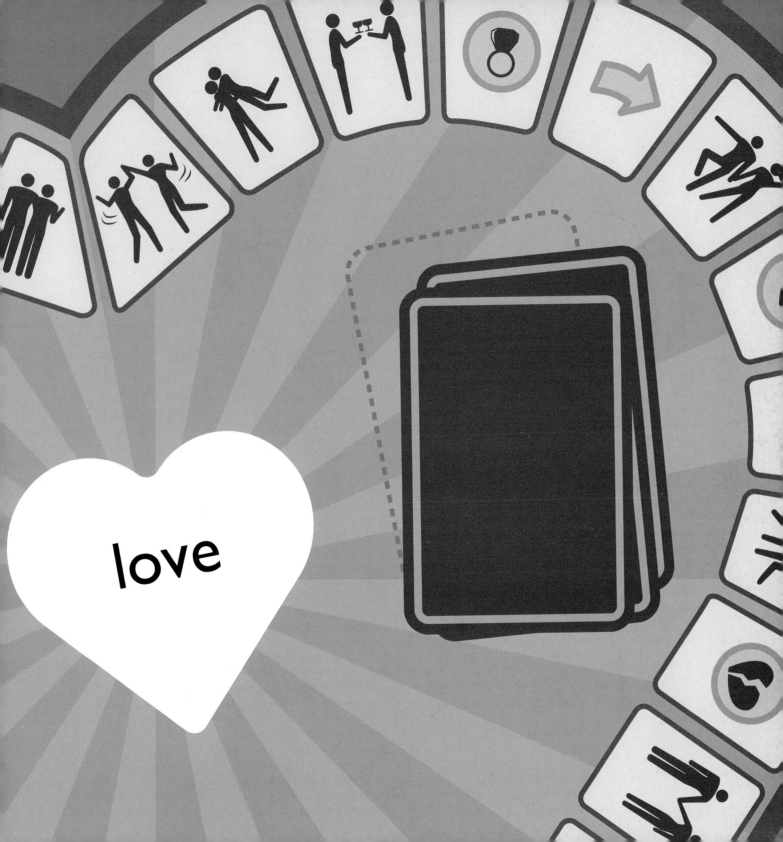

love

Got an overenthusiastic admirer? Avert your eyes and shrug off unwanted advances.

Get chatty—but let your body do the real talking! Lean in and place your hands so that they're visible and palm side up.

Keep an eye out for "peacocking," when a guy stands confidently with his chest puffed out. If she's touching her hair, she's liking it!

Spot someone sitting on their hands or protectively covering an erogenous zone? Looks like love isn't in the cards!

Scoot in closer and present your assets if you're keen; slouch down and cross your arms if you're not.

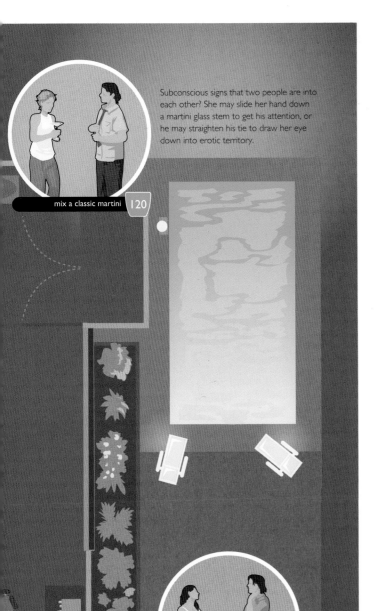

Subconscious signs that two people are into each other? She may slide her hand down a martini glass stem to get his attention, or he may straighten his tie to draw her eye down into erotic territory.

mix a classic martini 120

Imitation is the sincerest form of flattery. Let her know you like her by copying her (hopefully flirty!) moves.

hours : minutes	activity	
00:00	Make a grand entrance.	
00:02	Greet your host.	
00:05	Pay a visit to the bartender.	
00:06	Scope out the scene.	
00:10	Locate your buddies.	
00:30	Focus in on a hottie.	
00:31	Chat up that good-looking stranger.	
00:45	Hit the dance floor.	
01:00	Get another round.	
01:40	Retire to a private nook.	
01:45	Exchange phone numbers.	
04:00	Celebrate.	

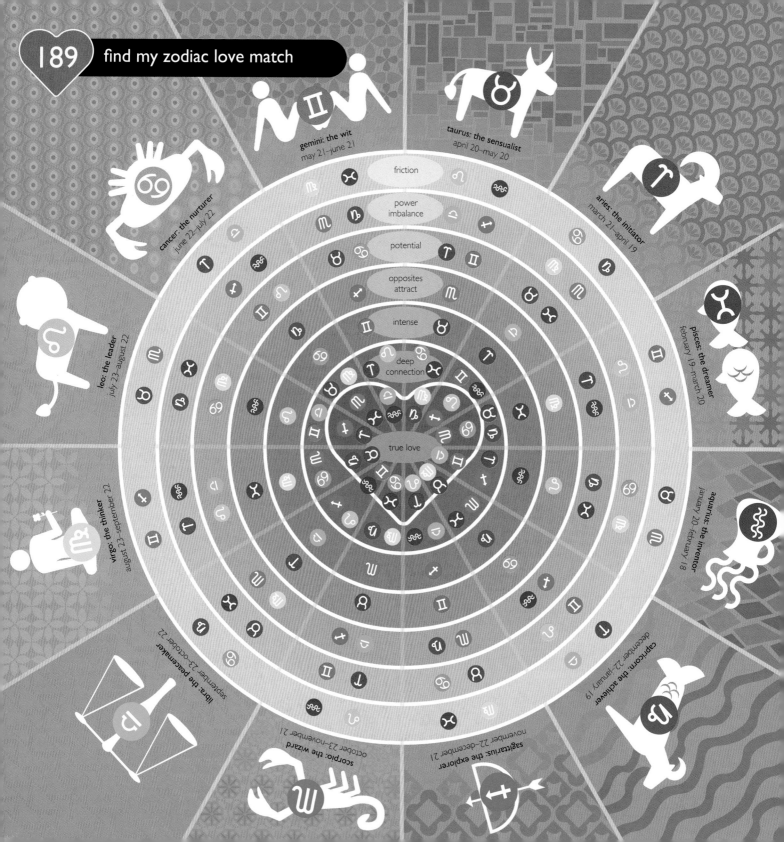

gemini: the wit
may 21–june 21

taurus: the sensualist
april 20–may 20

aries: the initiator
march 21–april 19

cancer: the nurturer
june 22–july 22

pisces: the dreamer
february 19–march 20

leo: the leader
july 23–august 22

aquarius: the inventor
january 20–february 18

virgo: the thinker
august 23–september 22

capricorn: the achiever
december 22–january 19

libra: the peacemaker
september 23–october 22

sagittarius: the explorer
november 22–december 21

scorpio: the wizard
october 23–november 21

friction

power imbalance

potential

opposites attract

intense

deep connection

true love

To discover your Chinese zodiac sign, find the year of your birth in the diagram below. Remember that the Chinese New Year falls in early February, so if you were born in January or early February, look for the year that precedes your birth year.

love matches

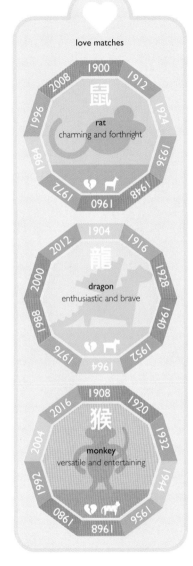

rat
charming and forthright

1900 · 1912 · 1924 · 1936 · 1948 · 1960 · 1972 · 1984 · 1996 · 2008

love matches

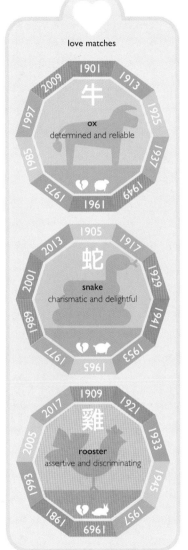

ox
determined and reliable

1901 · 1913 · 1925 · 1937 · 1949 · 1961 · 1973 · 1985 · 1997 · 2009

love matches

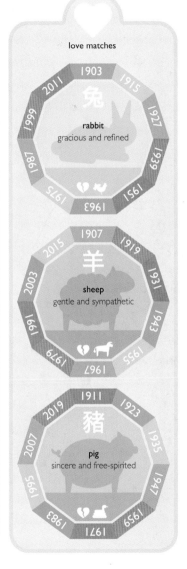

tiger
passionate and dynamic

1902 · 1914 · 1926 · 1938 · 1950 · 1962 · 1974 · 1986 · 1998 · 2010

love matches

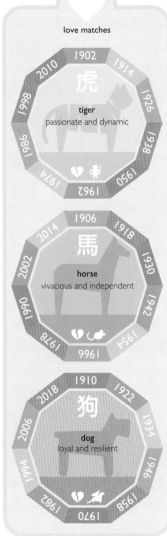

rabbit
gracious and refined

1903 · 1915 · 1927 · 1939 · 1951 · 1963 · 1975 · 1987 · 1999 · 2011

dragon
enthusiastic and brave

1904 · 1916 · 1928 · 1940 · 1952 · 1964 · 1976 · 1988 · 2000 · 2012

snake
charismatic and delightful

1905 · 1917 · 1929 · 1941 · 1953 · 1965 · 1977 · 1989 · 2001 · 2013

horse
vivacious and independent

1906 · 1918 · 1930 · 1942 · 1954 · 1966 · 1978 · 1990 · 2002 · 2014

sheep
gentle and sympathetic

1907 · 1919 · 1931 · 1943 · 1955 · 1967 · 1979 · 1991 · 2003 · 2015

monkey
versatile and entertaining

1908 · 1920 · 1932 · 1944 · 1956 · 1968 · 1980 · 1992 · 2004 · 2016

rooster
assertive and discriminating

1909 · 1921 · 1933 · 1945 · 1957 · 1969 · 1981 · 1993 · 2005 · 2017

dog
loyal and resilient

1910 · 1922 · 1934 · 1946 · 1958 · 1970 · 1982 · 1994 · 2006 · 2018

pig
sincere and free-spirited

1911 · 1923 · 1935 · 1947 · 1959 · 1971 · 1983 · 1995 · 2007 · 2019

Each animal sign and year is associated with one of these natural elements. Match the colors to find the elements of your animal and birth year—and to learn what they mean about you. For example, the natural element of all monkeys is metal, but a fire monkey born in 2016 will be more passionate than an earth monkey born in 1968.

earth
generous and cooperative;
seeks to grow and expand

fire
animated and restless;
loves to laugh

wood
disciplined and tenacious;
feels duty-bound to serve

metal
unyielding and reserved;
needs personal space

water
secretive and creative;
trusts intuition

191 get out of a car in a miniskirt

Swivel; place a foot down.

Bring the second foot down.

Brace yourself and stand.

192 sneak my arm around my date

Wait until she's at ease.

Begin the classic yawn.

Stretch, raising your arm.

193 tie a cherry stem in my mouth

Bite one side; bend in half.

Bite one side into a corner.

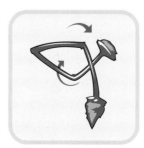
Bite a corner; loop through.

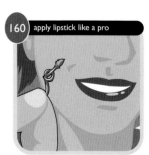
160 apply lipstick like a pro

 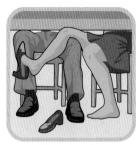

intrigue with a game of footsie · 194

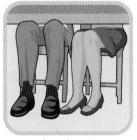 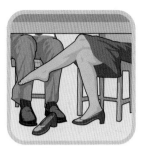

| Assess interest. | Move in closer. | Coyly rub and lock ankles. | Shed your shoe. | Switch legs; hook knees. |

give my sweetie a foot rub · 195

 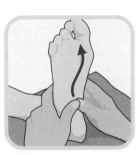 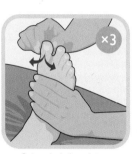 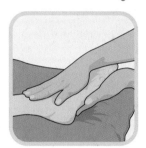

| Stroke the top of the foot. | Apply circular pressure. | Glide up the central groove. | Rub and wiggle each toe. ×3 | Finish with a soothing caress. |

spoon without arm discomfort · 196

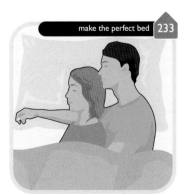

make the perfect bed 233

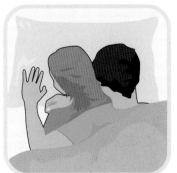 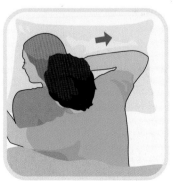 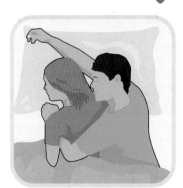

| Wrap your arms around your lover. | Gently roll her onto her stomach. | Pull your arm out from under her. | Place your arm above her. |

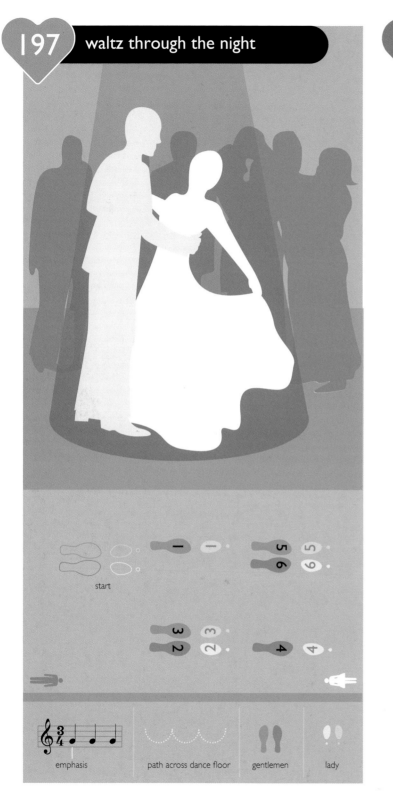

start

emphasis

path across dance floor

gentlemen

lady

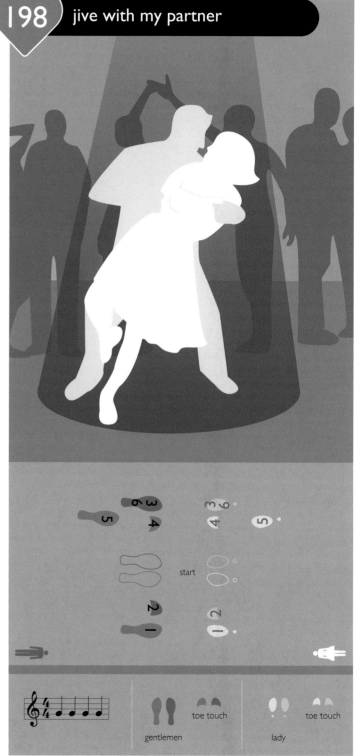

start

toe touch

gentlemen

toe touch

lady

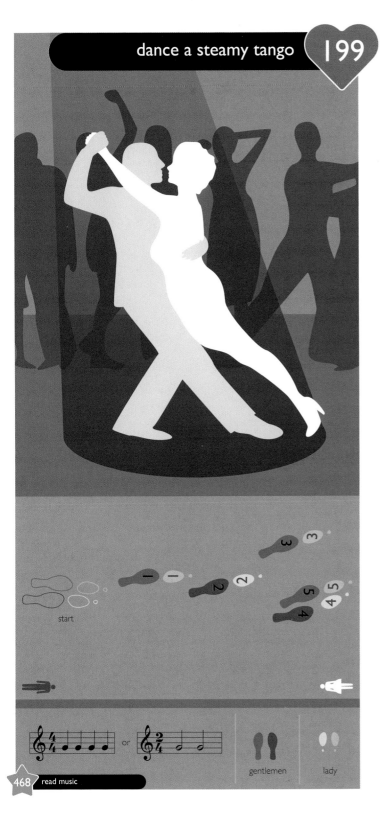

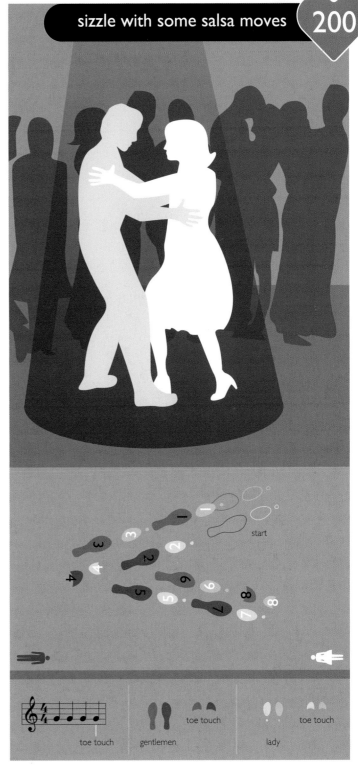

start

gentlemen | lady

or

toe touch | gentlemen | toe touch | lady | toe touch

start

flirt with emoticons

	
:]	joking
%*}	tipsy
</3	brokenhearted
=O	shocked
>:E	baring teeth
:-r	smoking
:3	playful
8-}	silly
:-D	grinning widely
:')	laughing and crying
:-x	no comment
!-(black eye
>:-O	yelling
:9	licking lips
`:-)	raised eyebrow
<3	heart
XD	laughing hard
<:O)	celebrating
:'-(shedding a tear
0:-)	innocent
>:-(angry
:-**	kissing back
:-&	tongue tied
=X	sealed lips
:P	sticking out tongue
>:]	evil grin
:- [serious
:-O	surprised
=\|	skeptical
:-*	kissing
(:-{	sexy mustache
(:-D	gossiping
B-)	proud
:-/	uneasy
8-\|	uncool
~ :-(steaming mad
;;)	batting eyelashes
}:-]	grinning devilishly
>O	ouch!
:-)	happy
:-S	frustrated
:-\|	indifferent
>;-('	spitting mad
;)	winking
:-K	vampire
=L	drooling
=)	happy
=(sad
\|-O	yawning
(:-&	angry
:-*)	blushing
&:-8-o-<	curvy lady
:)	happy
:(sad
S-)	rolling eyes
:-@	screaming
:-"	whistling
@}-,-'-,--	rose

(>")>

dancing

<^O^>

laughing loudly

(^.^)/

waving hello

^O^

excited

 happy

sad

 other

 angry

 flirty

\,,/(^_^)\,,/

rock on

d^_^b

listening to music

\(^o^)/

very excited

b(~_^)d

thumbs up

(/.\)

embarrassed

(-_-)

upset

(-_\\\)

emo

;_;

crying

(@_@)

dazed

(~.~)

sleepy

)-0_0-(

astonished

(o_O)

confused

(>_<)

frustrated

(u_u)

grumpy

(=_=)

annoyed

(9ò_ó)=@

throwing a punch

o

gawking

-^o^-

blushing

(0_<)

winking

_
_

starstruck

(>^_^)> <(^_^<)

hugging

(,,,)=^_^=(,,,)

purring

(o)_(o)

crazed

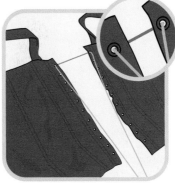

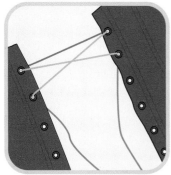

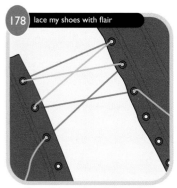

178 lace my shoes with flair

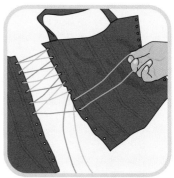

Lay the corset flat; lace the top.

Cross. Bring down through the eyelets.

Cross. Bring up through the eyelets.

Stop midway. Create a pull loop.

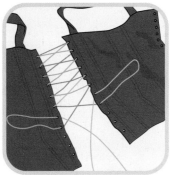

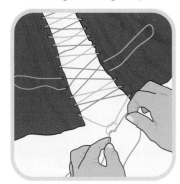

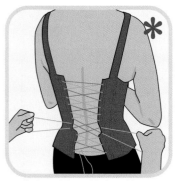

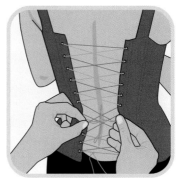

Create a second pull loop.

Tie off at the bottom.

Put it on; tighten with the pull loops.

Tie the pull loops.

 You may be tempted to lace your corset really tight and sexy, but it's best to start modestly so you get used to the constriction—and so you avoid hurting yourself. Try wearing it for half an hour a day, each day tightening the corset lace a bit more.

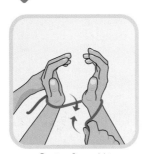

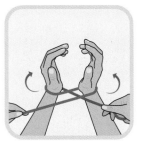

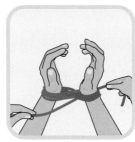

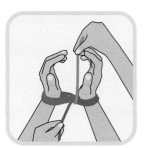

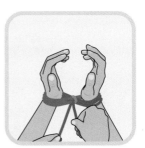

Create a figure eight.

Repeat.

Repeat once again.

Wrap the ends.

Tie off in the center.

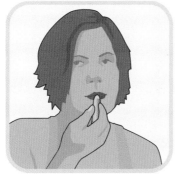

Make your lips moist and kissable.

Keep your breath fresh!

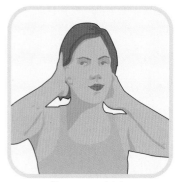

Tame any unruly hair.

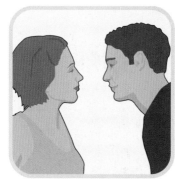

Make eye contact and lean in.

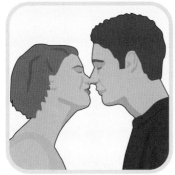

Tilt your head and close your eyes.

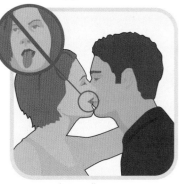

Let your lips meet.

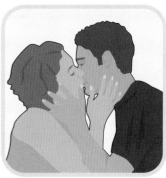

Get your hands involved.

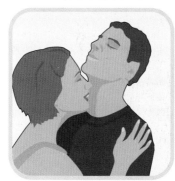

Explore new territory.

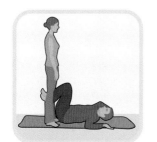

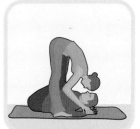

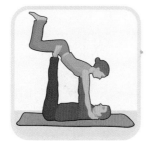

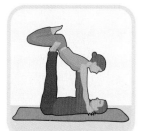

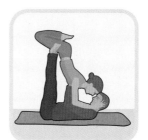

Embrace.

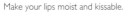

read my date's love line

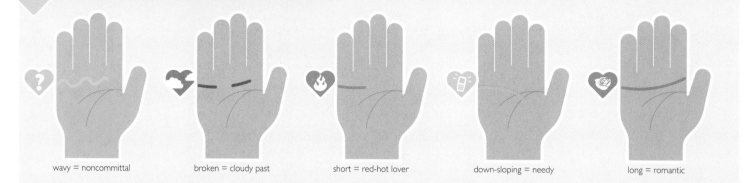

wavy = noncommittal broken = cloudy past short = red-hot lover down-sloping = needy long = romantic

read my date's head line

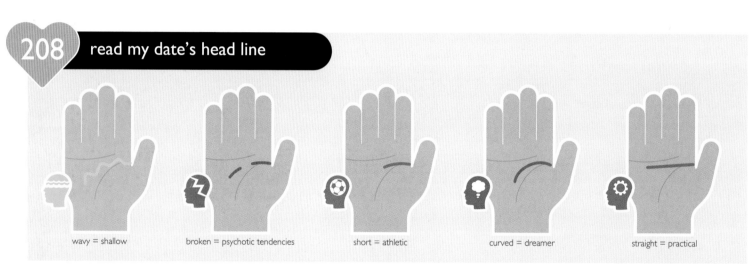

wavy = shallow broken = psychotic tendencies short = athletic curved = dreamer straight = practical

read my date's life line

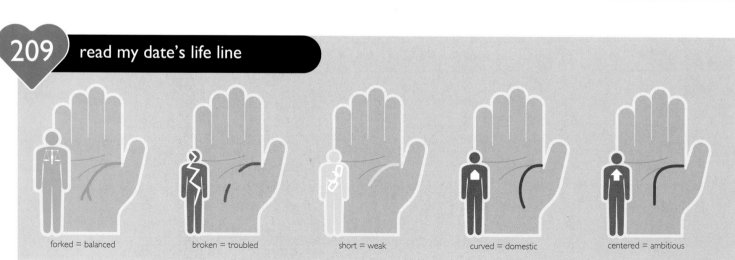

forked = balanced broken = troubled short = weak curved = domestic centered = ambitious

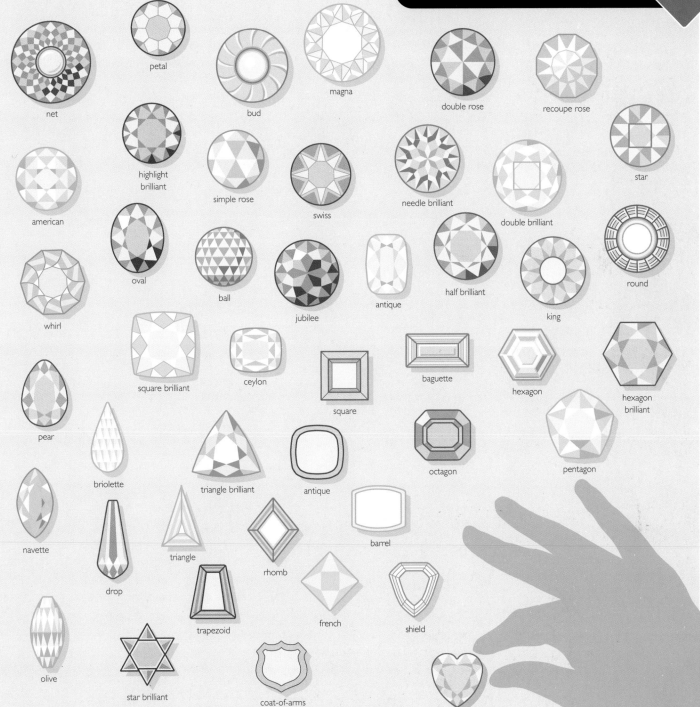

net

petal

bud

magna

double rose

recoupe rose

star

highlight brilliant

simple rose

swiss

needle brilliant

double brilliant

american

oval

ball

jubilee

antique

half brilliant

round

whirl

square brilliant

ceylon

square

baguette

hexagon

hexagon brilliant

king

pear

triangle brilliant

antique

octagon

pentagon

briolette

navette

drop

triangle

rhomb

barrel

french

shield

olive

trapezoid

star brilliant

coat-of-arms

heart

211 apply traditional bridal henna

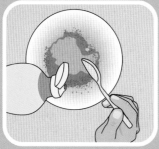
Mix lemon juice, sugar, and henna.

Cover until the top browns slightly.

Spoon into a pastry bag. Cut the tip.

212 make a henna pattern

This design, called the scorpion's mark, suggests love's stings and joys.

The game is represented by a grid design. It promises lighthearted times.

A zigzag mimics the pattern of rain. It represents fertility and abundance.

Ripples suggest water's life-giving and purifying powers.

Many patterns are purely decorative.

Buds come after a drought, bringing new life and vigor.

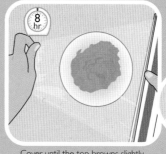

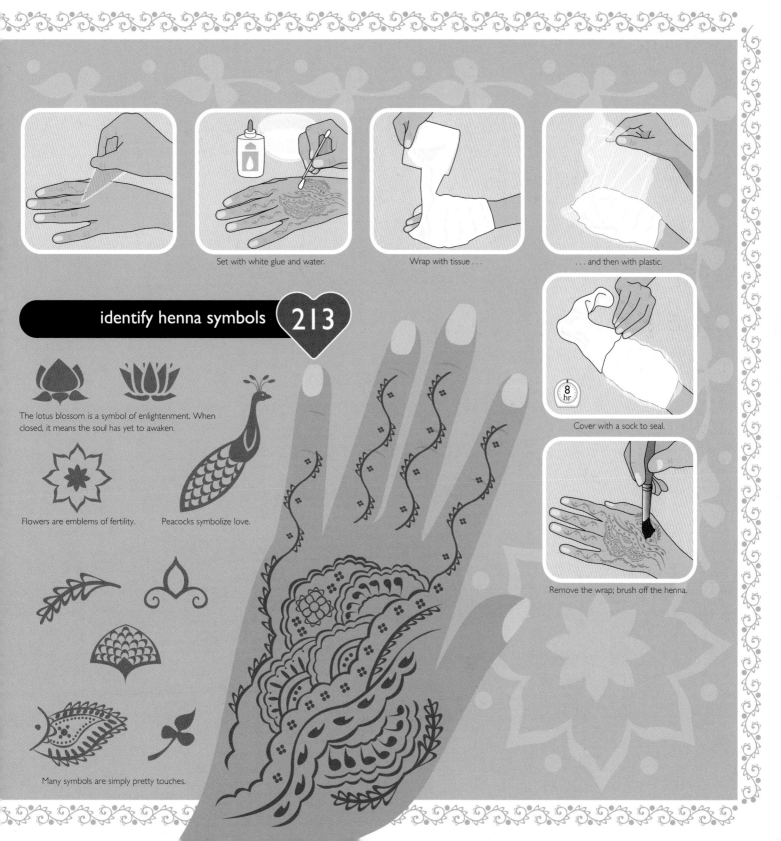

Set with white glue and water.

Wrap with tissue . . .

. . . and then with plastic.

Cover with a sock to seal.

Remove the wrap; brush off the henna.

identify henna symbols 213

The lotus blossom is a symbol of enlightenment. When closed, it means the soul has yet to awaken.

Flowers are emblems of fertility.

Peacocks symbolize love.

Many symbols are simply pretty touches.

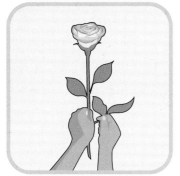

Remove any leaves or thorns.

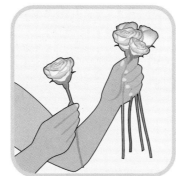

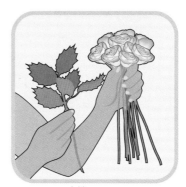

Add greenery.

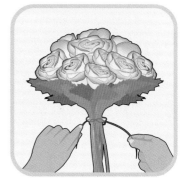

Secure with florist wire.

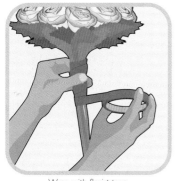

Wrap with florist tape.

Trim the stems.

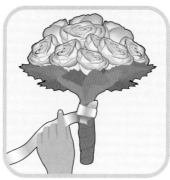

Adorn with satin wrapping.

Secure with pins.

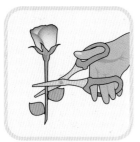

Trim the stem.

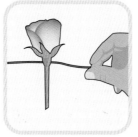

Insert florist wire.

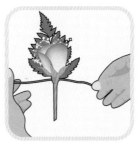

Layer over greenery; twist.

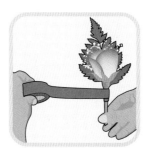

Wrap with florist tape.

Center on the lapel; pin.

Snip from any paper source.

Fold in half lengthwise.

Fold in half again.

Fold the end into a point.

Write an inscription—or an apology!

Secure with a floral pin.

Bend the pin in half to close.

twist a sophisticated chignon **143**

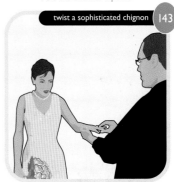

Put an usher on drunk duty.

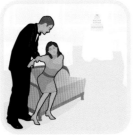

Help her sit down.

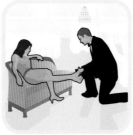

Remove hazardous shoes.

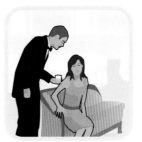

Bring her water.

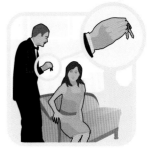

Confiscate those car keys!

Hey stargazers! Keep an eye out for the planet Venus. Named after the Roman goddess of love, this bright celestial speck is visible in the evening and morning hours.

Suds each other up with luxurious bath products.

Nix the interruptions! Turn off all phones, including your cell.

Got a Peeping Tom? Draw your curtains.

239 install a dimmer switch

Serve up sensuous, sumptuous food, like fondue. Don't forget the bubbly!

Show off your manners with a formal table setting.

Turn on the charm with a surprise picnic.

Let pets frolic outside while you cozy up to your date—it's less awkward!

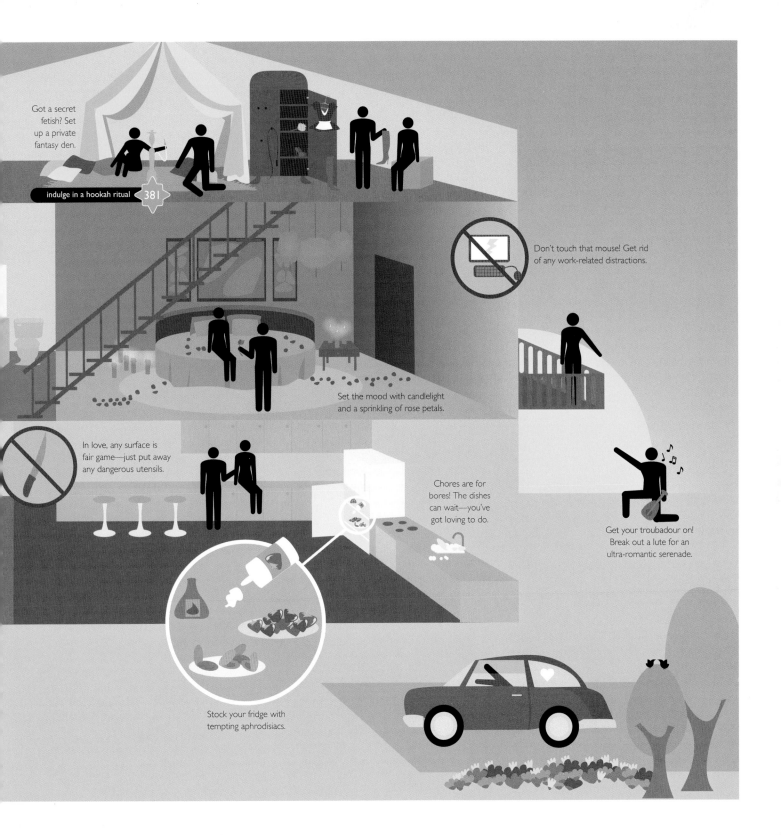

Got a secret fetish? Set up a private fantasy den.

indulge in a hookah ritual **381**

Don't touch that mouse! Get rid of any work-related distractions.

Set the mood with candlelight and a sprinkling of rose petals.

In love, any surface is fair game—just put away any dangerous utensils.

Chores are for bores! The dishes can wait—you've got loving to do.

Get your troubadour on! Break out a lute for an ultra-romantic serenade.

Stock your fridge with tempting aphrodisiacs.

nest

Complementary schemes couple colors that are polar opposites, providing vivid contrast.

We all know and love the color wheel: its whirling array of hues and shades promises limitless possibilities. Use these examples of color schemes to harness the color wheel's creative power and select perfect palettes for your home—whether you want to enliven a space with a peppy accent color or set up a peaceful, simple-hued sanctuary. Copy this page, cut out the examples, and cut away the shaded areas. Then lay each one over the color wheel and give it a spin to see what combinations come into view.

Analogous schemes pair colors that are side by side on the color wheel, adding nuance to a monochromatic look.

Triadic schemes offer both high-energy contrast and a welcome balance.

Give your room Asia's spice and flare with a palette of bright, festive colors, like orange and red.

Transport yourself to Morocco's striking streets with sandstone-colored walls, studded with occasional jewel tones.

Evoke the cheer of the Côte d'Azur with expansive yellow spaces that mimic the beach's pristine sands.

Ensconce yourself in woodland colors, like a mossy green or the soft brown of a doe.

Want a subtle monochromatic look, or a more colorful vibe? Match the numbered areas to the paint swatches to explore palette options.

Capture the city's sophistication and grit with various grays, punched up with bold, traffic-stopping color.

The rainforest's verdure makes it a peaceful haven. Small bright flashes suggest glimpses of exotic inhabitants, like fuchsia orchids.

Re-create an English garden, hinting at its lavender scent with a wide array of purples.

Tahiti is best expressed in gentle blues. Recline on a beige sofa to feel as if you're relaxing on its beaches.

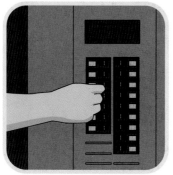

Turn off the power.

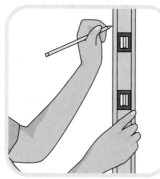

Draw a line from floor to ceiling.

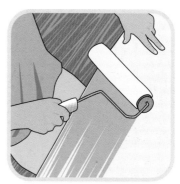

Activate the wallpaper with water.

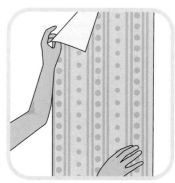

Align the paper with the line.

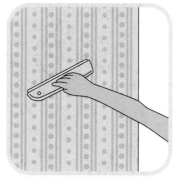

Paste; smooth out bubbles or wrinkles.

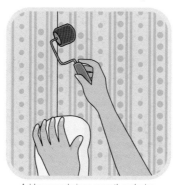

Add a second piece; smooth and wipe.

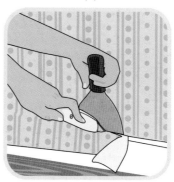

Trim along the ceiling and baseboards.

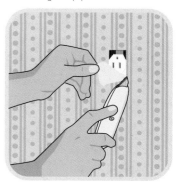

Cut around outlets; replace the plates.

Score the wallpaper.

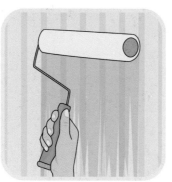

Moisten with water.

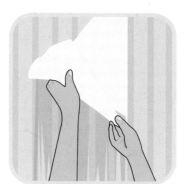

Keep damp; scrape off small bits.

¼ c (55 g) trisodium phosphate
1 gal (3¾ l) water

Scrape the paint's edges.

Sand the area.

Clean; let set.

Rinse with water. Repaint.

Prick the dent with a tack.

Apply a touch of water.

Cover; press on a bottle cap.

Iron to expand the wood.

Repaint, if desired.

 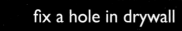
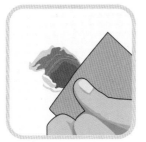

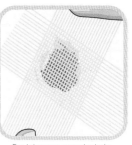

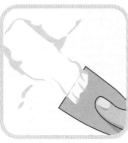

Sand the rough edges.

Put joint tape over the hole.

Apply spackle; smooth.

Let dry, then sand.

Wipe with a damp sponge.

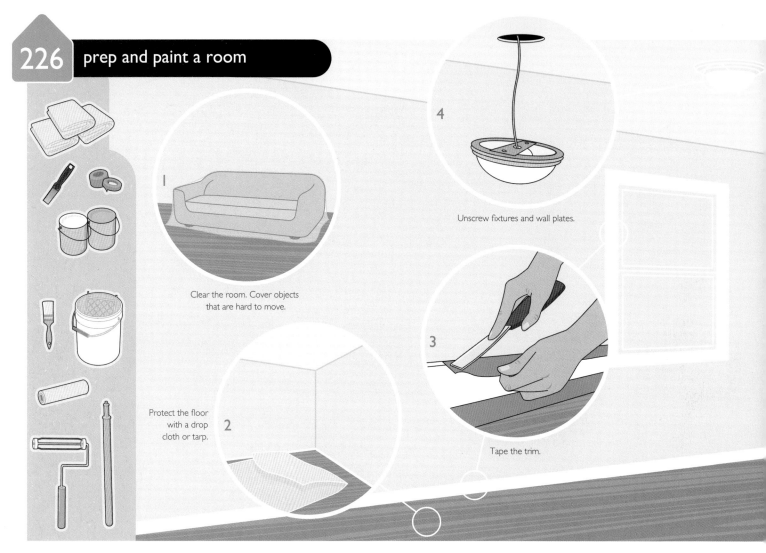

1
Clear the room. Cover objects that are hard to move.

2
Protect the floor with a drop cloth or tarp.

3
Tape the trim.

4
Unscrew fixtures and wall plates.

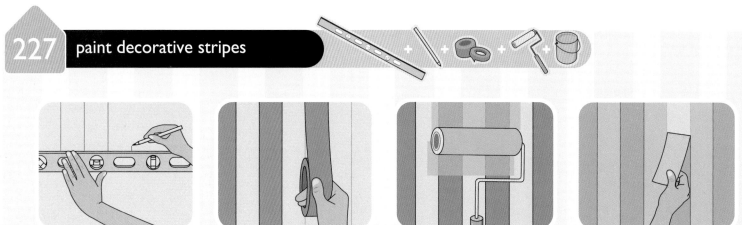

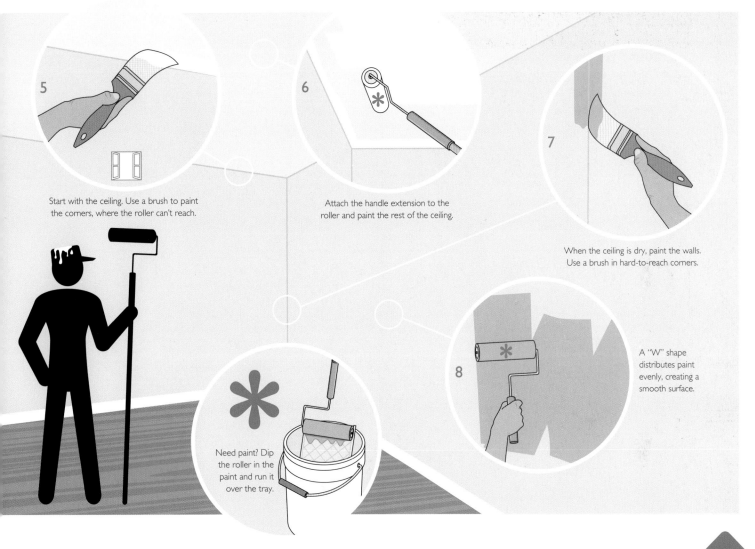

5 Start with the ceiling. Use a brush to paint the corners, where the roller can't reach.

6 Attach the handle extension to the roller and paint the rest of the ceiling.

7 When the ceiling is dry, paint the walls. Use a brush in hard-to-reach corners.

***** Need paint? Dip the roller in the paint and run it over the tray.

8 A "W" shape distributes paint evenly, creating a smooth surface.

dab a sponge-paint texture **228**

Mix the glaze and paint.

Brush on the paint to prevent globbing.

Layer colors for more texture.

229 fit together a dovetail joint

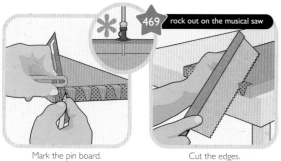

Mark the pin board.

Cut the edges.

Chisel away the waste; file.

Transfer to the tail board.

Cut the tail board; join.

469 rock out on the musical saw

 Place a wheel gauge on your pin board and scribe a line to indicate the depth of your tails and pins. For softwoods, mark the tails and pins with a slope of 1:6; for hardwoods, use 1:8.

230 hang a basic shelf

 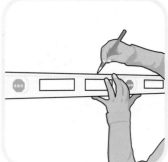 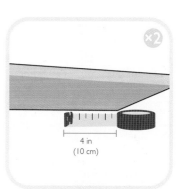

Mark the desired shelf height.

Measure the length of the shelf.

Measure for brackets.

4 in
(10 cm)

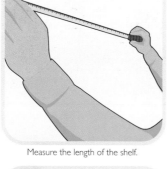 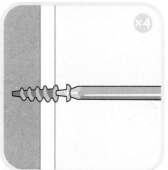

Screw in anchors, if there are no studs.

Place the screws in the anchors.

Fit the bracket onto the screws.

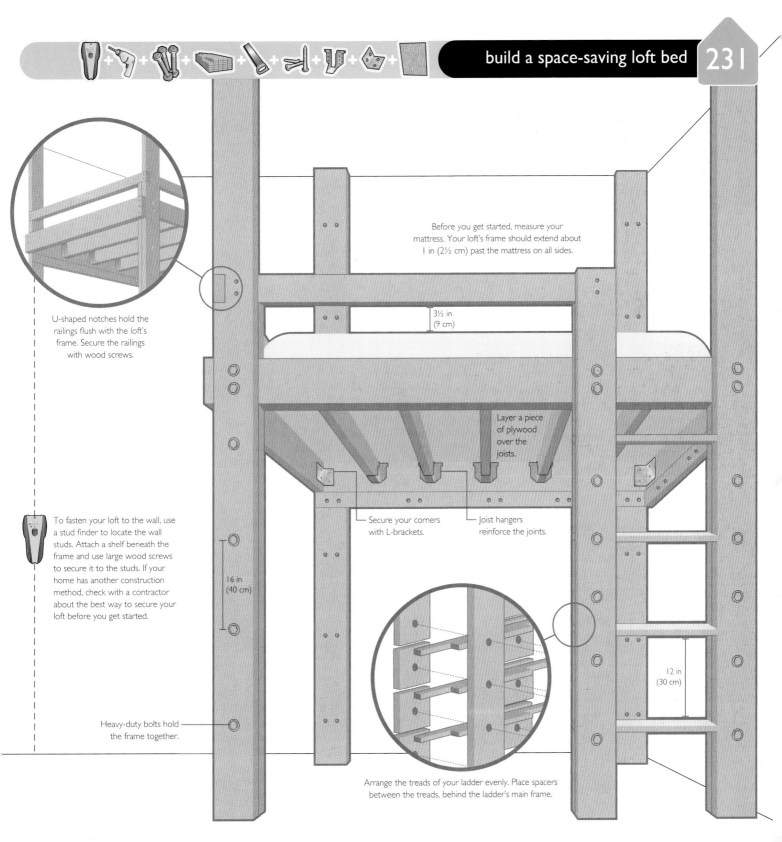

U-shaped notches hold the railings flush with the loft's frame. Secure the railings with wood screws.

Before you get started, measure your mattress. Your loft's frame should extend about 1 in (2½ cm) past the mattress on all sides.

3½ in (9 cm)

Layer a piece of plywood over the joists.

Secure your corners with L-brackets.

Joist hangers reinforce the joints.

To fasten your loft to the wall, use a stud finder to locate the wall studs. Attach a shelf beneath the frame and use large wood screws to secure it to the studs. If your home has another construction method, check with a contractor about the best way to secure your loft before you get started.

16 in (40 cm)

12 in (30 cm)

Heavy-duty bolts hold the frame together.

Arrange the treads of your ladder evenly. Place spacers between the treads, behind the ladder's main frame.

232 create a covered headboard

1. Cut plywood to fit.

2. Glue foam to the front.

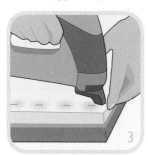

3.

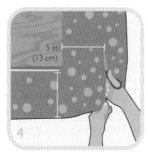

4. 5 in (13 cm)

5. Staple at the top center.

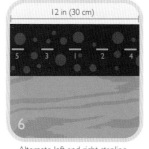

6. 12 in (30 cm) — 5 3 1 2 4 — Alternate left and right stapling.

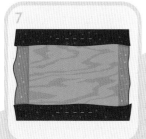

7.

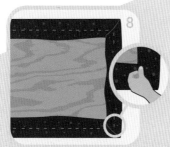

8.

Repeat on the bottom.

233 make the perfect bed

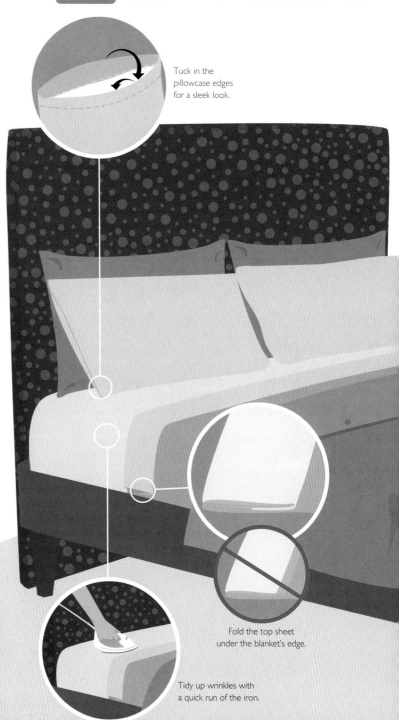

Tuck in the pillowcase edges for a sleek look.

Fold the top sheet under the blanket's edge.

Tidy up wrinkles with a quick run of the iron.

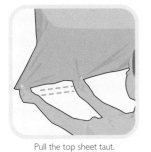 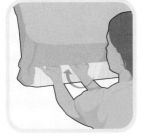 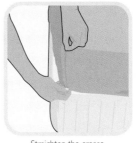
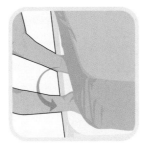 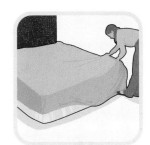

Pull the top sheet taut.

Straighten the crease.

Repeat on the other side.

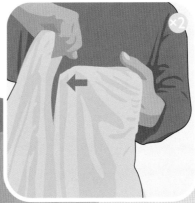

Insert one corner into another.

Pat down the corners.

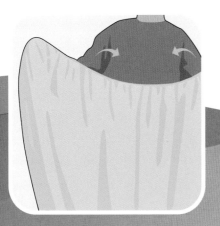

Fold into thirds, lengthwise.

Fold in half, widthwise.

Remove all metal.

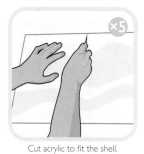

Cut acrylic to fit the shell.

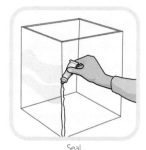

Seal.

Test; reseal any leaks.

Insert a platform.

Add water and conditioning.

286 build a koi pond

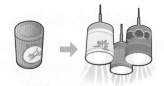

Close inside the shell.

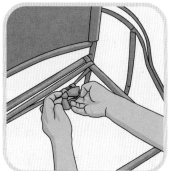

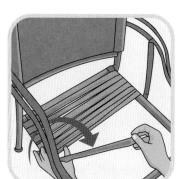

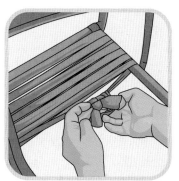

494 wheel-walk a unicycle

Cut out the tubes' valves.

Stretch around the frame; knot.

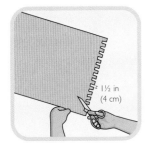

1½ in (4 cm)

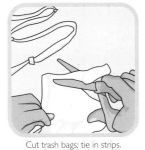

Cut trash bags; tie in strips.

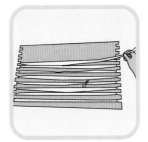

Wind around the loom.

Knot at the back.

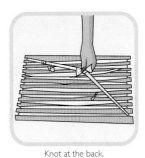

Cut through the handles.

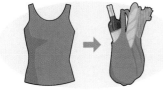

Tie the bags' handles.

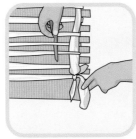

Tie in the front; weave.

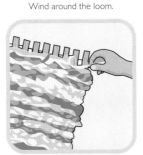

Tie off.

Cut off two at a time; knot.

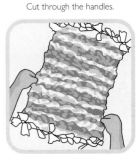

Trim the fringe; fluff.

Continue until covered.

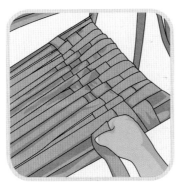

Weave the other way.

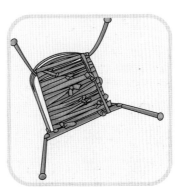

Knot on the underside as you go.

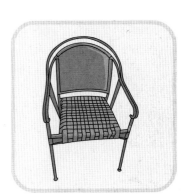

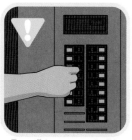

Turn off the power to the light.

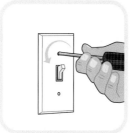

Unhook all three wires.

Align the wires.

Twist matching wires together.

Insert the wires into wire nuts.

Fold the wires back into the box.

Reattach the switch and plate.

So many wires! Not to fret. Simply match the hot, neutral, and ground wires from the wall box to the appropriate wires on the dimmer switch. In this case, the hot wire is black, the neutral wire is white, and the ground wires are green and copper-colored. If you don't see the same colors, check with a professional before proceeding, or use a voltage tester to figure out which wire is which.

You can purchase a wi-fi adapter and a USB cable at any computer supply store. So if you're heading off into the wilderness, but can't live without the Internet, stock up! It may take a little finessing to get the best signal.

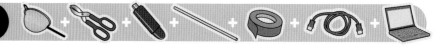

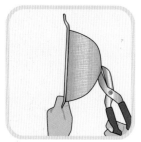

Cut a hole in the strainer.

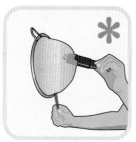

Put the adapter in the hole.

Tape to a long dowel.

Connect with a USB cable.

Adjust for the best signal.

Strip the ends.

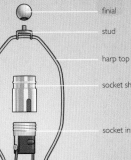

Make an underwriter's knot.

Identify the hot wire, which is smooth, and the neutral wire, which is ribbed.

Split the upper loose end of the cord.

Wrap the hot wire under the gold screw.

Insert the rod into the lamp base.

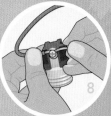

Wrap the neutral wire under the silver screw.

Feed the cord through the rod.

Tighten all the screws until the wires are secure.

Drill a hole for the cord in the side of the bottle. (Use a drill bit appropriate to the lamp base of your choosing.)

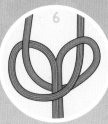

finial
stud
harp top
socket shell
socket interior
underwriter's knot
socket cap
harp bottom
neck
locknut

lamp rod

Reassemble the socket.

Put together the plug.

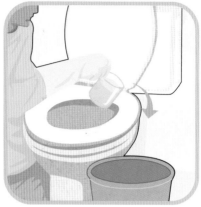
Remove most of the water.

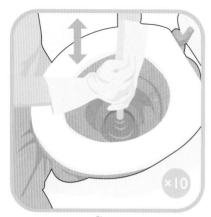
Plunge.

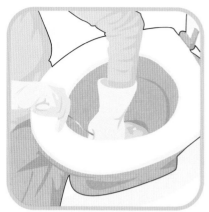
Unbend a hanger; twist into the clog.

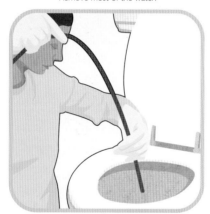
Remove the hanger; insert a drain snake.

Rotate; pull to loosen the clog.

Flush when the water begins to drain.

243 retrieve a valuable from a drain

Turn off the water.

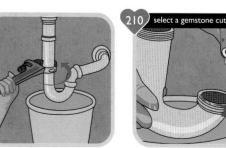
Loosen the nuts on the trap.

210 select a gemstone cut

Remove the trap; search.

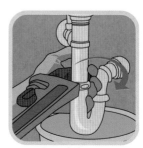
Reattach the trap.

Cover the wrench with pipe tape.

Loosen the showerhead from the pipe.

Remove the O-ring, if damaged.

Soak in white vinegar to remove clogs.

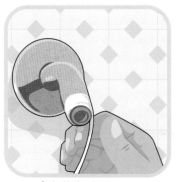
Seal with the pipe tape.

Place a new O-ring.

Reattach the showerhead.

Gently tighten.

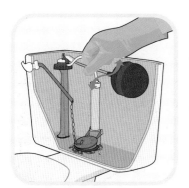
Move the arm away from the sides.

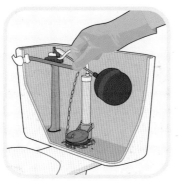
Adjust the chain and flush arm.

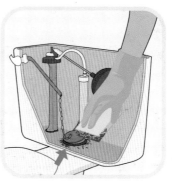
Clean the flush valve seat.

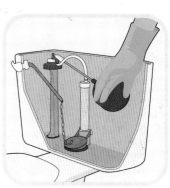
Check the flush ball for leaks.

246 tidy up on a daily basis

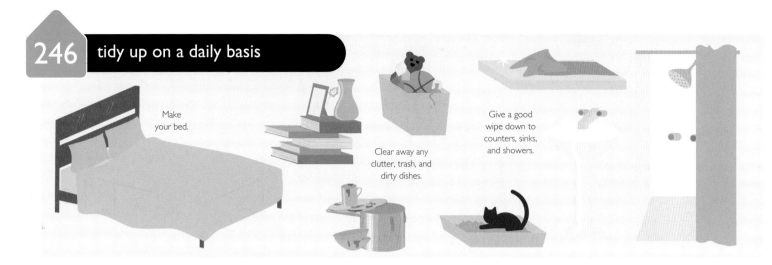

Make your bed.

Clear away any clutter, trash, and dirty dishes.

Give a good wipe down to counters, sinks, and showers.

247 clean up every week

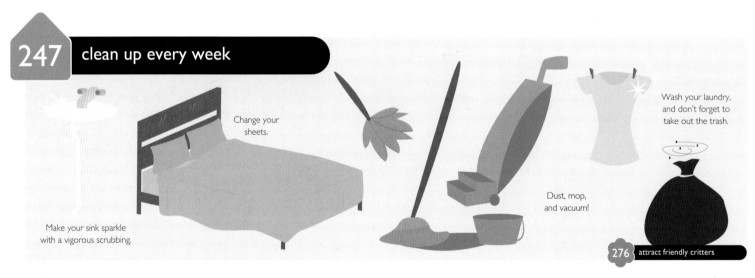

Change your sheets.

Make your sink sparkle with a vigorous scrubbing.

Dust, mop, and vacuum!

Wash your laundry, and don't forget to take out the trash.

276 attract friendly critters

248 do seasonal household tasks

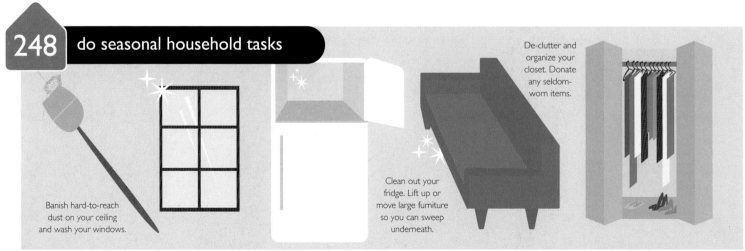

De-clutter and organize your closet. Donate any seldom-worn items.

Banish hard-to-reach dust on your ceiling and wash your windows.

Clean out your fridge. Lift up or move large furniture so you can sweep underneath.

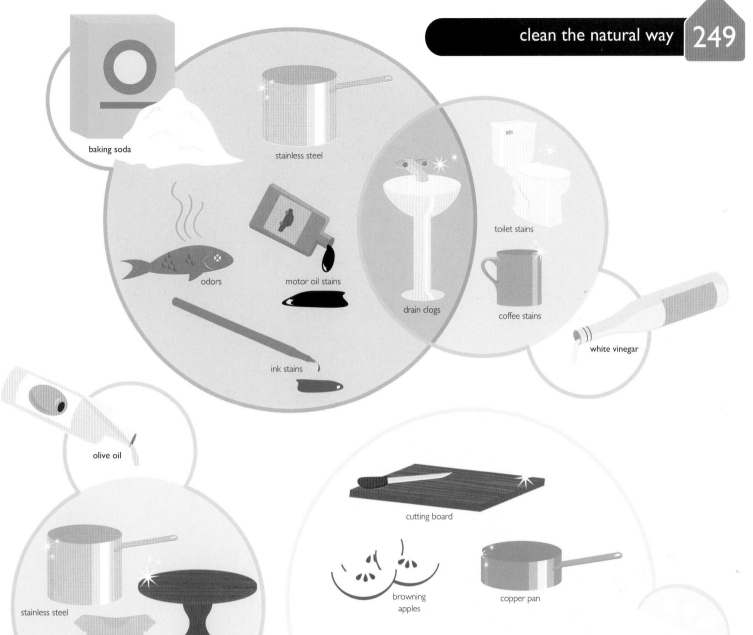

baking soda

stainless steel

odors

motor oil stains

drain clogs

toilet stains

coffee stains

white vinegar

ink stains

olive oil

stainless steel

wood

tar stains

cutting board

browning apples

copper pan

lemon

tea stains

yellowed clothing

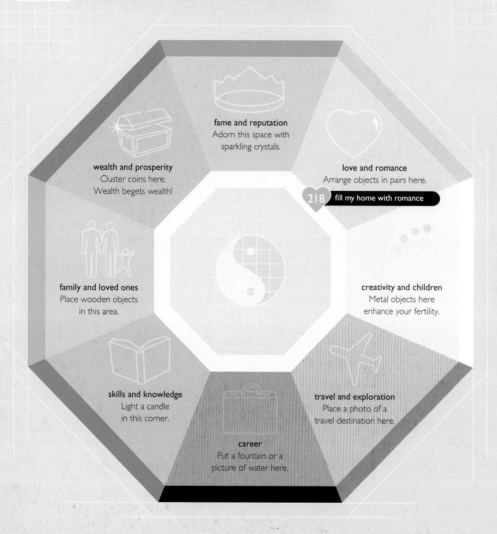

fame and reputation
Adorn this space with sparkling crystals.

wealth and prosperity
Cluster coins here. Wealth begets wealth!

love and romance
Arrange objects in pairs here.

218 fill my home with romance

family and loved ones
Place wooden objects in this area.

creativity and children
Metal objects here enhance your fertility.

skills and knowledge
Light a candle in this corner.

travel and exploration
Place a photo of a travel destination here.

career
Put a fountain or a picture of water here.

Align the bottom of this diagram (called a bagua) with the front of your home, and imagine it overlaying your entire space. Then arrange your belongings to bring good fortune in the life areas that matter most to you.

good luck
Bad house plan? Add items that are clean, flowing, natural, and living to make any space more inviting.

Mirrors bounce light and energy from room to room.

Open your curtains during the day to fill your home with positive light and energy. Close them at night to keep energy in.

bad luck
To keep positive energy flowing freely, remove items that are dead, broken, unnatural, dirty, or blocking good forces.

A metal bed conducts electricity, which can interfere with positive chi.

Open the door to let spirits leave.

Light the sage smudge stick.

Place in an abalone shell.

Wave while thinking good thoughts.

Grind to extinguish.

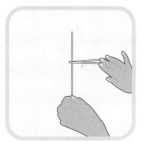

Fold a straw over another.

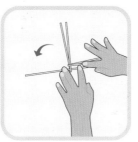

Rotate; fold another.

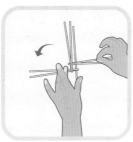

Repeat.

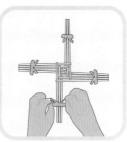

Tie off when complete.

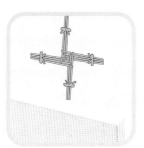

Hang over a doorway.

Got a bare window begging for a little embellishment?
Learn how to hang curtains, and how to spruce them
up with well-chosen details, like finials and trims.

Cap off your curtain rod with a charming finial.

Secure with
drapery hooks.

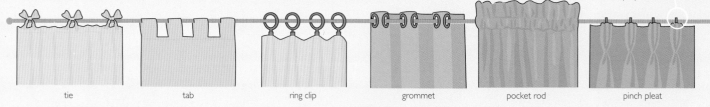

| tie | tab | ring clip | grommet | pocket rod | pinch pleat |

casual → formal

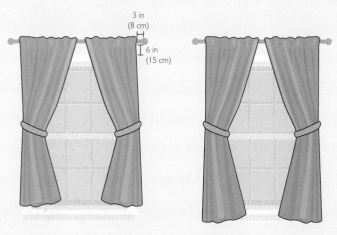

3 in
(8 cm)

6 in
(15 cm)

For casual curtains, align the bottom with the windowsill or the apron.

lip cord

brush fringe

ball fringe

tassel fringe

beaded fringe

Deck out your curtains with custom trimmings, like tassels
and beads. Simply stitch them along the bottom hem.

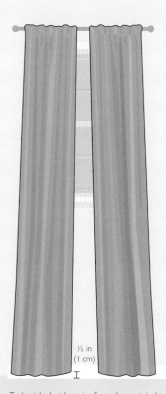

½ in
(1 cm)

To banish dust bunnies from the curtains'
hem, let the bottom hang above the floor.

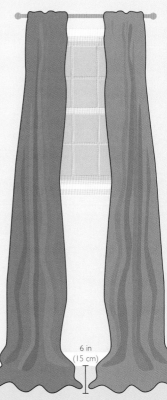

6 in
(15 cm)

For a dramatic touch, allow the fabric
to puddle gracefully on the floor.

Once you've got the basics down, experiment with other classic drapery types. How about café-style curtains for your kitchen, or an impressive set of bishop sleeves in your dining room?

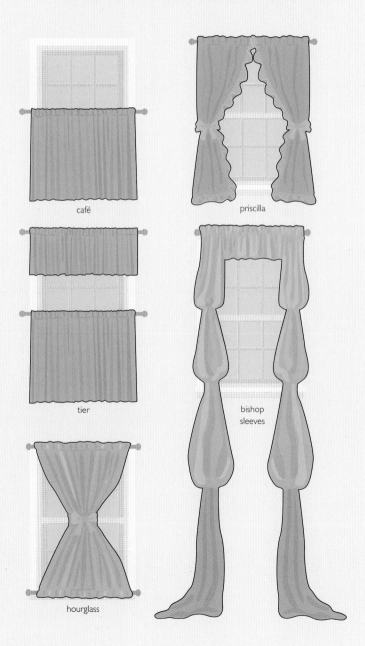

café

priscilla

tier

bishop sleeves

hourglass

Measure; double the width.

Trim the fabric.

Fold a clean edge; press.

Fold the hem; press.

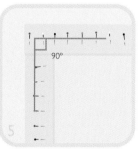

All corners meet neatly.

Sew along the edges.

Knot the thread in back. Trim.

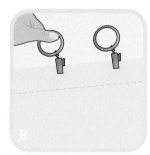

Attach the clips, then hang.

Mix soil and water; shake.

Let set; check the results.

Determine the wall size.

Make a workspace.

Create the needed mixture.

Stomp until well mixed.

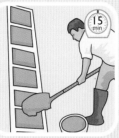

Place the clay in a mold.

Lay the bricks flat.

Stand them on their sides.

Kick to test its strength.

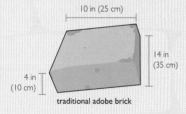

10 in (25 cm)

14 in (35 cm)

4 in (10 cm)

traditional adobe brick

* Before you start stirring up your adobe mixture, test a soil sample to see what crucial ingredients your soil lacks. Typically, ideal adobe contains 70 percent sand and 30 percent clay. Add water and a few ample handfuls of straw to make the mixture thick but malleable, then shovel it into a ladder-like wooden frame. You can build this frame to make bricks of any size, but the traditional adobe brick size is recommended.

Start with a solid foundation.

Mix a mud-straw mortar.

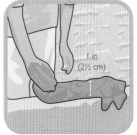

1 in (2½ cm)

Spread the mortar.

Place bricks on the mortar.

lime powder
water

Seal with a lime wash.

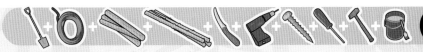
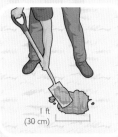

Dig holes for the fence posts.

Place the posts; make level.

Fill the holes; tamp down.

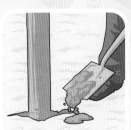

Cut the crosspieces.

Drill into the crosspieces.

I ft (30 cm)

45°

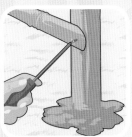

Screw to the post.

Cut and place the poles.

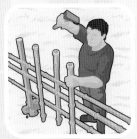

Drive them into the ground.

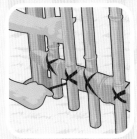

Tie each juncture.

Finish with preservative.

To create a natural seal (and make your fence last longer), cut each bamboo post above a diaphragm.

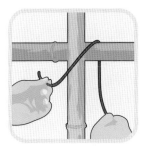

Weave around the joint.

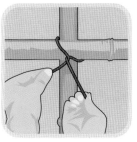

Twist behind the joint.

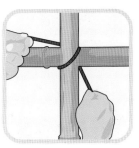

Bring around to the front.

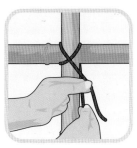

Cross over the left end.

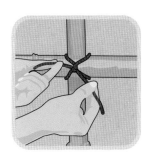

Knot behind the joint; trim.

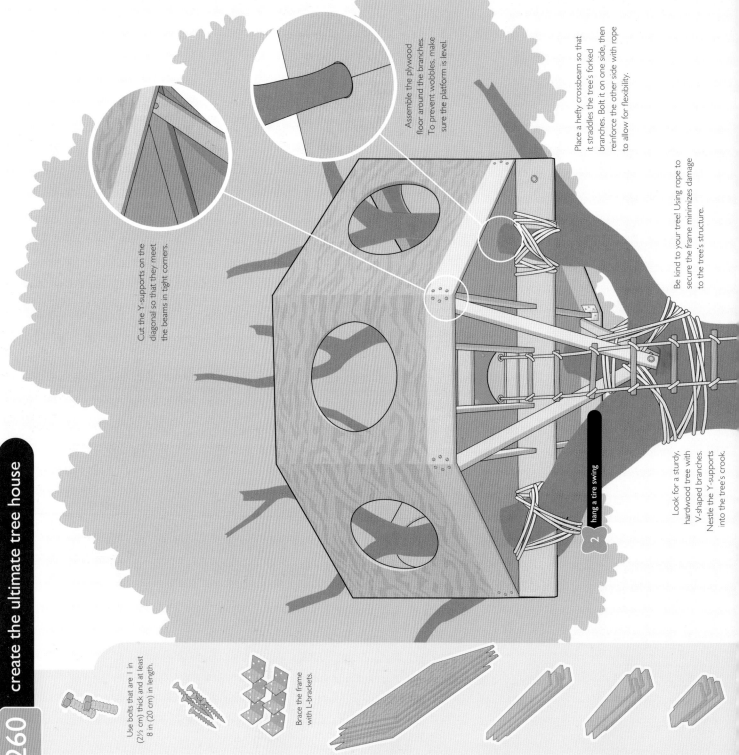

Cut the Y-supports on the diagonal so that they meet the beams in tight corners.

Assemble the plywood floor around the branches. To prevent wobbles, make sure the platform is level.

Place a hefty crossbeam so that it straddles the tree's forked branches. Bolt it on one side, then reinforce the other side with rope to allow for flexibility.

Be kind to your tree! Using rope to secure the frame minimizes damage to the tree's structure.

2 hang a tire swing

Look for a sturdy, hardwood tree with V-shaped branches. Nestle the Y-supports into the tree's crook.

Use bolts that are 1 in (2½ cm) thick and at least 8 in (20 cm) in length.

Brace the frame with L-brackets.

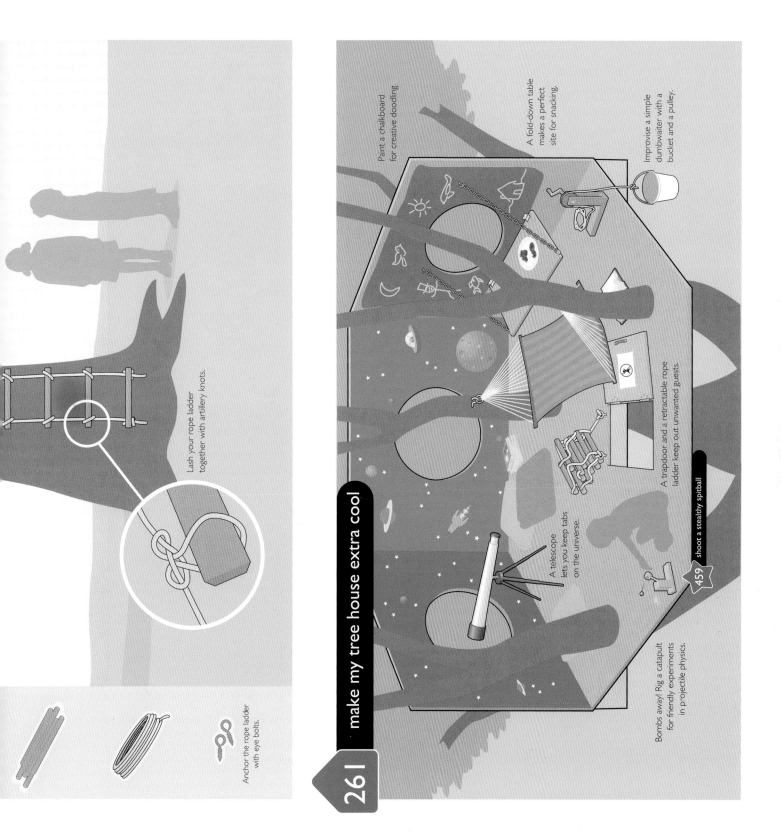

Lash your rope ladder together with artillery knots.

Anchor the rope ladder with eye bolts.

Paint a chalkboard for creative doodling.

A fold-down table makes a perfect site for snacking.

Improvise a simple dumbwaiter with a bucket and a pulley.

A trapdoor and a retractable rope ladder keep out unwanted guests.

A telescope lets you keep tabs on the universe.

Bombs away! Rig a catapult for friendly experiments in projectile physics.

459 shoot a stealthy spitball

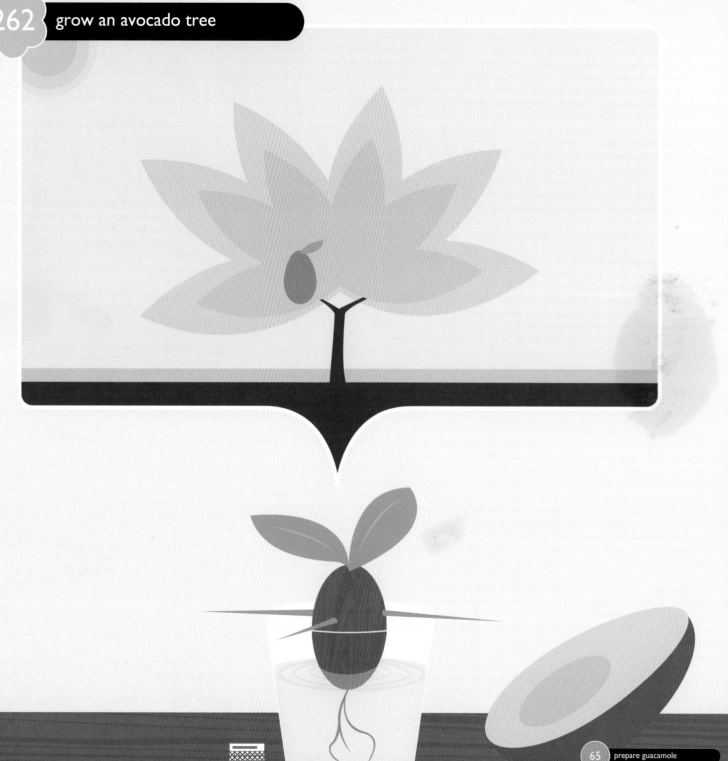

65 prepare guacamole

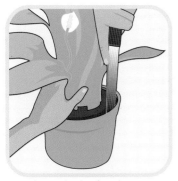

Loosen the plant from the pot.

Place a mesh filter over the hole.

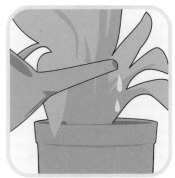

1 in
(2½ cm)

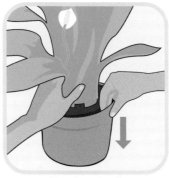

Tamp down the soil.

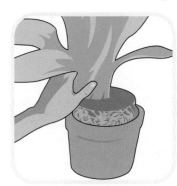

Water settles the roots.

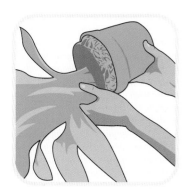

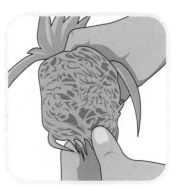

Tease the outer roots on the sides.

Tease the coiled roots at the bottom.

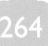

Continue repotting.

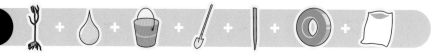

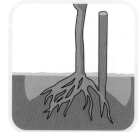

Spread the roots.

2 ft (60 cm)

Insert a stake into a mound.

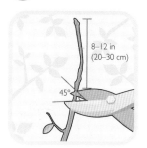

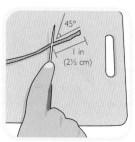

The crown should be level.

Make a barrier with mulch.

3 ft (1 m)

tangerine

key lime

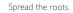
meyer lemon

blood orange

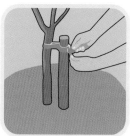
pomelo

ruby grapefruit

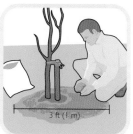
kumquat

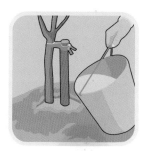
buddha's hand
citron

8–12 in
(20–30 cm)

45°

Select and cut a bud.

Place in a plastic bag.

3 months

Store in the refrigerator.

45°
1 in
(2½ cm)

Trim the bud.

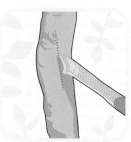

Make an incision.

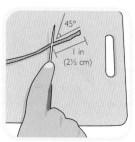

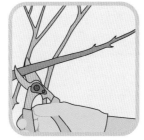

Cut brown or striated canes.

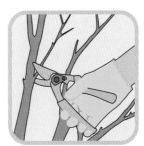

Remove horizontal canes.

Remove pencil-thin canes.

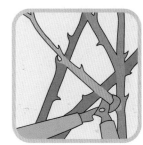

Cut off interior canes.

Remove crossed canes.

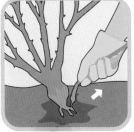

Pull out any suckers.

Cut above outward buds.

Prune to healthy tissue.

Coat with sealant.

Create a vase shape.

cabbage rose

damask rose

alba rose

gallica rose

bermuda rose

bourbon rose

make a boutonniere 215

tea rose

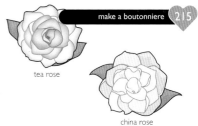

china rose

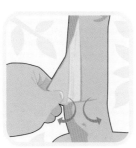

Cut a T-shape.

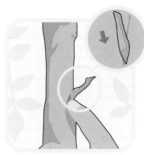

Peel back the flaps.

Nestle the bud in the bark.

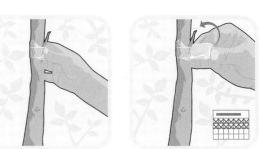

Remove the tape.

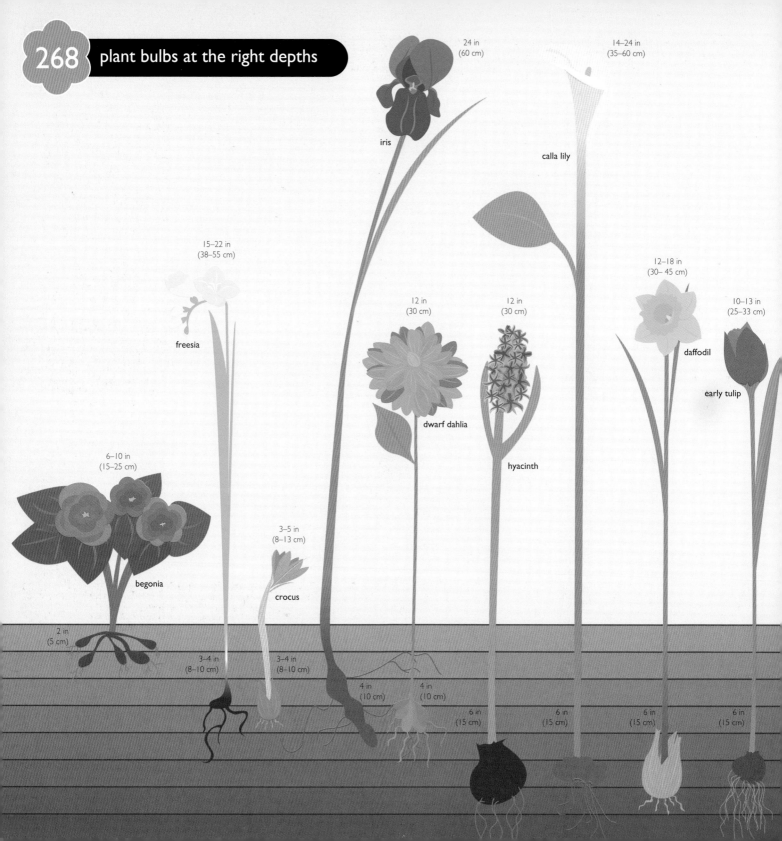

iris

24 in
(60 cm)

calla lily

14–24 in
(35–60 cm)

15–22 in
(38–55 cm)

freesia

12 in
(30 cm)

12 in
(30 cm)

12–18 in
(30– 45 cm)

daffodil

10–13 in
(25–33 cm)

early tulip

dwarf dahlia

hyacinth

6–10 in
(15–25 cm)

begonia

3–5 in
(8–13 cm)

crocus

2 in
(5 cm)

3–4 in
(8–10 cm)

3–4 in
(8–10 cm)

4 in
(10 cm)

4 in
(10 cm)

6 in
(15 cm)

6 in
(15 cm)

6 in
(15 cm)

6 in
(15 cm)

Check for rootballs.

Place in dappled light.

Place in more direct light.

Plant on an overcast day.

Overturn the planting bed.

Space appropriately.

Cover with soil.

Water daily at first.

 To see if the seedlings are ready for transplant, gingerly remove each with a stick and look for a rootball (a clump of roots and soil) and a star-shaped leaf pattern (called true leaves). Then gradually expose the seedlings to more and more direct sunlight, and plant them in a hole twice the size of the rootball. Be sure all danger of frost has passed!

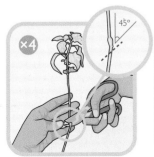

Cut below the bud.

Make a notch; bend.

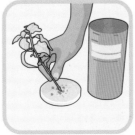

Dip in rooting hormone.

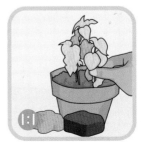

Plant in sand and peat moss.

Cover to trap moisture.

271 create a japanese zen garden

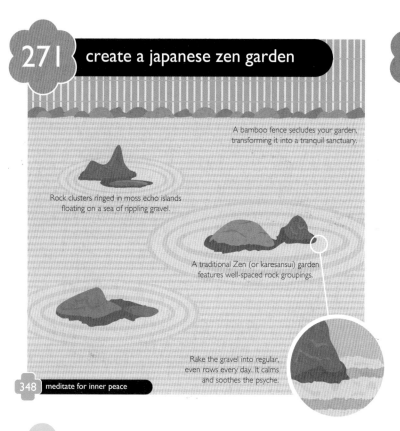

A bamboo fence secludes your garden, transforming it into a tranquil sanctuary.

Rock clusters ringed in moss echo islands floating on a sea of rippling gravel.

A traditional Zen (or karesansui) garden features well-spaced rock groupings.

Rake the gravel into regular, even rows every day. It calms and soothes the psyche.

348 meditate for inner peace

272 design a french parterre garden

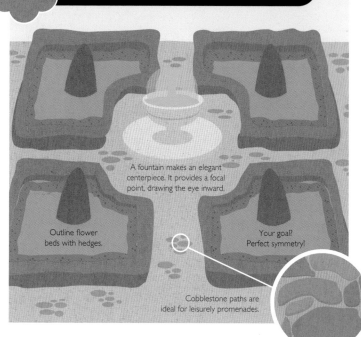

A fountain makes an elegant centerpiece. It provides a focal point, drawing the eye inward.

Outline flower beds with hedges.

Your goal? Perfect symmetry!

Cobblestone paths are ideal for leisurely promenades.

273 plant an edible garden

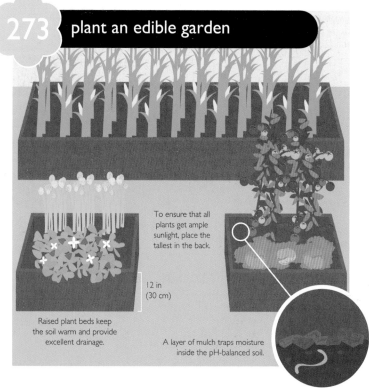

To ensure that all plants get ample sunlight, place the tallest in the back.

12 in (30 cm)

Raised plant beds keep the soil warm and provide excellent drainage.

A layer of mulch traps moisture inside the pH-balanced soil.

274 foster a succulent garden

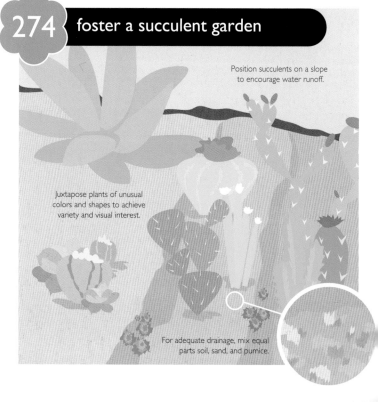

Position succulents on a slope to encourage water runoff.

Juxtapose plants of unusual colors and shapes to achieve variety and visual interest.

For adequate drainage, mix equal parts soil, sand, and pumice.

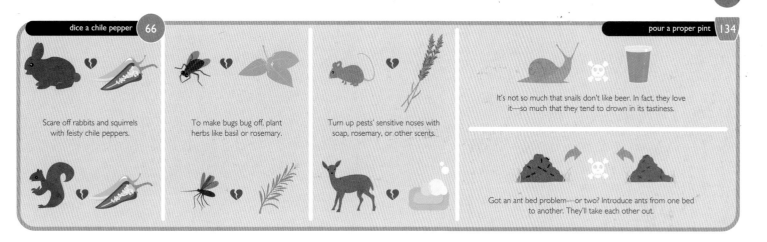

dice a chile pepper 66

pour a proper pint 134

Scare off rabbits and squirrels with feisty chile peppers.

To make bugs bug off, plant herbs like basil or rosemary.

Turn up pests' sensitive noses with soap, rosemary, or other scents.

It's not so much that snails don't like beer. In fact, they love it—so much that they tend to drown in its tastiness.

Got an ant bed problem—or two? Introduce ants from one bed to another. They'll take each other out.

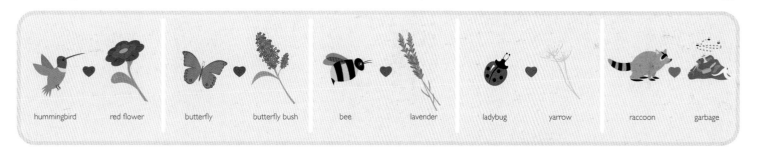

hummingbird red flower butterfly butterfly bush bee lavender ladybug yarrow raccoon garbage

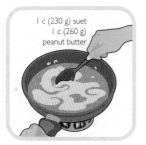

1 c (230 g) suet
1 c (260 g) peanut butter

2 c (320 g) cornmeal
2 c (180 g) oats

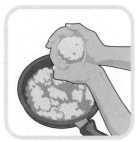

Form balls. Chill until hard.

Place in a mesh bag.

Hang, and enjoy the visitors!

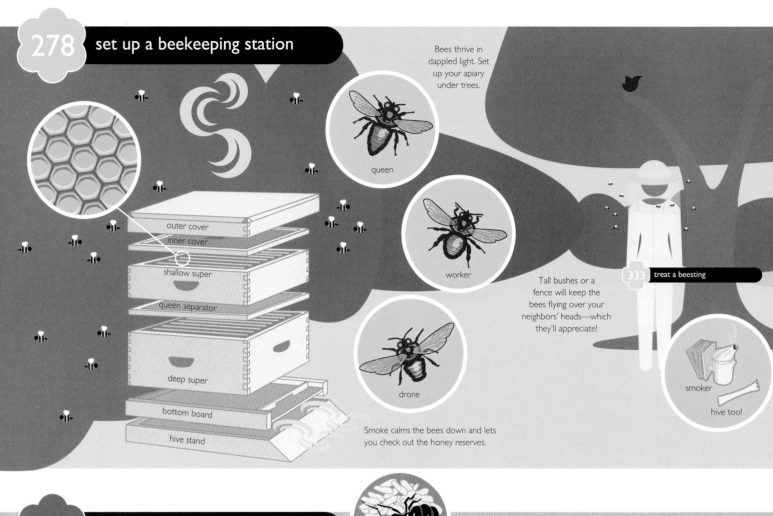

Bees thrive in dappled light. Set up your apiary under trees.

queen

worker

drone

Tall bushes or a fence will keep the bees flying over your neighbors' heads—which they'll appreciate!

Smoke calms the bees down and lets you check out the honey reserves.

outer cover
inner cover
shallow super
queen separator
deep super
bottom board
hive stand

333 treat a beesting

smoker

hive tool

279 build an ant farm

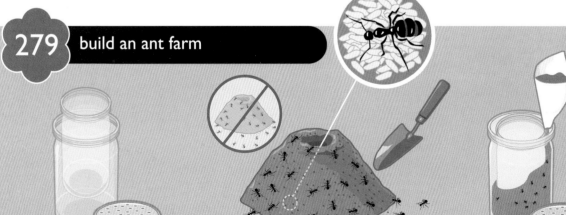

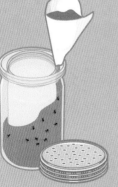

Insert a jar inside a wider one of the same height. Prick the wider jar's lid.

Find an ant hill, and remove the worker ants, the queen, and some eggs. Avoid fire ants, though!

Gently funnel the soil and worker ants around the inner jar.

Add the queen and her eggs last.

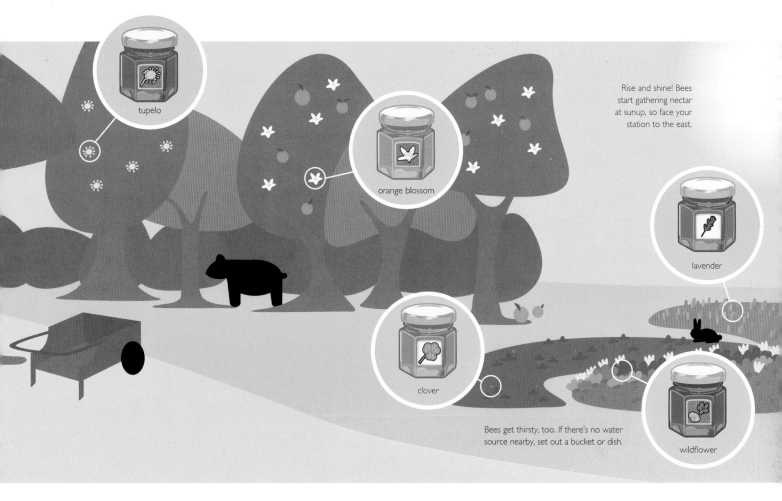

tupelo

orange blossom

lavender

clover

wildflower

Rise and shine! Bees start gathering nectar at sunup, so face your station to the east.

Bees get thirsty, too. If there's no water source nearby, set out a bucket or dish.

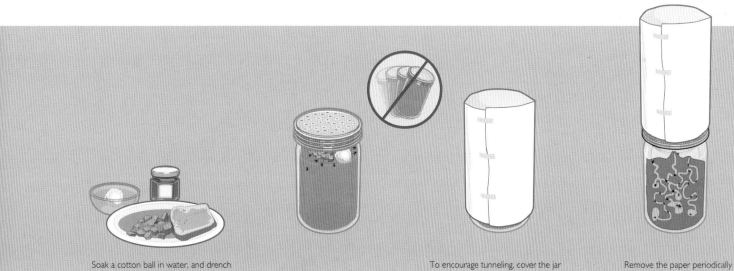

Soak a cotton ball in water, and drench some bread crumbs in honey.

Place inside the jar.

To encourage tunneling, cover the jar so the ants think they're underground.

Remove the paper periodically to check on their progress.

Coax into a milking stall.

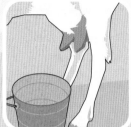

Wash with warm water.

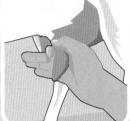

Tighten in one motion.

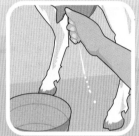

Direct the first spray away.

Stop when the teats shrink.

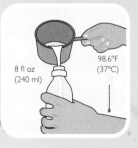

8 fl oz
(240 ml)

98.6°F
(37°C)

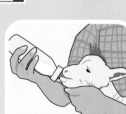

Hold and comfort the lamb.

Stroke the throat.

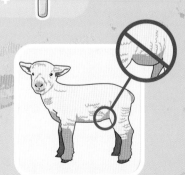

Stop before he's too full!

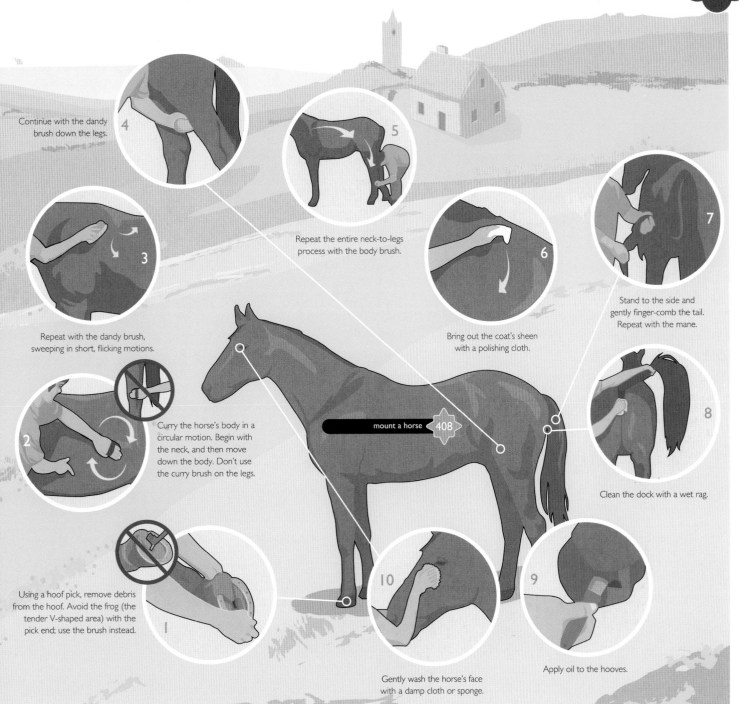

Continue with the dandy brush down the legs.

4

5

Repeat the entire neck-to-legs process with the body brush.

3

Bring out the coat's sheen with a polishing cloth.

6

7

Stand to the side and gently finger-comb the tail. Repeat with the mane.

Repeat with the dandy brush, sweeping in short, flicking motions.

Curry the horse's body in a circular motion. Begin with the neck, and then move down the body. Don't use the curry brush on the legs.

2

mount a horse 408

8

Clean the dock with a wet rag.

Using a hoof pick, remove debris from the hoof. Avoid the frog (the tender V-shaped area) with the pick end; use the brush instead.

1

10

9

Apply oil to the hooves.

Gently wash the horse's face with a damp cloth or sponge.

 + +

Feed grubs to the crickets.

Check the spider's location.

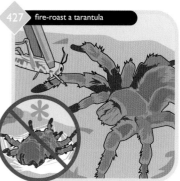

427 fire-roast a tarantula

Offer one cricket at a time.

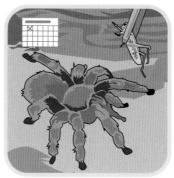

Remove all uneaten crickets.

 Has your tarantula flipped over on his back and spun a web? If so, he's molting, and shouldn't be touched or fed until his molt is complete—otherwise, he might cut himself on his shell. He may look fierce, but he's awfully sensitive!

284 determine a box turtle's gender

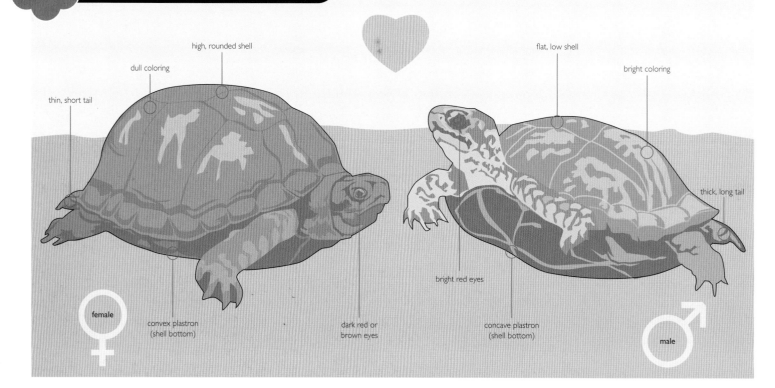

high, rounded shell

dull coloring

thin, short tail

female

convex plastron
(shell bottom)

dark red or
brown eyes

flat, low shell

bright coloring

thick, long tail

bright red eyes

concave plastron
(shell bottom)

male

give a parrot a bath 285

Choose a warm, bright time.

Spray mist above the parrot.

If he flaps his wings, he likes it.

Let him air-dry and preen himself.

 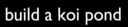

build a koi pond 286

Stake out the desired shape.

Dig a hole with terraces.

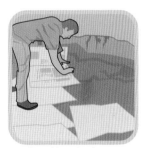

Line with sand and paper.

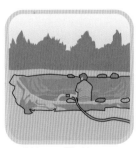

Add a tarp. Fill with water.

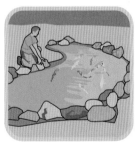

Edge with rocks. Add fish!

hug a hedgehog 287

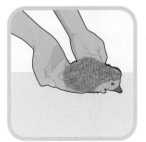

Scoop from behind.

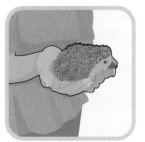

Cup in your hands.

pick up a rabbit 288

snare a hare 429

Pick up by the bottom.

Carry close to your chest.

289 brush a pup's teeth

Approach when relaxed.

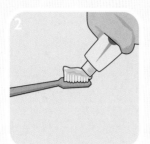

Use special dog toothpaste.

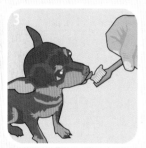

Let him taste it.

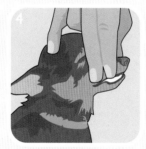

Lift the mouth open.

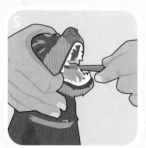

Brush the upper back teeth.

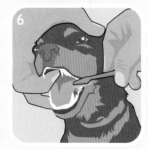

Brush the lower back teeth.

Check for signs of illness.

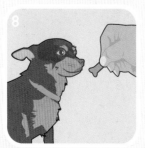

Reward with treats and praise.

290 read a dog's body language

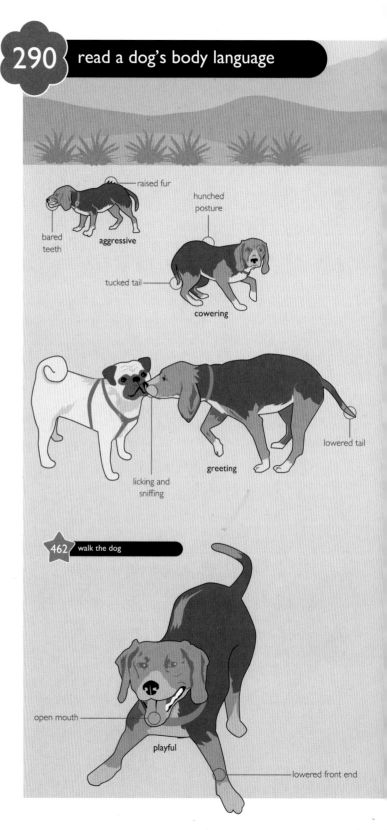

raised fur

hunched posture

bared teeth

aggressive

tucked tail

cowering

licking and sniffing

greeting

lowered tail

462 walk the dog

open mouth

playful

lowered front end

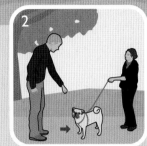

1. May I pet your dog?

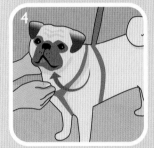

2. Approach slowly from the front.

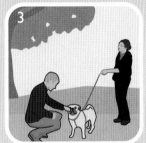

3. Let the dog smell your fist.

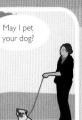

4. Stroke under the chin first.

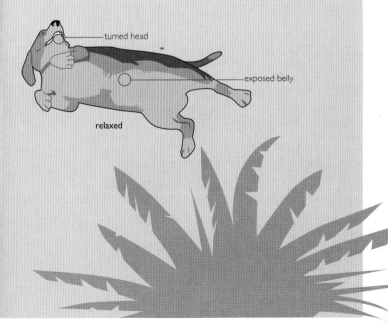

turned head

exposed belly

relaxed

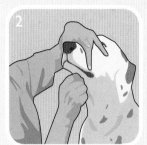

1. Start with a happy dog.

2. Hold the muzzle.

3. Pry open the mouth.

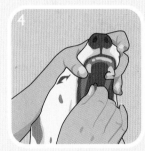

4.

5. Close the jaw; rub the throat.

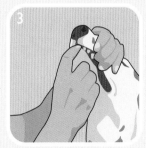

6. Don't forget the reward!

Fit two fingers between the dog's collar and skin.

A breakaway clasp prevents strangulation.

Put your pooch's name and your contact info on a reflective tag.

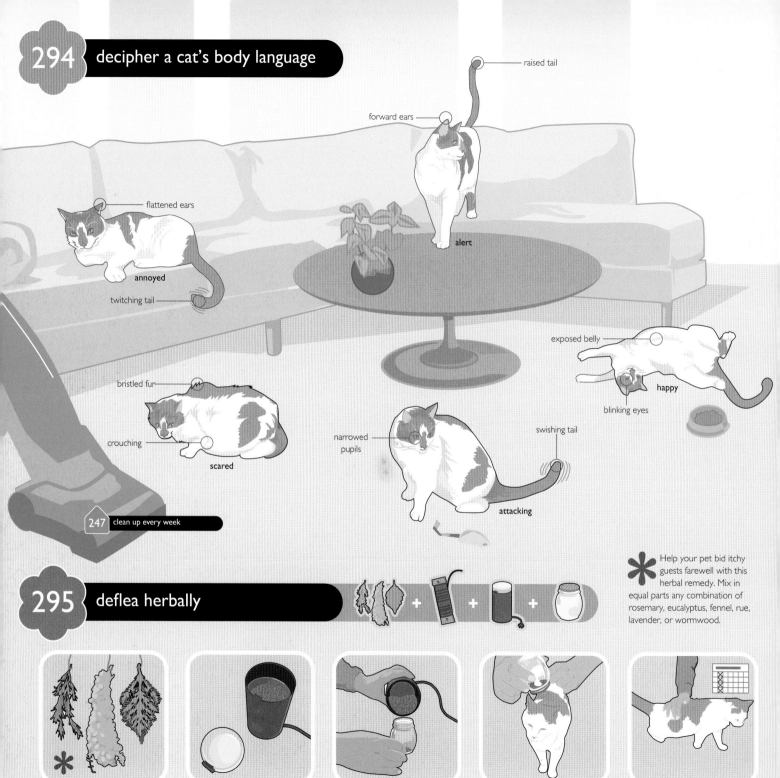

294 decipher a cat's body language

raised tail

forward ears

alert

flattened ears

annoyed

twitching tail

exposed belly

happy

blinking eyes

bristled fur

crouching

scared

narrowed pupils

swishing tail

attacking

247 clean up every week

295 deflea herbally

Help your pet bid itchy guests farewell with this herbal remedy. Mix in equal parts any combination of rosemary, eucalyptus, fennel, rue, lavender, or wormwood.

Hang the herbs to dry.

Grind the herbs finely.

Rub into the fur.

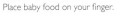

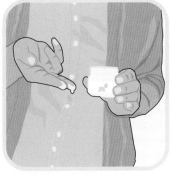
Place baby food on your finger.

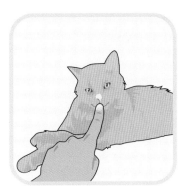

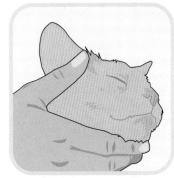
Let him get a good taste.

Once he's won over, pet him.

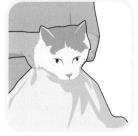
A towel prevents scratches.

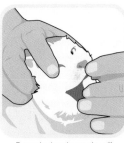
Press the jaw; insert the pill.

Rub until she swallows it.

Don't forget a treat!

bandage a nasty wound **338**

Start with a relaxed cat.

Press to extend the claws.

Hold the clippers vertically.

90°
Cut away from the quick.

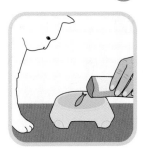
Reward a patient kitty.

299 bathe a baby

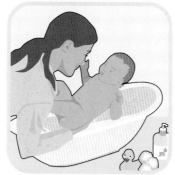

95°F (35°C)

2–3 in (5–8 cm)

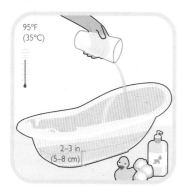

Be sure to support the baby's head.

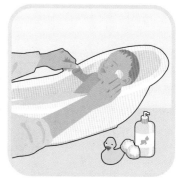

95°F (35°C)

Prevent chills with warm water.

Wash the face with a cotton ball.

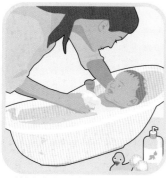

Wash the baby's front, top to bottom.

 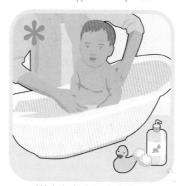

Wash the back, top to bottom.

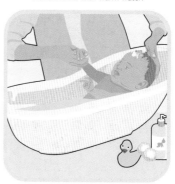

Gently suds the scalp.

Pat dry. Wrap in a towel.

Be sure to have a hand on your baby at all times while he's splashing around in the tub. This prevents him from slipping underwater—and it makes him feel safe. Likewise, never leave him alone in the tub. Keep all supplies within arm's reach.

300 cook up yummy baby food

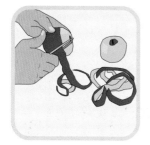

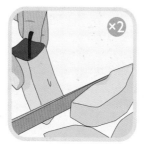

×2

1–2 tbsp water

30 min

Add the apples and water; simmer.

Mash until smooth; let cool.

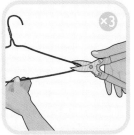

Remove the horizontal bar.

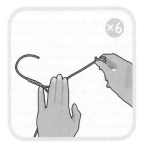

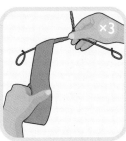

Trim any excess.

Arrange the three hangers.

Tape together.

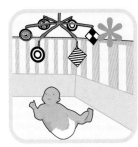

Glue to card; tie to cables.

Hang out of reach.

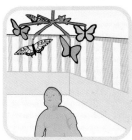

Update with bright shapes.

Mobiles are so fascinating—babies can't help reaching up for them! To prevent the decorations from becoming choking hazards, use cable ties or other sturdy fasteners under 1½ ft (45 cm) in length to secure the dangling objects well out of your baby's reach. As she grows and her eyes start to pick up on color differences, swap the black-and-white objects for more brightly colored and whimsical decorations. Take it down, however, as soon as she can push up on her hands or knees.

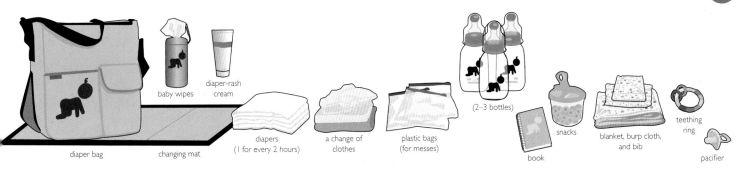

diaper bag

changing mat

baby wipes

diaper-rash cream

diapers
(1 for every 2 hours)

a change of clothes

plastic bags
(for messes)

(2–3 bottles)

book

snacks

blanket, burp cloth, and bib

teething ring

pacifier

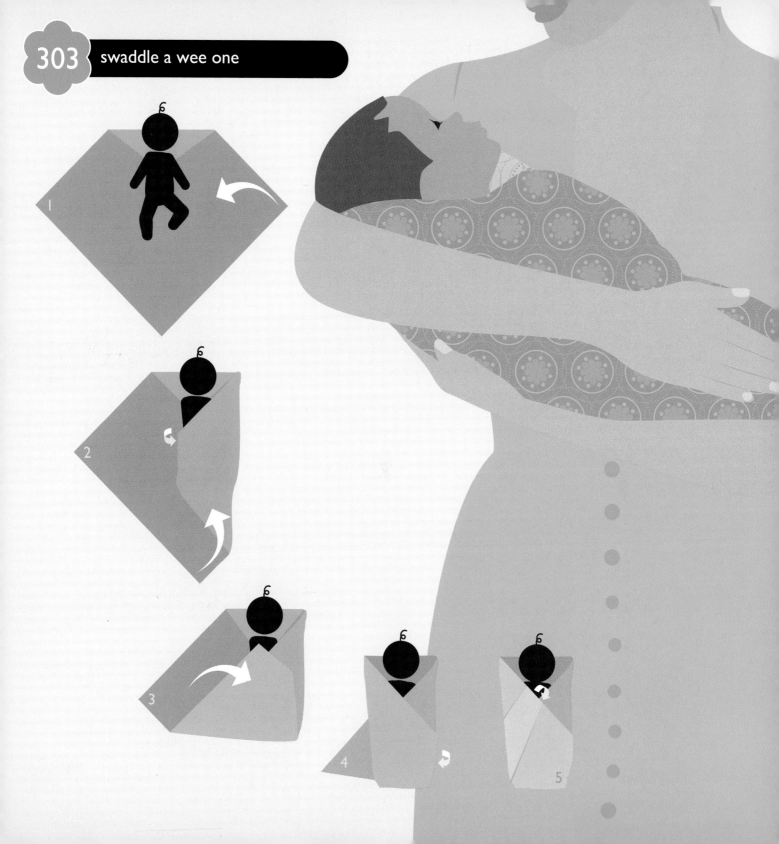

burp a baby 304

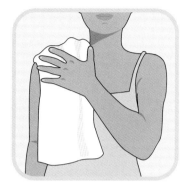 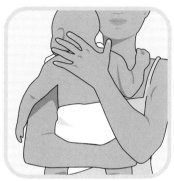 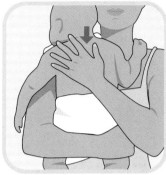 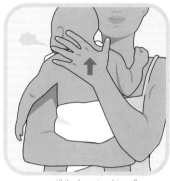

Pat the baby's back . . .

. . . until the burp is achieved!

massage a colicky baby 305

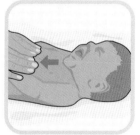 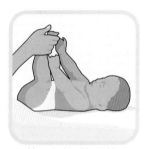 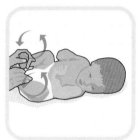 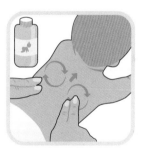 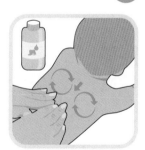

Stroke the baby's abdomen.

Move the legs side to side.

Cycle those legs!

diaper a tiny tot 306

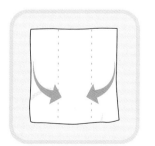 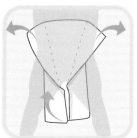 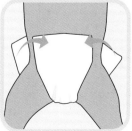 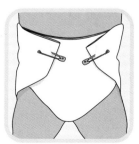

Place the baby; fold.

307 teach a kid to ride a bike

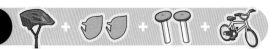

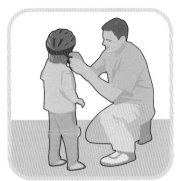

Suit her up in protective gear.

Raise the training wheels each week.

Remove them when she's ready.

384 patch a blown-out bike tire

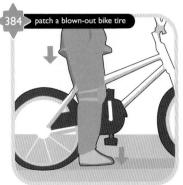

Adjust until her feet touch the ground.

Find an open, sloping grassy area.

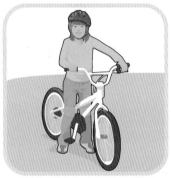

Walk while balancing on the saddle.

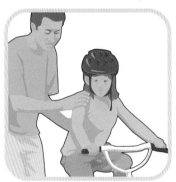

Support her shoulders.

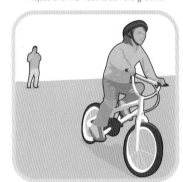

308 banish imaginary monsters

Big, hairy, and . . .

Listen to her fears.

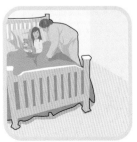

Tuck her into her own bed.

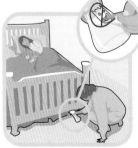

Spray "monster repellent."

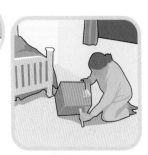

Set up a trap.

zZz

Turn on a night-light.

 + + +

Isolate the gum.

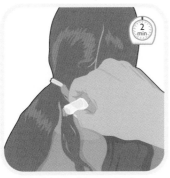

Apply ice until the gum breaks.

Comb out the pieces.

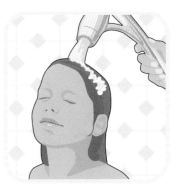

 + + + + ⬭

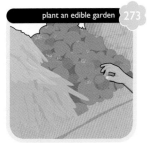

plant an edible garden 273

Select vegetables together.

Prepare them as a team.

Serve veggies first.

Let him see you eat them.

Make a goofy design.

serve a banana-octopus snack 311

Cut eight "tentacles."

Make slits for eyes.

Insert raisins into the slits.

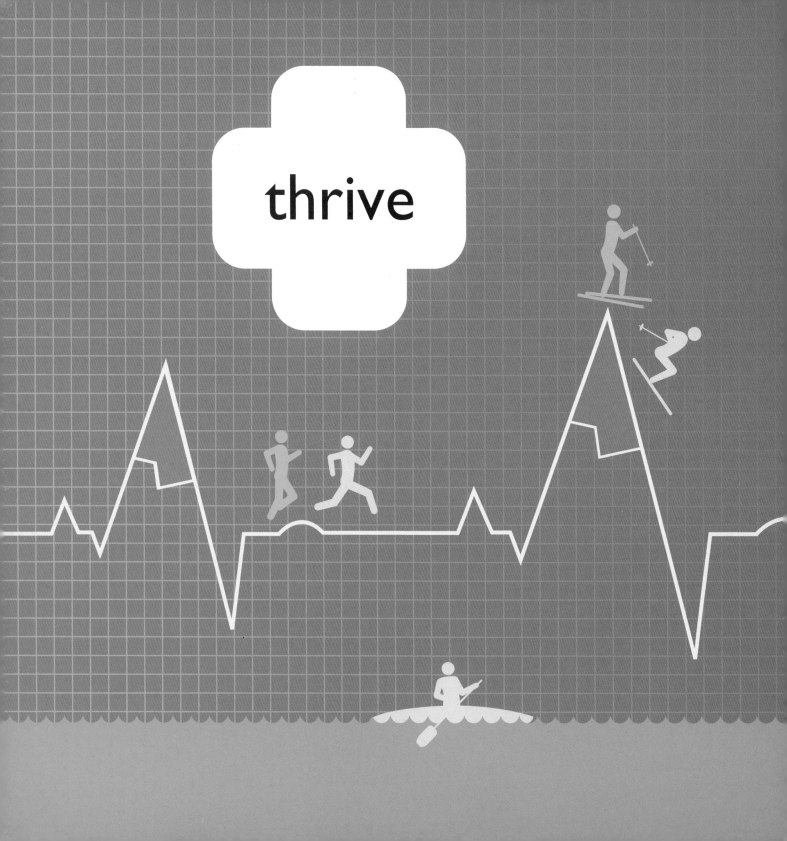

thrive

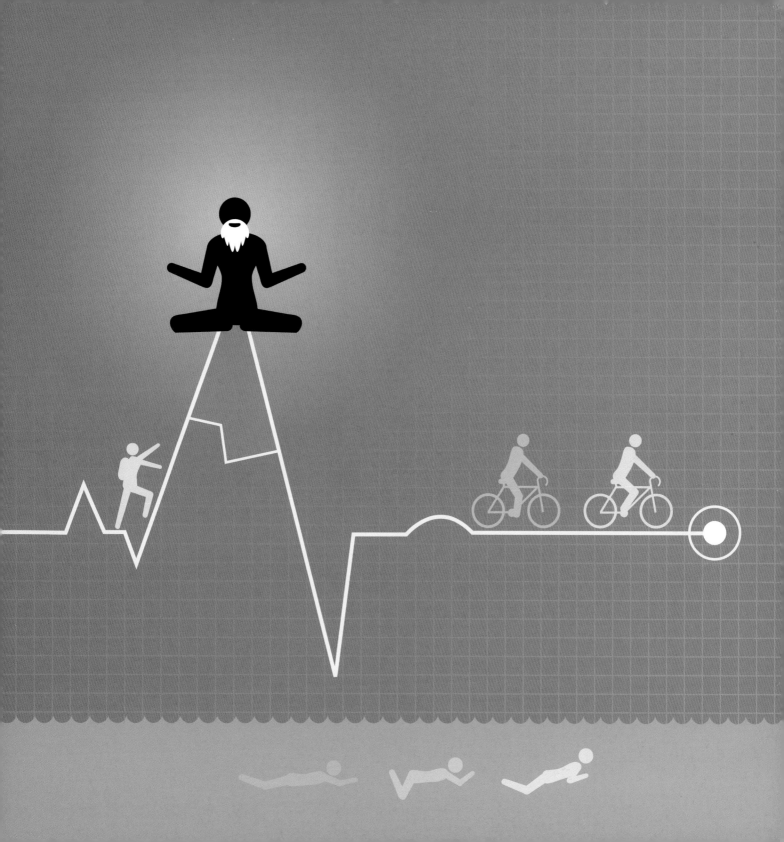

club type		average distance	
driver		150–200 yd (140–180 m)	200–260 yd (180–240 m)
3-wood		125–180 yd (115–165 m)	180–235 yd (165–215 m)
5-wood		105–170 yd (95–155 m)	170–210 yd (155–190 m)
2-iron		105–170 yd (95–155 m)	170–210 yd (155–190 m)
3-iron		100–160 yd (90–145 m)	160–200 yd (145–180 m)
4-iron		90–150 yd (80–135 m)	150–185 yd (135–170 m)
5-iron		80–140 yd (75–130 m)	140–170 yd (130–155 m)
6-iron		70–130 yd (65–120 m)	130–160 yd (120–145 m)
7-iron		65–120 yd (60–110 m)	120–150 yd (110–135 m)
8-iron		60–110 yd (55–100 m)	110–140 yd (100–130 m)
9-iron		55–95 yd (50–85 m)	95–130 yd (85–120 m)
pitching wedge		50–80 yd (45–75 m)	80–120 yd (75–110 m)
sand wedge		40–60 yd (35–55 m)	60–100 yd (55–90 m)

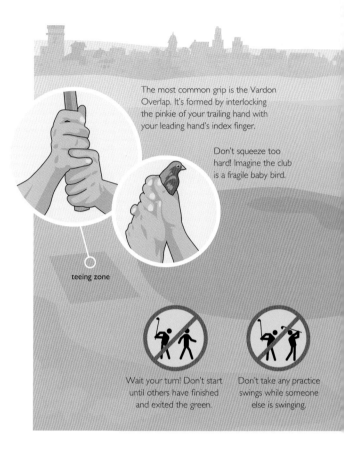

The most common grip is the Vardon Overlap. It's formed by interlocking the pinkie of your trailing hand with your leading hand's index finger.

Don't squeeze too hard! Imagine the club is a fragile baby bird.

teeing zone

Wait your turn! Don't start until others have finished and exited the green.

Don't take any practice swings while someone else is swinging.

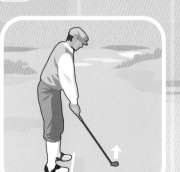

Stand parallel to the line of flight.

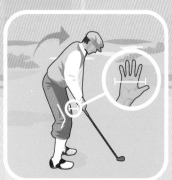

Lean forward; bend your knees.

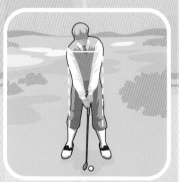

Keep your feet at shoulders' width.

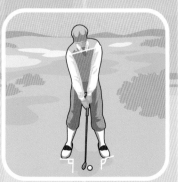

Lift your left shoulder; angle your feet.

 + + +

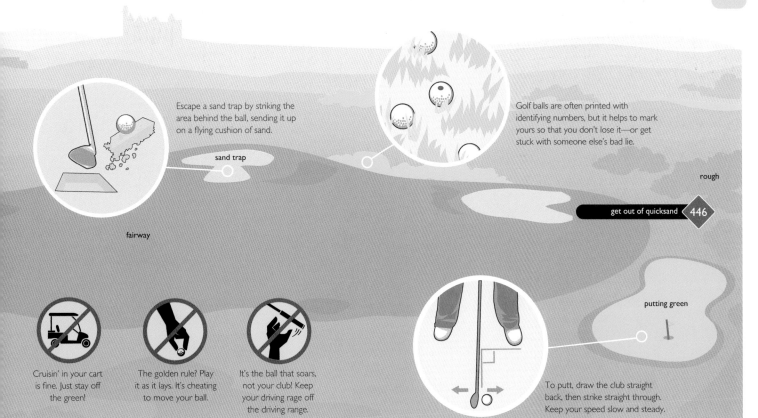

Escape a sand trap by striking the area behind the ball, sending it up on a flying cushion of sand.

sand trap

Golf balls are often printed with identifying numbers, but it helps to mark yours so that you don't lose it—or get stuck with someone else's bad lie.

rough

get out of quicksand 446

fairway

Cruisin' in your cart is fine. Just stay off the green!

The golden rule? Play it as it lays. It's cheating to move your ball.

It's the ball that soars, not your club! Keep your driving rage off the driving range.

putting green

To putt, draw the club straight back, then strike straight through. Keep your speed slow and steady.

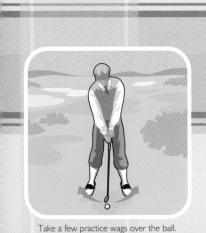

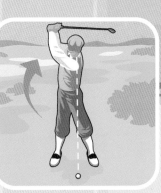

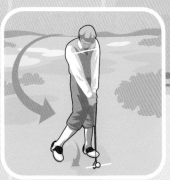

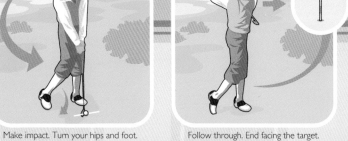

Take a few practice wags over the ball.

Swing from the hips; focus on the ball.

Make impact. Turn your hips and foot.

Follow through. End facing the target.

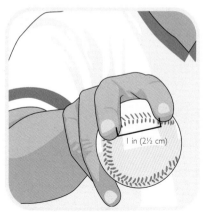

Index and middle fingers go on the seam.

Conceal your pitch grip.

Shift to your right foot; angle your left.

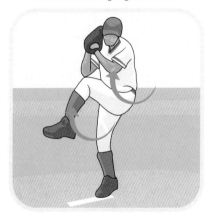

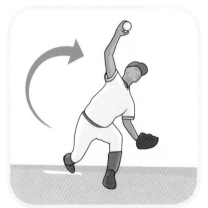

Release with your fingers over the ball.

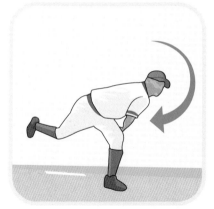

Stand at the free-throw line.

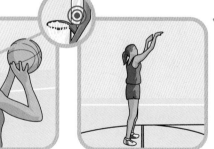

Focus on the backboard.

Straighten; flick your wrists.

460 spin a basketball on my finger

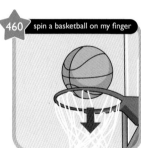

Swish!

Stand behind the baseline.

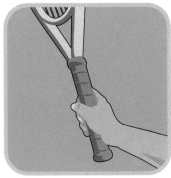
Grasp in a continental grip.

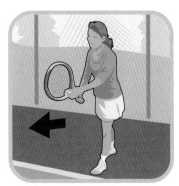
Point your racquet at the target.

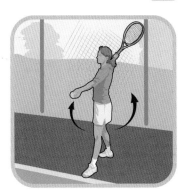

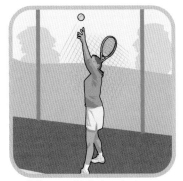
Shift your weight backward; release.

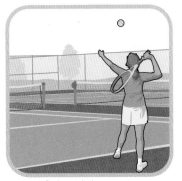
Backscratch the racquet.

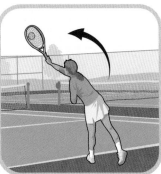
Straighten. Hit at the highest point.

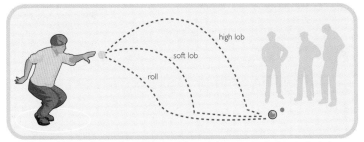
high lob

soft lob

roll

Pick a lobbing technique. Stay within the circle, and place your boule close to the jack.

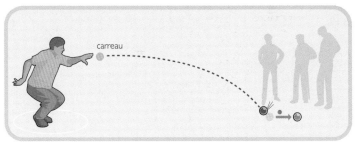
carreau

Throw a carreau to knock a rival's boule away from the jack.

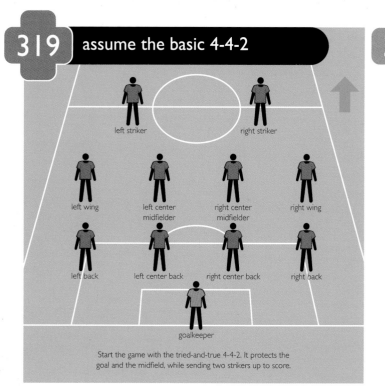

319 assume the basic 4-4-2

left striker · right striker

left wing · left center midfielder · right center midfielder · right wing

left back · left center back · right center back · right back

goalkeeper

Start the game with the tried-and-true 4-4-2. It protects the goal and the midfield, while sending two strikers up to score.

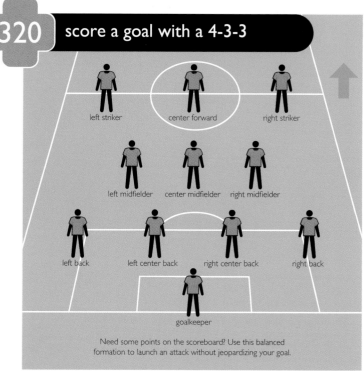

320 score a goal with a 4-3-3

left striker · center forward · right striker

left midfielder · center midfielder · right midfielder

left back · left center back · right center back · right back

goalkeeper

Need some points on the scoreboard? Use this balanced formation to launch an attack without jeopardizing your goal.

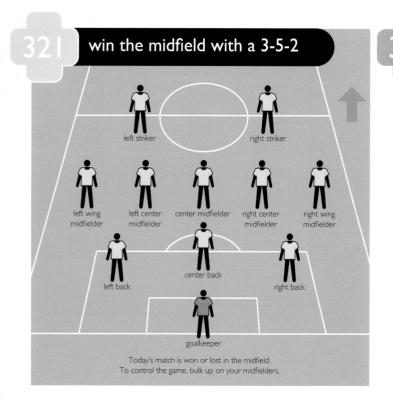

321 win the midfield with a 3-5-2

left striker · right striker

left wing midfielder · left center midfielder · center midfielder · right center midfielder · right wing midfielder

left back · center back · right back

goalkeeper

Today's match is won or lost in the midfield. To control the game, bulk up on your midfielders.

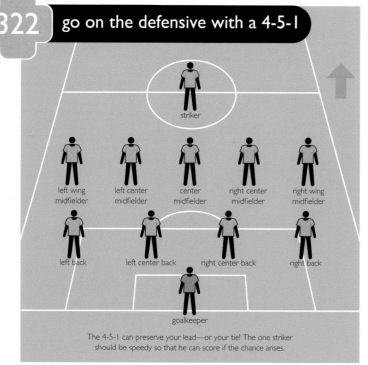

322 go on the defensive with a 4-5-1

striker

left wing midfielder · left center midfielder · center midfielder · right center midfielder · right wing midfielder

left back · left center back · right center back · right back

goalkeeper

The 4-5-1 can preserve your lead—or your tie! The one striker should be speedy so that he can score if the chance arises.

Headbutting is a notorious red-card offense.

Watch your mouth! Cursing and other rude conduct will get you a yellow card.

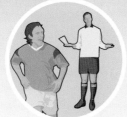

Exit or enter the field without the ref's approval and you'll get a yellow card.

Careful there, hot shot! Two yellow cards equal a red card, which puts you out of the game.

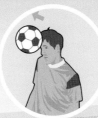

Hit squarely.

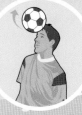

Hit the lower part of the ball to send it up.

Spit on someone and you'll end up with a red card—and on the bench.

Bend from the waist. Keep your mouth closed.

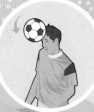

Hit the upper part of the ball to send it down.

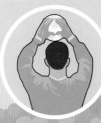

Make a diamond with your hands.

Assume the basic goalkeeper position.

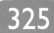

Dive to make the catch.

Pull to your chest.

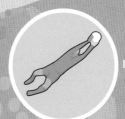

Hug the ball to your chest.

Cover the ball.

326 understand my vitamins

Remember your mom's advice—take your vitamins! Let this cheat sheet help you select the vitamin-rich foods that your body systems need, and learn how much of each vitamin you and your family require on a daily basis.

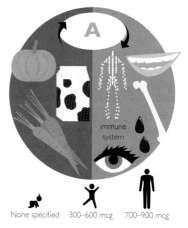

A
immune system

None specified | 300–600 mcg | 700–900 mcg

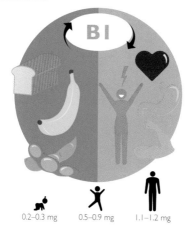

B1

0.2–0.3 mg | 0.5–0.9 mg | 1.1–1.2 mg

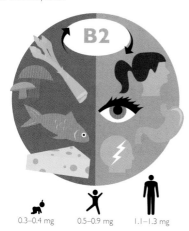

B2

0.3–0.4 mg | 0.5–0.9 mg | 1.1–1.3 mg

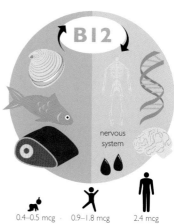

B12
nervous system

0.4–0.5 mcg | 0.9–1.8 mcg | 2.4 mcg

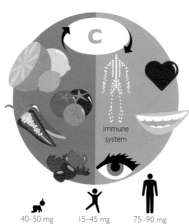

C
immune system

40–50 mg | 15–45 mg | 75–90 mg

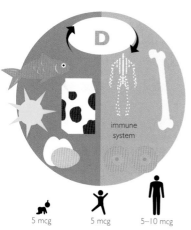

D
immune system

5 mcg | 5 mcg | 5–10 mcg

327 pick a calorie-burning activity

Did you know that you're always burning calories—even while you sleep? Check out how many calories the average person (175 lbs/80 kg) burns while participating in the following activities for one hour.

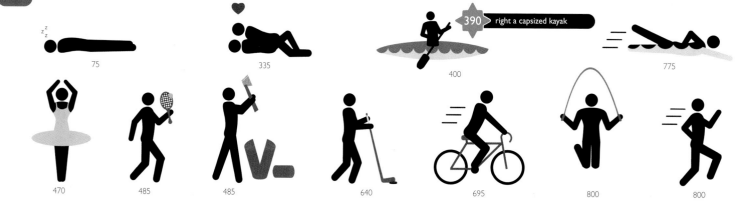

75

335

390 › right a capsized kayak

400

775

470

485

485

640

695

800

800

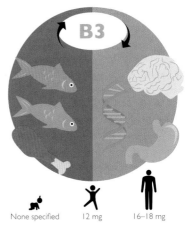

B3

None specified — 12 mg — 16–18 mg

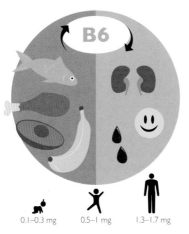

B6

0.1–0.3 mg — 0.5–1 mg — 1.3–1.7 mg

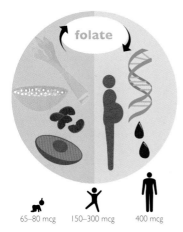

folate

65–80 mcg — 150–300 mcg — 400 mcg

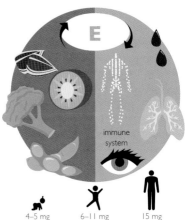

E

immune system

4–5 mg — 6–11 mg — 15 mg

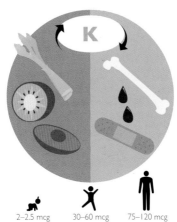

K

2–2.5 mcg — 30–60 mcg — 75–120 mcg

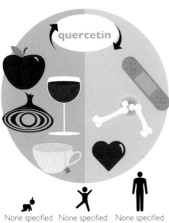

quercetin

None specified — None specified — None specified

What does a serving size look like, exactly? Try envisioning a steak as a deck of cards, or a potato as a computer mouse—that's a serving size! Use these handy visualizations and daily recommendations to eat a balanced diet.

6–11 grain servings per day

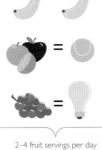

3–5 vegetable servings per day

2–4 fruit servings per day

craft a playing-card wallet 24

2–3 protein servings per day

2–3 dairy servings per day

Soothe life's minor aches and pains with this traditional Chinese treatment. First, locate the point that corresponds to your discomfort, then press the area with your thumb or elbow. The pressure will stimulate your organs and enhance energy and blood flow throughout your body, resulting in a wave of relief.

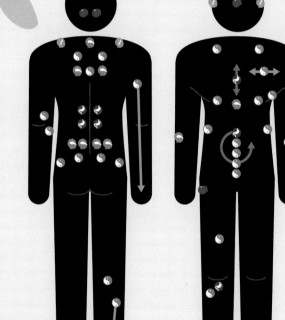

palm

back

sole

top

back

front

general well-being

headache

insomnia

allergies and sinus

indigestion

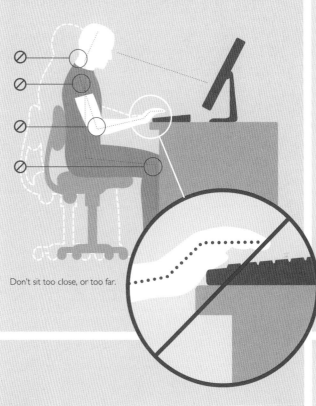

Don't sit too close, or too far.

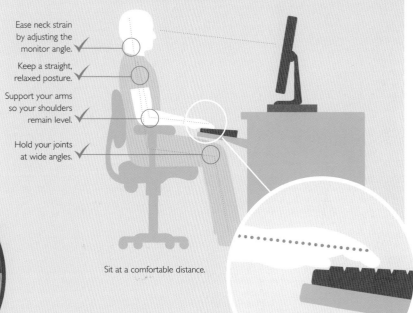

Ease neck strain by adjusting the monitor angle.

Keep a straight, relaxed posture.

Support your arms so your shoulders remain level.

Hold your joints at wide angles.

Sit at a comfortable distance.

A low keyboard aligns the arm and hand, preventing wrist strain.

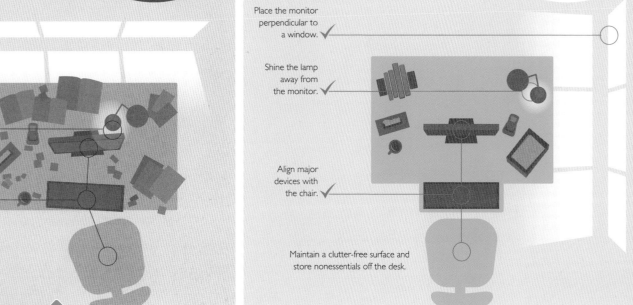

Place the monitor perpendicular to a window.

Shine the lamp away from the monitor.

Align major devices with the chair.

Maintain a clutter-free surface and store nonessentials off the desk.

organize using feng shui 250

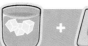 + + +

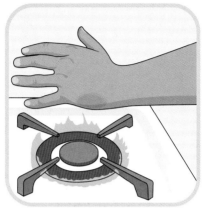
Remove from the burn source.

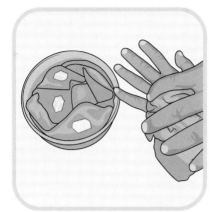
Soak cloths in ice water; apply.

If it turns white, it's a first-degree burn.

Apply antibiotic ointment.

Cover with a bandage.

Monitor for discoloration.

332 stop a nosebleed

Apply intermittent pressure.

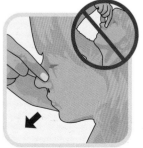
Lean forward.

A cloth catches blood.

Moisturize the nostril.

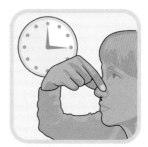
If bleeding persists, get help.

Quickly remove the stinger.

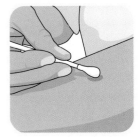

Clean with rubbing alcohol.

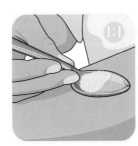

Add baking soda and water.

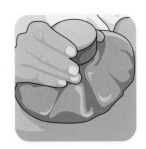

Monitor for hives.

pull out a splinter 334

Gently wash the site.

Squeeze around the splinter.

Sanitize with rubbing alcohol.

Enlarge the hole.

remove an object from my eye 335

Wash your hands first.

Swab; remove the object.

Lie down; flush with saline.

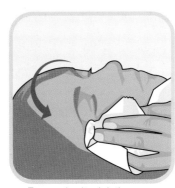

Turn your head to drain the excess.

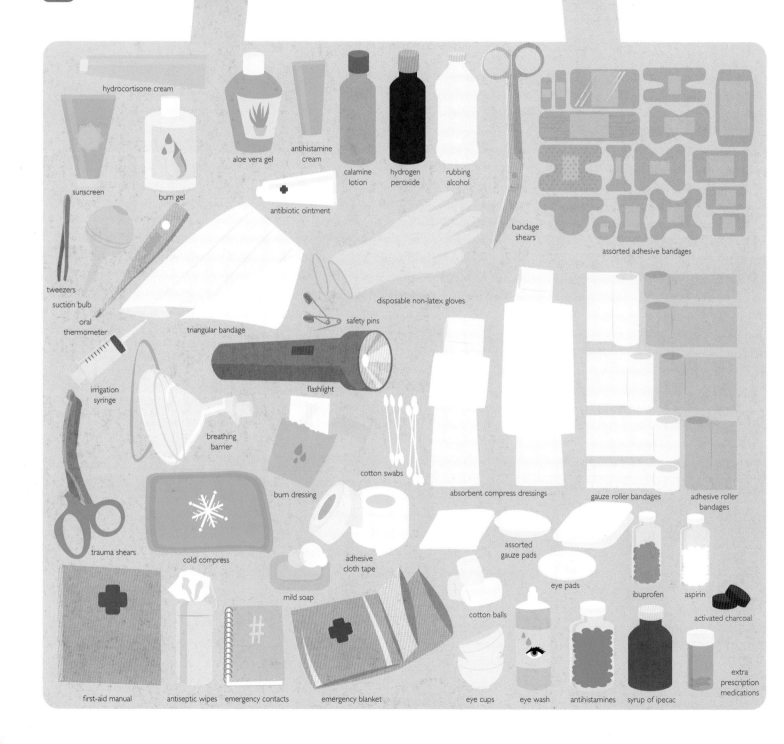

hydrocortisone cream

aloe vera gel

antihistamine cream

calamine lotion

hydrogen peroxide

rubbing alcohol

sunscreen

burn gel

antibiotic ointment

bandage shears

assorted adhesive bandages

tweezers

suction bulb

oral thermometer

triangular bandage

disposable non-latex gloves

safety pins

irrigation syringe

flashlight

breathing barrier

cotton swabs

absorbent compress dressings

gauze roller bandages

adhesive roller bandages

burn dressing

trauma shears

cold compress

adhesive cloth tape

assorted gauze pads

eye pads

ibuprofen

aspirin

activated charcoal

mild soap

cotton balls

first-aid manual

antiseptic wipes

emergency contacts

emergency blanket

eye cups

eye wash

antihistamines

syrup of ipecac

extra prescription medications

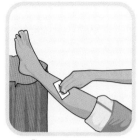

Elevate. Apply pressure.

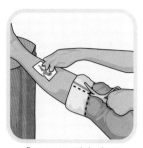

Remove constricting items.

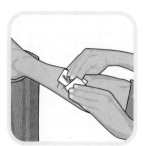

Layer additional gauze.

Find a pressure point.

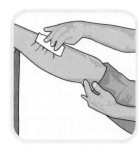

Pressure slows the bleeding.

 If the wound is so deep that you see yellow fatty tissue, or if it's hard to pinch closed, it needs stitches.

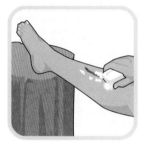

Elevate. Wash the site.

Check if it needs stitches.

Apply antibiotic ointment.

Cover with a bandage.

Add a waterproof covering.

 Use a tourniquet only when bleeding is severe. If the wound is just below a joint, knot above or close to the joint.

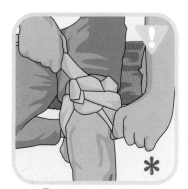

Tie a knot above the injury.

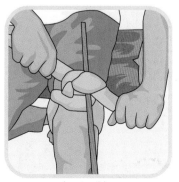

Insert a stick.

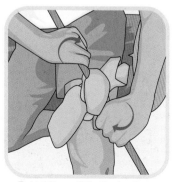

Twist; tighten until the bleeding stops.

9-1-1

340 perform cpr

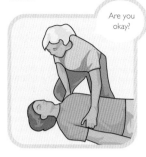

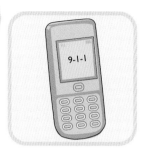

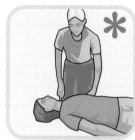
Listen for breathing.

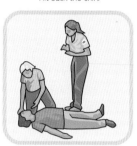
Briefly feel for a pulse.

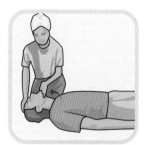
Tilt back the chin.

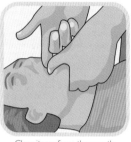
Clear items from the mouth.

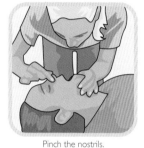
Pinch the nostrils.

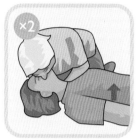
Breathe for the victim.

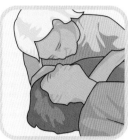
Pump on the breastbone.

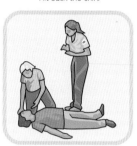
Repeat until help arrives.

 Expediency is key! Don't spend much time checking for a pulse. Likewise, while rescue breathing saves lives, some experts think that chest compressions are the most crucial element in CPR. So if the victim is suffering from cardiac arrest, or if you can't administer rescue breathing, start with chest compressions.

341 save a choking victim

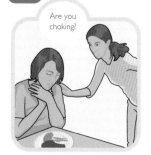

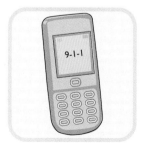

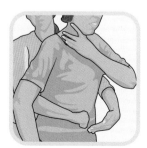
Strike the back.

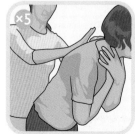
Place the fist below the ribs.

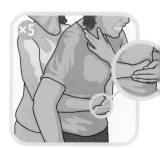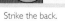
Give abdominal thrusts.

Remove the shoe and sock.

Position a folded mat.

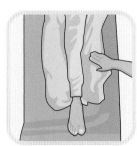

Pad behind the knee.

Pad on either side.

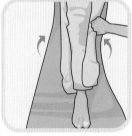

Gather around the leg.

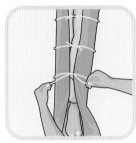

Secure with several knots.

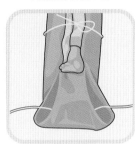

Pull rope through the fold.

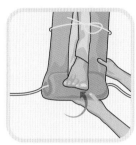

Roll up the excess.

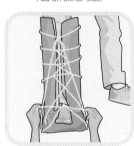

Crisscross; tie off.

 If you're alone and can't knot the sling, simply remove and tie it. Then slip it over your head and gently ease your arm back into place.

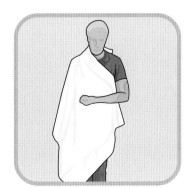

Place folded fabric under the arm.

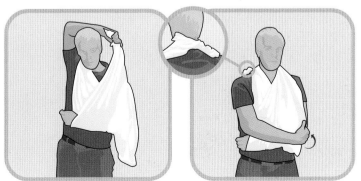

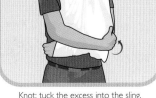

Loop the fabric around the neck.

Knot; tuck the excess into the sling.

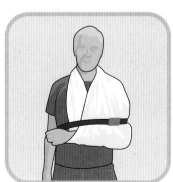

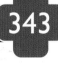

Secure to prevent movement.

Stop that taxi!

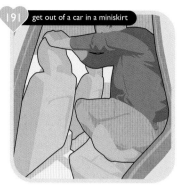

|91| get out of a car in a miniskirt

Crouch. Let gravity do its work.

Gently catch the baby.

Wipe the baby's face.

 As the baby's head crests, check that the umbilical cord isn't wrapped around the neck, posing a strangulation hazard. If it has, gently slip your index finger between the neck and the cord, then slide the cord over the baby's head. If the placenta happens to come out, wrap it in a towel and take it with you to the hospital.

 The best time to perform a breast exam is a few days after your period ends, and many women choose to do so right after a shower or bath. What are you feeling for, exactly? Anything at all—seriously! If you notice any change in the way your breasts look or feel, make an appointment with your doctor. You know the adage—better safe than sorry!

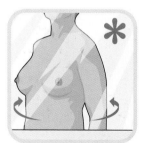

Rotate, looking for changes.

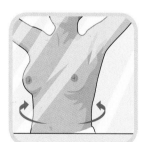

Raise your arms and repeat.

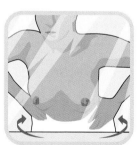

Bend over and repeat.

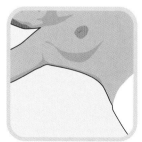

Lie down. Raise your arm.

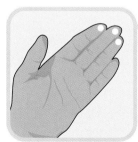

Use the pads of three fingers.

Vary pressure as you feel.

Cover the entire breast.

Inspect the nipple.

Feel the lymph nodes.

Repeat on the other breast.

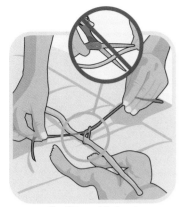
Tie off the umbilical cord.

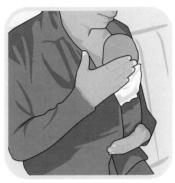
To keep warm, hold the baby close.

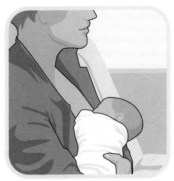
Begin breast-feeding, if possible.

Hurry to the hospital.

breast-feed an infant `346`

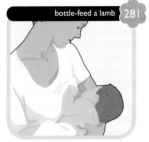
bottle-feed a lamb `281`
Hold the baby, belly to belly.

Slightly pinch the breast.

Place the nipple on the lips.

Slide the lower jaw down.

Tilt the baby's head forward.

save a choking baby `347`

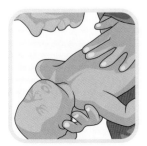
Listen for breathing.

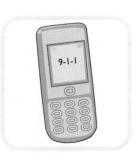
9-1-1

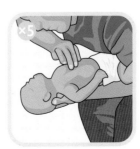
Strike the back.

Press the sternum.

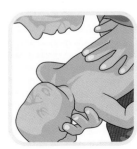
Check for breathing. Repeat.

singing bowl and stick

photo of a beautiful vista

mandala

plant

Surround yourself with soothing, spiritual items, then sit comfortably. Relax and let your inhalations and exhalations roll through you. If thoughts occur to you, simply acknowledge them, and return your attention to your breath.

If a sound distracts you, mentally label it a "noise" and return to the breath . . .

candle

If you feel worry, frustration, or any other emotion (even a positive one), think "emotion" to yourself and return to the breath . . .

photo of a loved one

If you catch yourself planning or mulling over an issue, say "thought" to yourself and return to the breath . . .

If you experience an itch, cramp, or tingle, think "physical sensation" and return to the breath . . .

leaf

As your practice advances, gradually increase the length of your meditation sessions.

prayer beads

beginner

practitioner

intermediate

advanced

adept

true master

nearly to nirvana

crystal music flower incense

Shower before entering the sauna.

Add water to the hot coals.

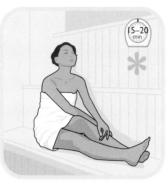

Bask, luxuriating in the heat.

Brush your skin with the wet whisk.

save a hypothermia victim 441

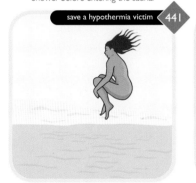

Take an exhilarating dip.

Stay hydrated!

Repeat the cycle until satisfied.

Shower when finished.

 True Fins go au naturel in the sauna, indulging in a head-to-toe cleansing ritual that leaves no pore unopened. If hanging out in the buff makes you shy, wrap up in a towel—just remove it before delighting in a few whips of the damp birch whisk, called a vihta. The whisk's leaves invigorate your skin, while its fresh smell revitalizes.

 pamper with a hot-stone massage 350

skip a stone across water 461

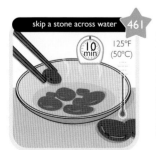

125°F (50°C)

Massage your limbs.

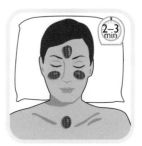

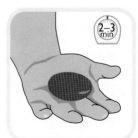

Rest a stone in each palm.

351 heal with reiki

Ask your ego to step aside.

Channel the universe.

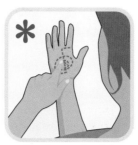
Trace the correct symbol.

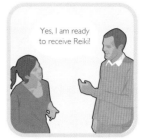
Yes, I am ready to receive Reiki!

Position yourselves.

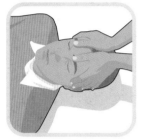
Scan the chakra for needs.

Focus on a target area.

Soothed spots tingle with warmth.

Treat all needy spots.

Relax. Discuss the effects.

 Melt away pain with this Japanese technique, which uses energy transfer from one person to another to heal. Before a session, a Reiki master traces symbols on her palm or patient.

 cho ku ray This symbol increases and focuses energy.

 sei hei ki This emblem treats emotional imbalances.

 hon sha ze sho nen This symbol sends energy to far-away people.

352 do a simple tai chi move

 Mimic the graceful, fluid motions of the clouds with this meditative tai chi move, called "wave hands like clouds." As your hands circle, imagine that you are rotating them around a ball of energy. Repeat steps three through five three times to complete the sequence.

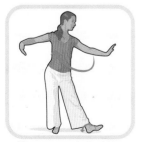
Move your arm to the right.

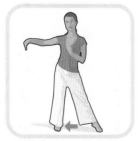
Shift. Open your right hand.

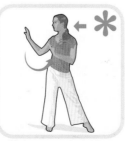
Circle your arms; look right.

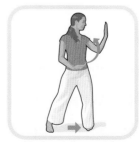
Continue circling; turn left.

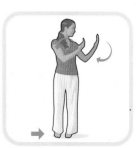
Step together.

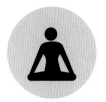

sukasana
(easy)

upavistha konasana
(seated wide-legged straddle)

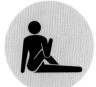

ardha matsyendrasana
(half twist)

for beginners

for beginners and
pregnant women

for beginners
and children

for intermediate
practitioners

svanasana
(table)

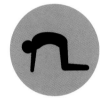

marjariasana
(cat)

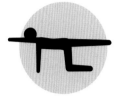

bitilasana
(cow)

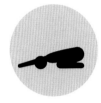

chakravakasana
(sunbird)

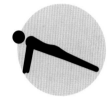

garbhasana
(child)

phalahakasana
(plank)

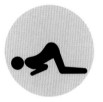

astang pranam
(caterpillar)

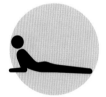

bhujangasana
(modified cobra)

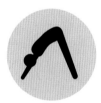

adho mukha svanasana
(downward dog)

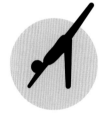

ardha adho mukha shvanasana
(half downward dog)

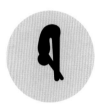

uttanasana
(standing forward bend)

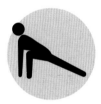

utthita ashwa sanchalanasana
(high lunge)

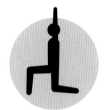

ardha virabhadrasana
(low warrior)

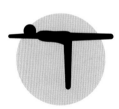

virabhadrasana III
(warrior III)

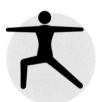

virabhadrasana II
(warrior II)

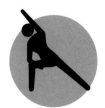

parsvakonasana
(modified side angle)

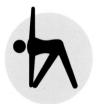

trikonasana
(triangle)

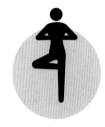

vrksasana
(tree)

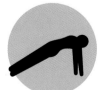

purvottanasana
(inclined plane)

dhanurasana
(bow)

ustrasana
(camel)

ardha sarvangasana
(half shoulder stand)

halasana
(plough)

shavasana
(modified corpse)

354 train to run long distance

Lace up those running shoes! To boost your endurance, alternate a few minutes of jogging and walking, each week jogging a little more. Rest a few days between workouts.

walk jog

	day 1	day 2	day 3
week 1	1min 1½min ×8 Total = 20 min	1min 1½min ×8 Total = 20 min	1min 1½min ×8 Total = 20 min
week 2	1½ 2 ×6 Total = 21 min	1½ 2 ×6 Total = 21 min	1½ 2 ×6 Total = 21 min
week 3	1½ 3 / 1½ 3 ×2 Total = 18 min	1½ 3 / 1½ 3 ×2 Total = 18 min	1½ 3 / 1½ 3 ×2 Total = 18 min
week 4	3 5 3 5 1½ 2½ 1½ Total = 21½ min	3 5 3 5 1½ 2½ 1½ Total = 21½ min	3 5 3 5 1½ 2½ 1½ Total = 21½ min
week 5	5 5 5 3 3 Total = 21 min	8 8 5 Total = 21 min	21 Total = 21 min
week 6	5 8 5 3 3 Total = 24 min	10 10 3 Total = 23 min	25 Total = 25 min
week 7	25 Total = 25 min	25 Total = 25 min	28 Total = 28 min
week 8	28 Total = 28 min	28 Total = 28 min	30 Total = 30 min
week 9	30 Total = 30 min	30 Total = 30 min	30 Total = 30 min

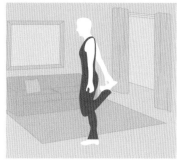

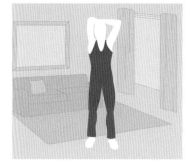

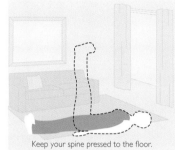

Keep your spine pressed to the floor.

Wrap a towel around your foot and pull.

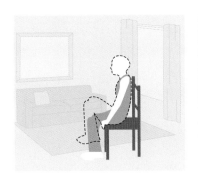
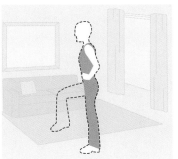

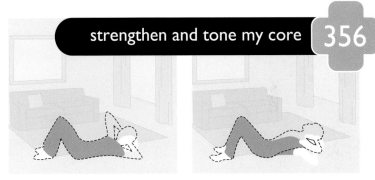

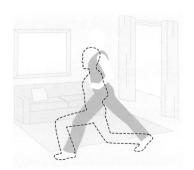

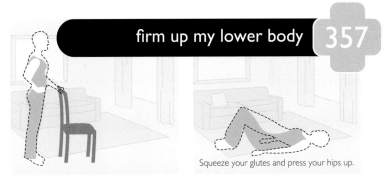

Squeeze your glutes and press your hips up.

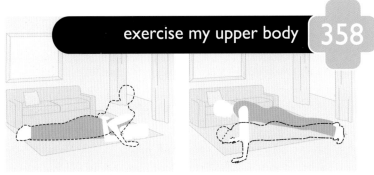

359 do the front crawl

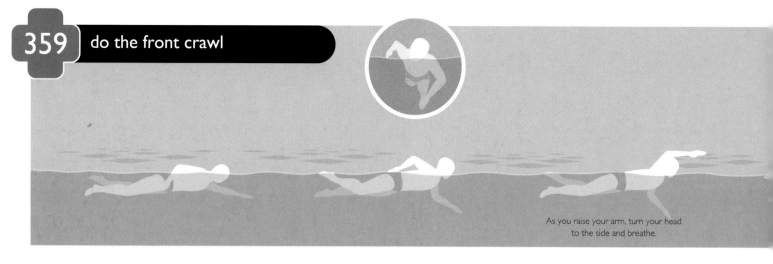

As you raise your arm, turn your head to the side and breathe.

360 paddle the backstroke

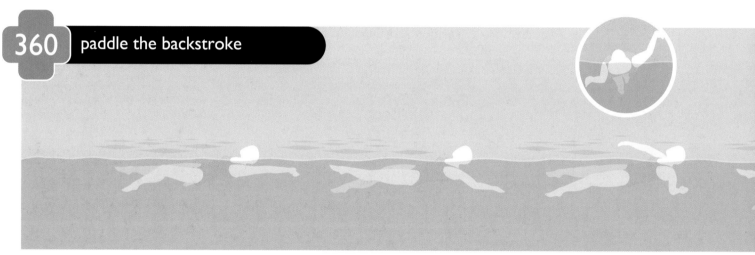

361 swim the breaststroke

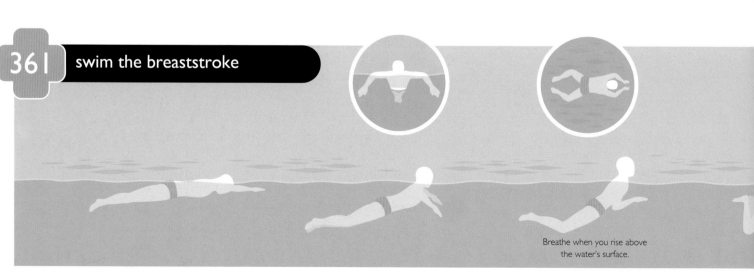

Breathe when you rise above the water's surface.

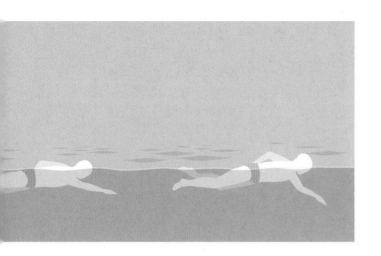

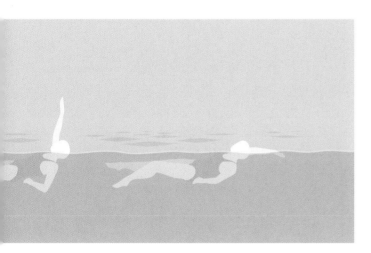

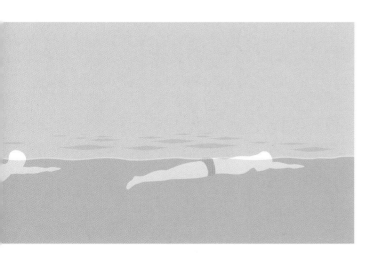

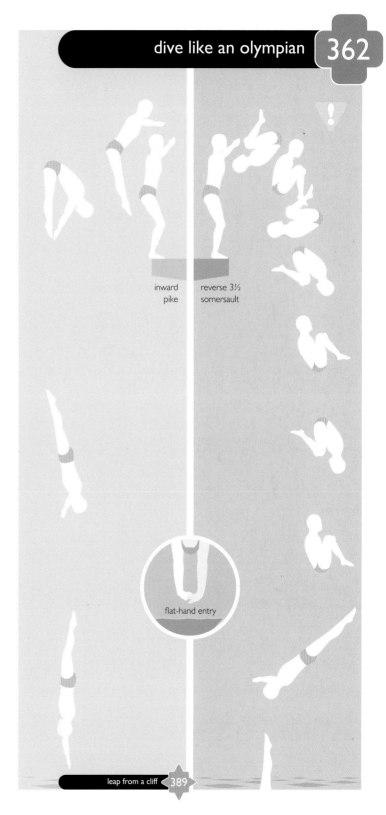

inward
pike

reverse 3½
somersault

flat-hand entry

leap from a cliff 389

363 recover from falling in skis

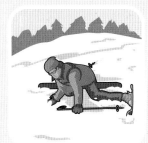
Get your bearings.

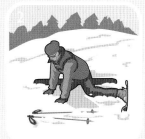
Remove the poles; set aside.

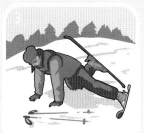
Tuck your back knee.

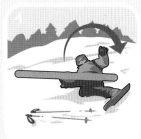
Bring your top leg around.

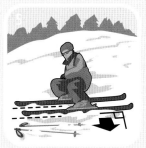
Hold your legs parallel.

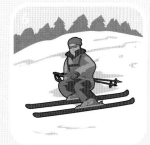
Gather the poles.

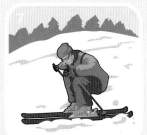
Push up on the poles to stand.

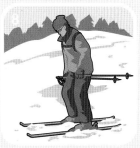
Resume skiing!

364 ski down a slope

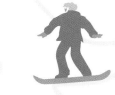

falling leaf
1 To begin sliding, press forward on your lead foot. To stop, pull back on the same foot. It's like a gas pedal!

linking turns
1 Shift your weight forward and aim your skis downhill.

2 Veer your skis uphill to complete your turn.

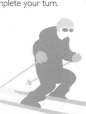

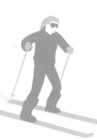

traversing
Spot a cozy chalet on the other side of the slope? Traverse by slanting your skis so that they ride on their upper edges. Shift your weight to your downhill ski.

snowplow
Beginners can coast by spreading their feet shoulders' width apart, slightly bending their knees, and turning their toes inward.

sideslip
Slope too sleep? Decrease your speed by digging back into the snow. To go faster, lean toward the toe edge.

2 To change directions, press down on the front of your other foot.

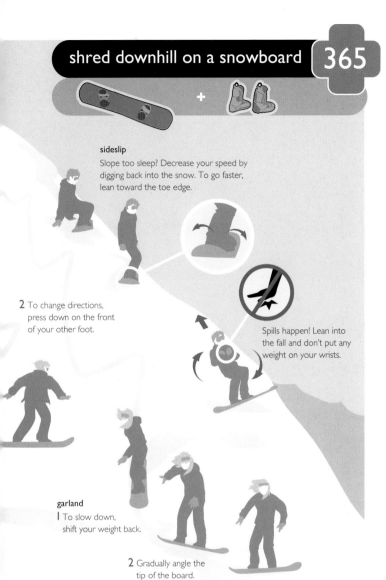

Spills happen! Lean into the fall and don't put any weight on your wrists.

garland
1 To slow down, shift your weight back.

2 Gradually angle the tip of the board.

3 Turn your board uphill to come to a complete stop.

Long boards are for advanced or mountaineering snowboarders.

Boards of medium length are great for a variety of terrains.

Beginners find short boards easier to maneuver. A plus: you can do cool tricks on them.

stand up on a surfboard ◄ 396

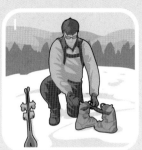
Join the boot straps.

Swing over your shoulder.

Grab the skis and poles. Stand.

Carry the skis over your shoulder.

herringbone **sidestep** **walk**

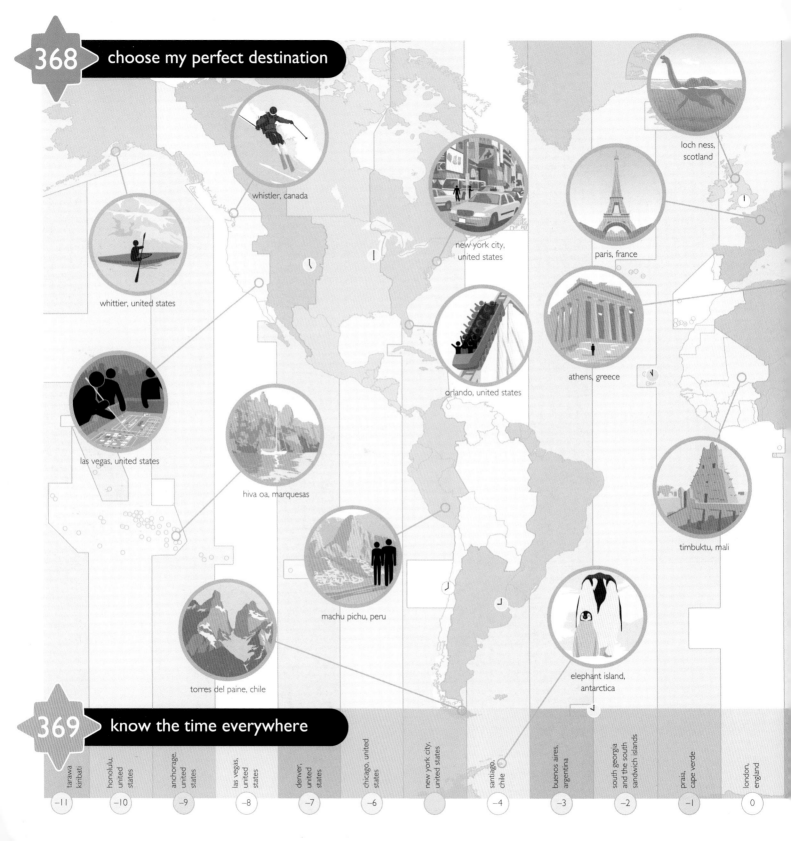

whistler, canada

loch ness, scotland

new york city, united states

paris, france

whittier, united states

athens, greece

las vegas, united states

orlando, united states

hiva oa, marquesas

timbuktu, mali

machu pichu, peru

torres del paine, chile

elephant island, antarctica

tarawa, kiribati	honolulu, united states	anchorage, united states	las vegas, united states	denver, united states	chicago, united states	new york city, united states	santiago, chile	buenos aires, argentina	south georgia and the south sandwich islands	praia, cape verde	london, england
−11	−10	−9	−8	−7	−6		−4	−3	−2	−1	0

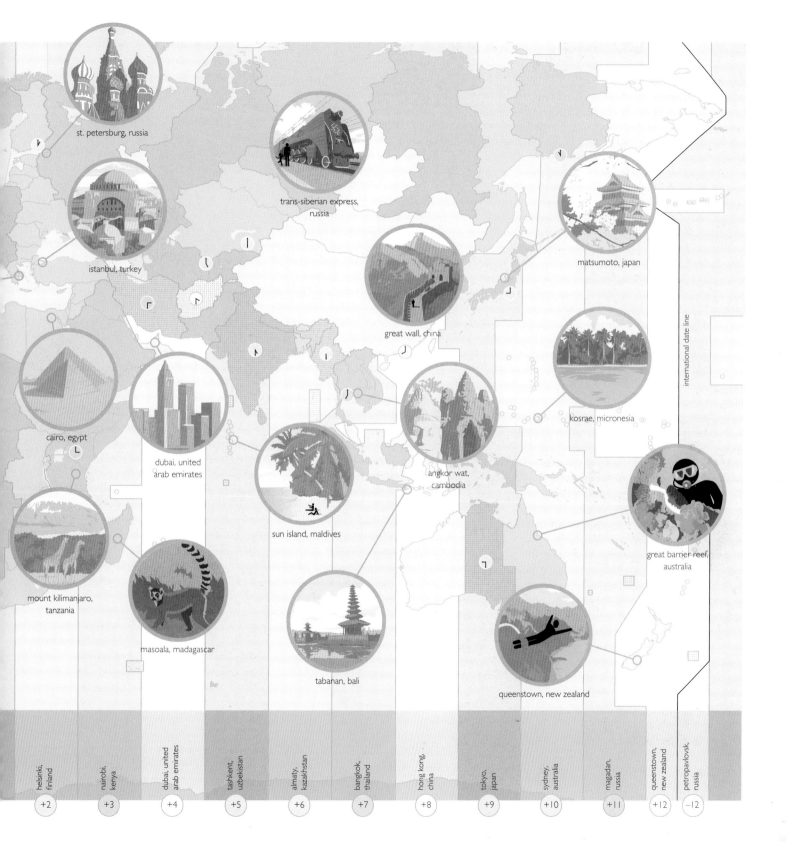

st. petersburg, russia

trans-siberian express, russia

matsumoto, japan

istanbul, turkey

great wall, china

kosrae, micronesia

cairo, egypt

dubai, united arab emirates

angkor wat, cambodia

sun island, maldives

great barrier reef, australia

mount kilimanjaro, tanzania

masoala, madagascar

tabanan, bali

queenstown, new zealand

international date line

helsinki, finland +2
nairobi, kenya +3
dubai, united arab emirates +4
tashkent, uzbekistan +5
almaty, kazakhstan +6
bangkok, thailand +7
hong kong, china +8
tokyo, japan +9
sydney, australia +10
magadan, russia +11
queenstown, new zealand +12
petropavlovsk, russia −12

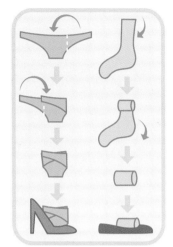

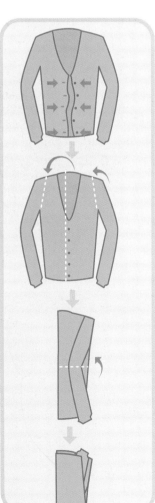

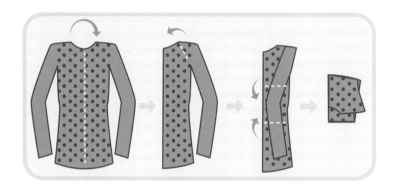

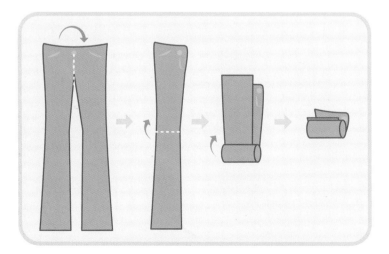

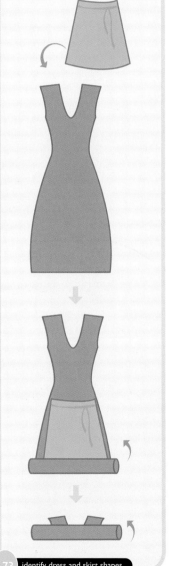

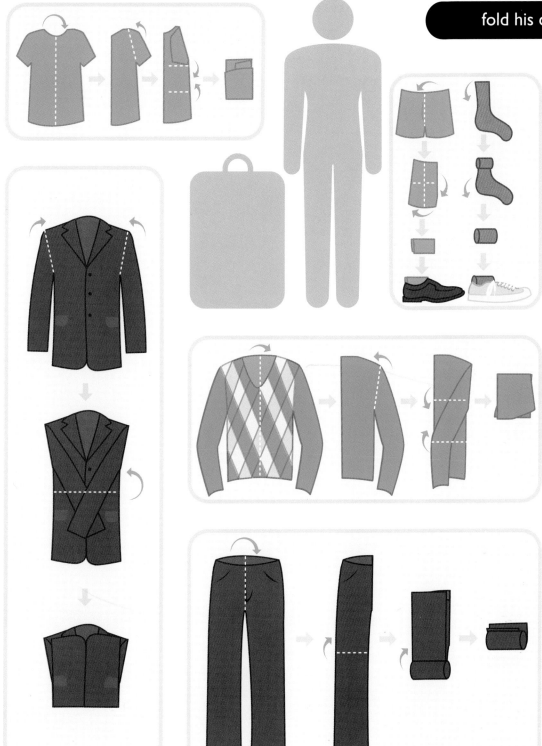

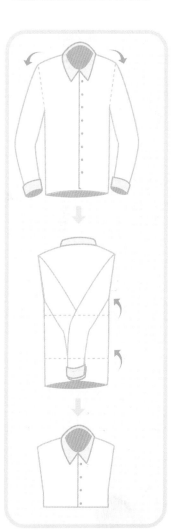

372 ▸ choose the best airplane seat

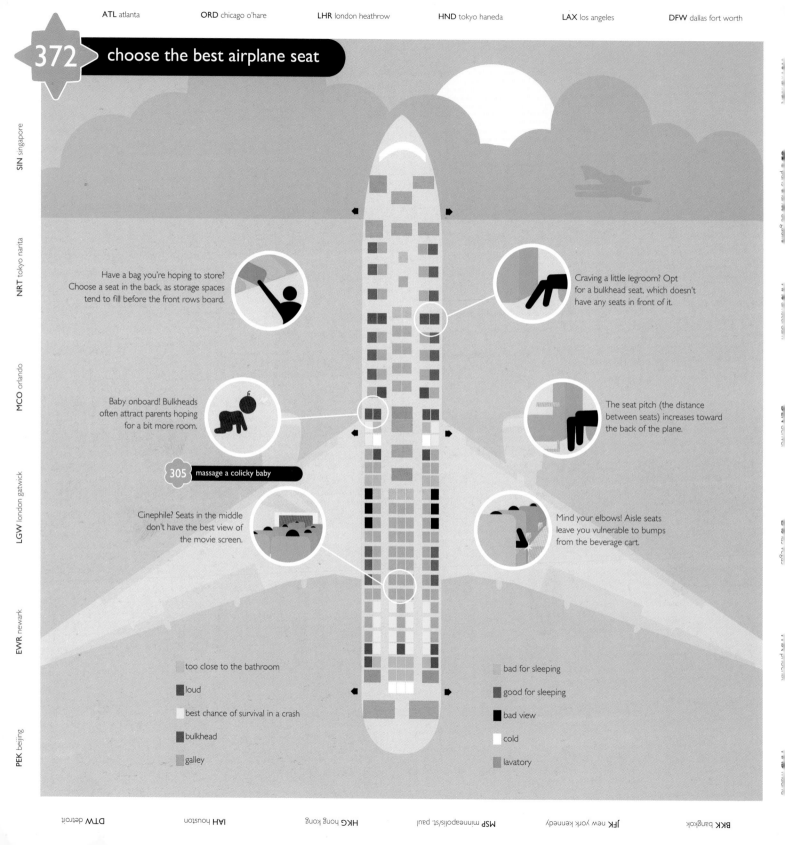

Have a bag you're hoping to store? Choose a seat in the back, as storage spaces tend to fill before the front rows board.

Craving a little legroom? Opt for a bulkhead seat, which doesn't have any seats in front of it.

Baby onboard! Bulkheads often attract parents hoping for a bit more room.

The seat pitch (the distance between seats) increases toward the back of the plane.

305 massage a colicky baby

Cinephile? Seats in the middle don't have the best view of the movie screen.

Mind your elbows! Aisle seats leave you vulnerable to bumps from the beverage cart.

too close to the bathroom

loud

best chance of survival in a crash

bulkhead

galley

bad for sleeping

good for sleeping

bad view

cold

lavatory

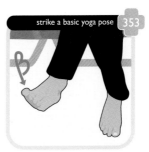

Stretch your sides.

Arch your back.

Apply pressure to the legs.

strike a basic yoga pose 353

Draw the alphabet.

Roll a fist down your thigh.

Switch to your destination's time.

Stay hydrated.

Stretch to keep the blood flowing.

Sleep, if on an overnight flight.

Once you've arrived, stay in daylight.

Eat at the local mealtimes.

Go to sleep at the local bedtime.

Go easy on the sleeping aids.

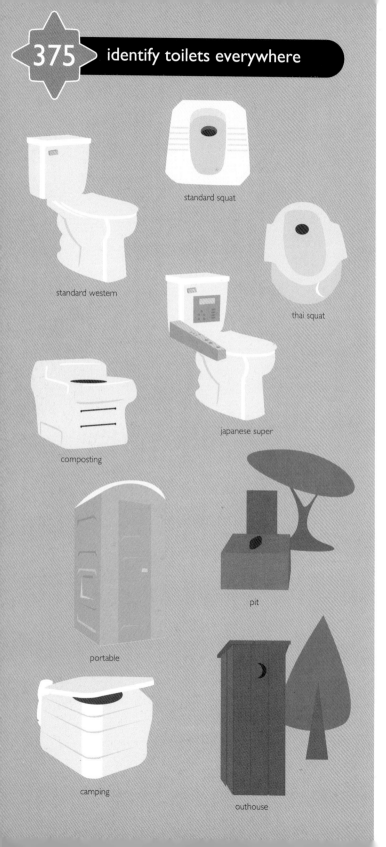

standard squat

standard western

thai squat

japanese super

composting

portable

pit

camping

outhouse

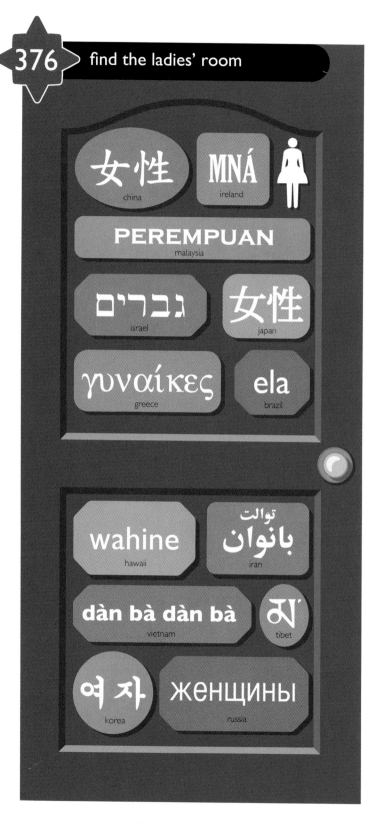

女性
china

MNÁ
ireland

PEREMPUAN
malaysia

גברים
israel

女性
japan

γυναίκες
greece

ela
brazil

wahine
hawaii

توالت بانوان
iran

dàn bà dàn bà
vietnam

ন
tibet

여자
korea

женщины
russia

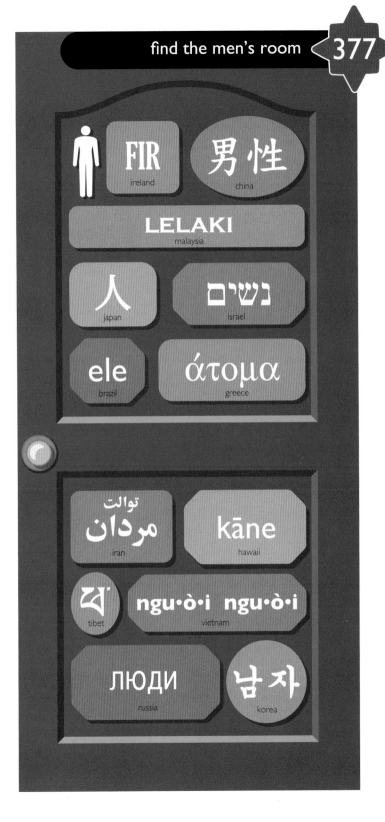

FIR
ireland

男性
china

LELAKI
malaysia

人
japan

נשים
israel

ele
brazil

άτομα
greece

توالت مردان
iran

kāne
hawaii

ཨ
tibet

ngu•ờ•i ngu•ờ•i
vietnam

ЛЮДИ
russia

남자
korea

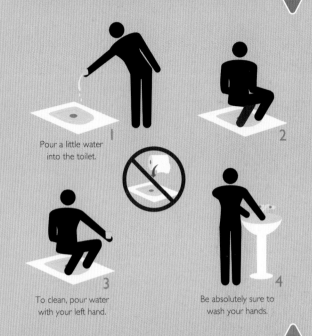

Pour a little water
into the toilet.

To clean, pour water
with your left hand.

Be absolutely sure to
wash your hands.

Remove your pants and
underwear (to keep them dry).

Adjust the temperature
and the jet force.

Straddle, facing the controls.

Rinse the bowl with the jets on low.

Toss onto the ground.

Pick up one; toss in the air.

Pick up another.

Catch the one in the air.

Toss and catch all.

Continue picking up the gonggi stones one by one until you've collected all five. Repeat the process, picking up two at a time, then three at a time, then four at a time. Finally, throw the stones into the air and catch them on the back of your hand. Whatever number you successfully catch is your score!

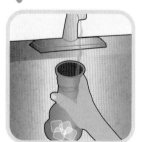

Fill with ice water.

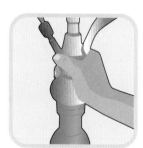

Seal the argile to the vase.

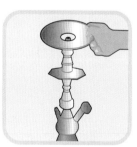

Add the tray.

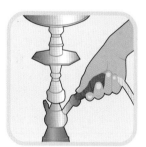

Attach the hose.

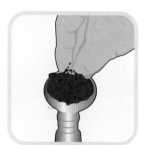

Attach the bowl; pack.

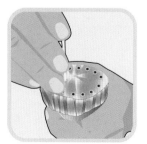

Cover with foil; prick.

Heat a coal.

Place over the bowl.

Brush off ash as it gathers.

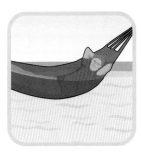
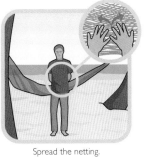

Spread the netting.

Sleep on a diagonal.

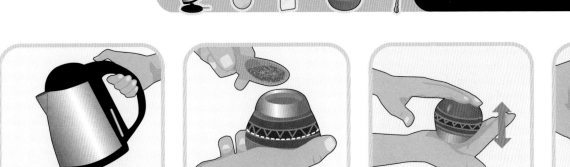

Heat the water.

Fill the gourd three-fourths full.

Cover with your hand; shake well.

Tilt to slant the leaves.

 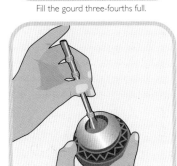 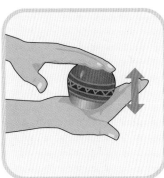

serve thai iced tea 125

Splash cold water on the low side.

Insert the bombilla.

Fill to the brim with hot water.

Drink from the bombilla; share.

384 patch a blown-out bike tire

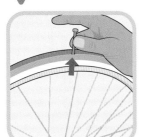
Remove the object.

Let out a little air.

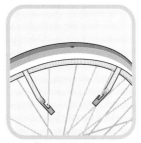
Prop with tire levers.

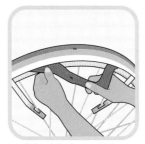
Pull out the damaged tube.

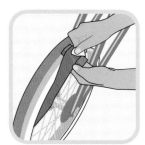
Sand the punctured area.

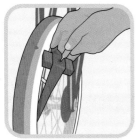
Apply glue.

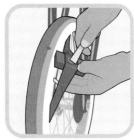
Apply the patch; press.

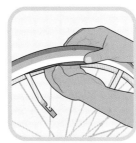
Tuck the tube back inside.

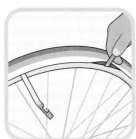
Remove the tire levers.

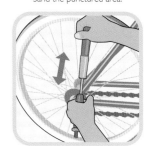
Reinflate the tire.

385 fix a flat bike tire with money

Find the hole; pull the tire off the rim.

Flatten out a bill.

237 weave an inner-tube chair seat

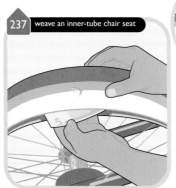
Lay between the hole and the rim.

Ride home quickly to patch properly.

left turn right turn right turn (alternate) vehicle on the left vehicle on the right railroad crossing slowing or stopping pothole on the left pothole on the right

7 Bend the right leg under you.

8 Continue. Use handholds.

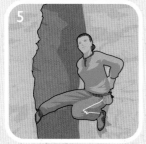
5 Bend the left leg under you.

6 Place above the right leg.

3 Place a foot up; brace yourself.

4 Feel for handholds.

1 Chalk up!

2 Climb into the chimney.

387 shimmy up a rock chimney

388 rappel down a sheer rock face

1 Anchors distribute the weight.

2 Attach rope to the anchors.

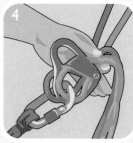
3 Hook on the rappel device.

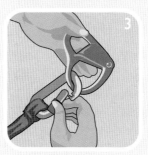
4 Thread two rope bights; close.

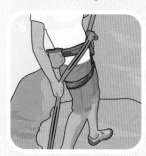
5 Grasp the rope.

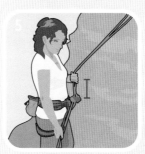
6 Grab the excess.

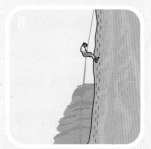
7 Wrap slightly around your hip.

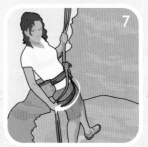
8 Walk down the cliff face.

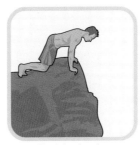 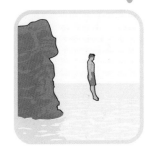

leap from a cliff 389

25 ft (8 m)

12+ ft (4+ m) deep

Scout for a safe jumping site.

Check for rocks.

Check for obstacles.

Stand up straight as a pencil.

Wait—continued

 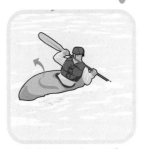

right a capsized kayak 390

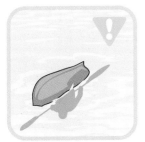

Bend forward over the bow.

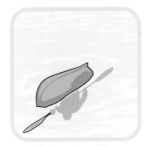

Stick up the paddle.

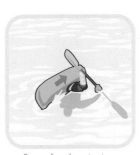

Sweep from bow to stern.

Snap your hip as you roll.

Straighten; steady yourself.

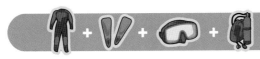

clear water from a scuba mask 391

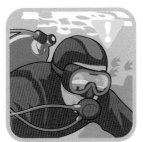

Be alert to water in the mask.

Press, slightly breaking the seal.

Tilt your head back.

Exhale slowly through your nose.

Resecure your mask.

a (alfa) keep clear

b (bravo) dangerous cargo

c (charlie) yes

Need to communicate with another ship, but can't use your radio? Say it with nautical flags! String up a single message, or spell out your own greeting.

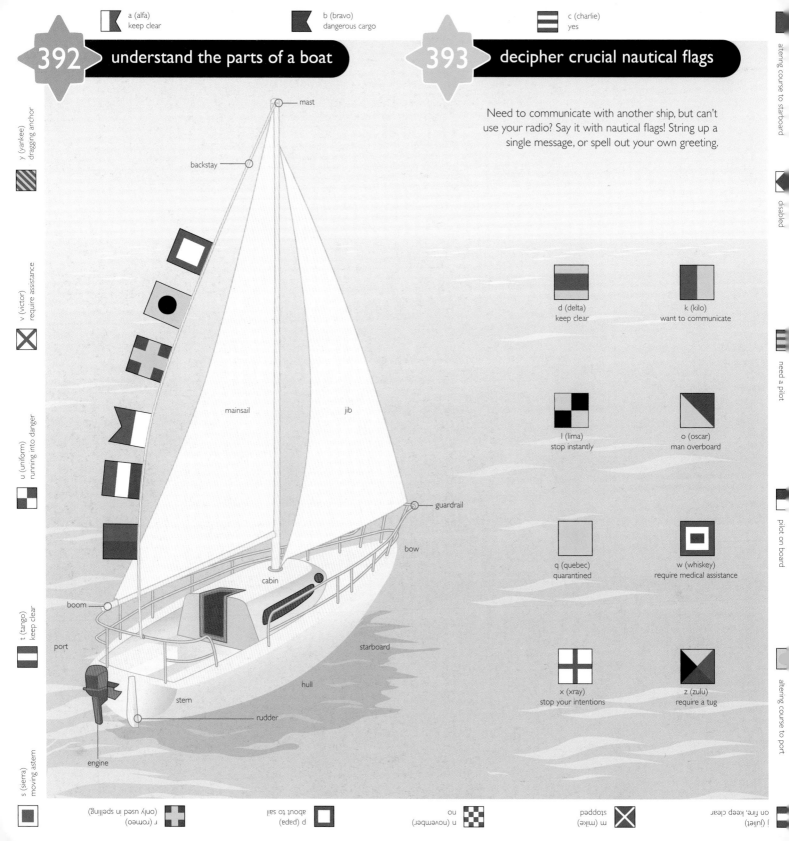

mast

backstay

mainsail

jib

guardrail

bow

cabin

boom

port

starboard

hull

stem

rudder

engine

d (delta) keep clear

k (kilo) want to communicate

l (lima) stop instantly

o (oscar) man overboard

q (quebec) quarantined

w (whiskey) require medical assistance

x (xray) stop your intentions

z (zulu) require a tug

y (yankee) dragging anchor

v (victor) require assistance

u (uniform) running into danger

t (tango) keep clear

s (sierra) moving astern

altering course to starboard

disabled

need a pilot

pilot on board

altering course to port

r (romeo) (only used in spelling)

p (papa) about to sail

n (november) no

m (mike) stopped

j (juliet) on fire, keep clear

Take antinausea medicine.

Find fresh air.

451 ⟩ survive a shipwreck

Look toward the bow.

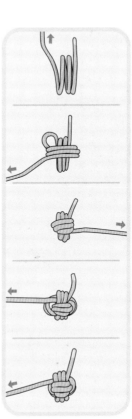

Settle your stomach.

tie basic sailing knots ⟨ 395

figure eight: secures the end of the line

two half-hitches: secures the boat to the dock

bowline: forms a fixed loop at the end of the line

monkey's fist: weighs down a heaving line

cleat hitch: secures the line to a deck cleat

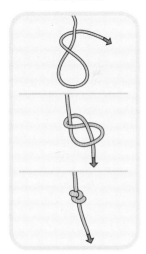

figure eight

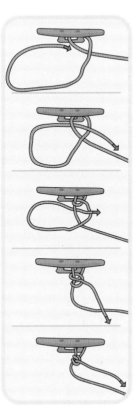

two half-hitches

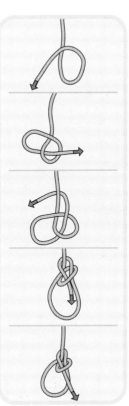

bowline

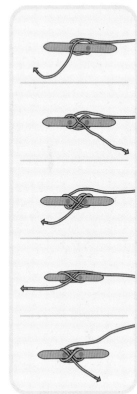

monkey's fist

cleat hitch

396 stand up on a surfboard

2 Paddle out.

3 Take your place in the lineup and scout for the perfect wave. (Don't drop in on someone else's ride!)

4 Spot a good one? Paddle forward quickly, checking the wave as it swells up behind you.

5 After the wave lifts the board, grasp the rails.

6 Pop up, springing off your toes—not your knees.

1 Wax the deck (the top) and the rails (the sides).

497 ollie like a pro

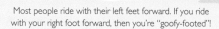

Most people ride with their left feet forward. If you ride with your right foot forward, then you're "goofy-footed"!

397 do a killer duck dive

Grip; push down the nose.

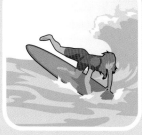

Lean; push your knee down.

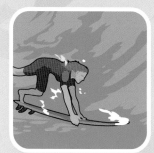

Go under the wave.

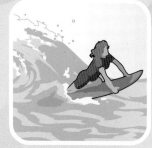

Angle the board upward.

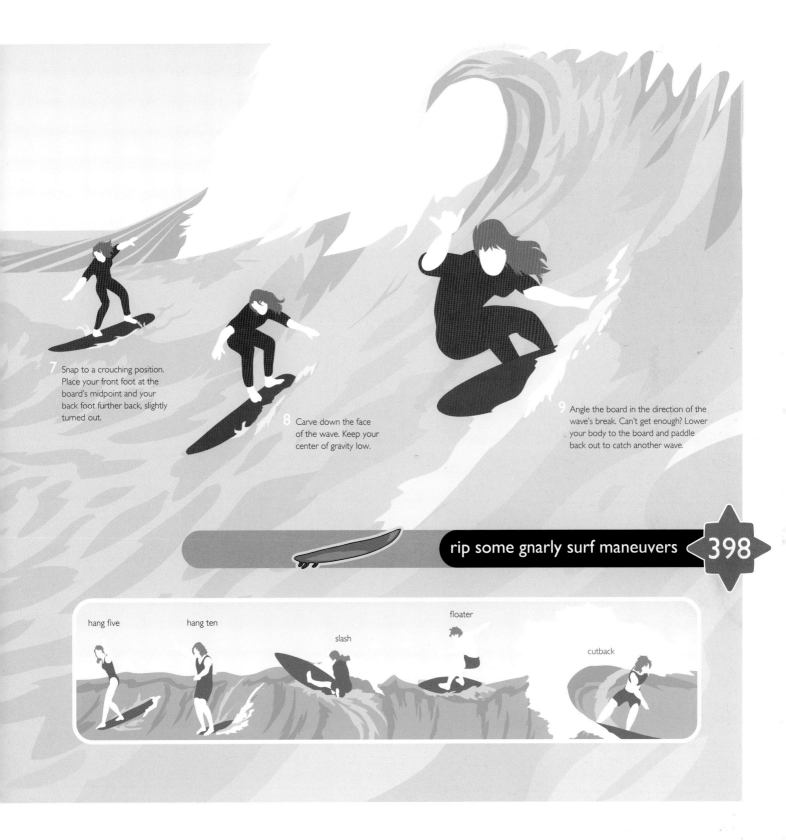

7 Snap to a crouching position. Place your front foot at the board's midpoint and your back foot further back, slightly turned out.

8 Carve down the face of the wave. Keep your center of gravity low.

9 Angle the board in the direction of the wave's break. Can't get enough? Lower your body to the board and paddle back out to catch another wave.

rip some gnarly surf maneuvers 398

hang five

hang ten

slash

floater

cutback

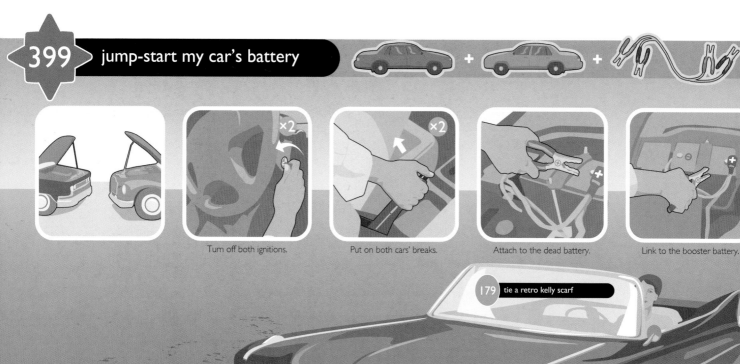

Turn off both ignitions.

Put on both cars' breaks.

Attach to the dead battery.

Link to the booster battery.

179 tie a retro kelly scarf

400 fix my car's flat tire

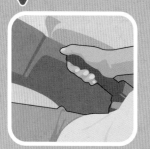

Put on the break.

Remove the hubcap.

Loosen the lugs.

Raise the car off the ground.

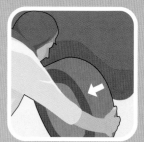

Remove the lugs and tire.

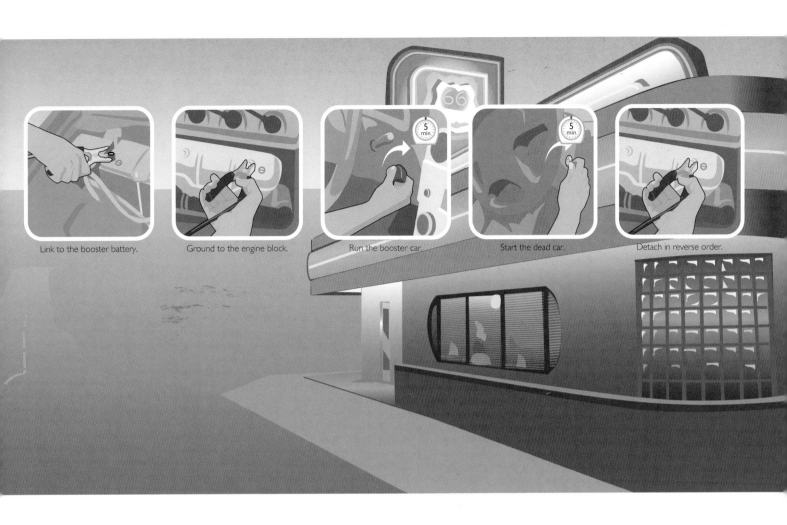

Link to the booster battery.

Ground to the engine block.

Run the booster car.

Start the dead car.

Detach in reverse order.

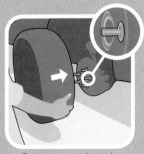

Put a spare over the studs.

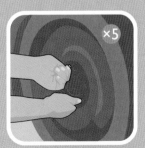

Screw on the lugs.

Lower, remove the jack.

Tighten the lugs.

Drive to a service station.

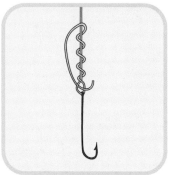

Create a slack coil.

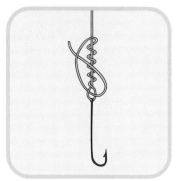

Thread through the loop.

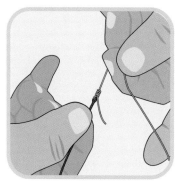

Pull the clinch knot tight.

Attach the bobber.

Bait the hook.

Cast the line; wait for a bite.

Jerk up to hook the fish.

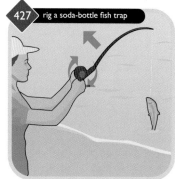

427 rig a soda-bottle fish trap

Pull and reel.

402 build a roaring campfire

Place tinder in a fire pit.

Stand twigs around it.

Add a layer of larger wood.

Encircle with logs.

Light the tinder inside.

Peel bark from the stick.

Butter the bread.

Add cheese; hold over fire.

Remove from the flame; flip.

Grill the other side.

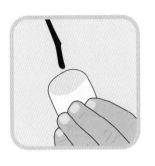

Heat until toasty.

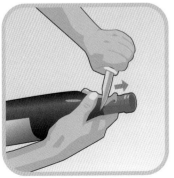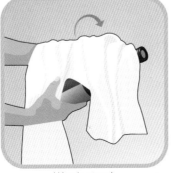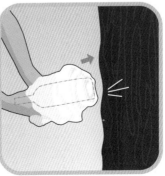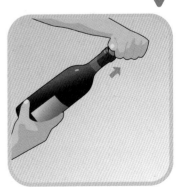

Remove the foil.

Wrap in a towel.

Hit the bottom repeatedly.

When cork emerges, pull it out.

406 mount an elephant

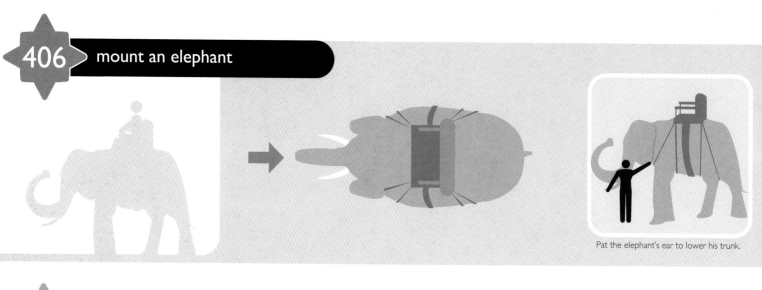

Pat the elephant's ear to lower his trunk.

407 mount a camel

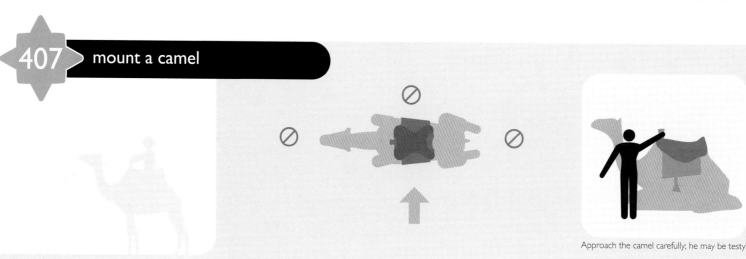

Approach the camel carefully; he may be testy!

408 mount a horse

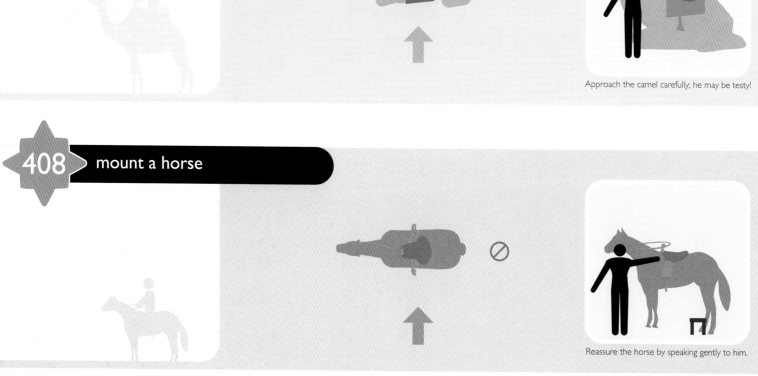

Reassure the horse by speaking gently to him.

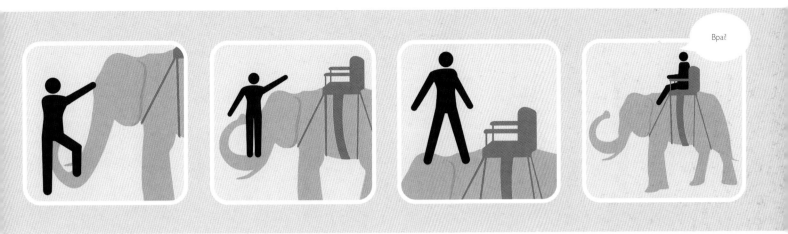

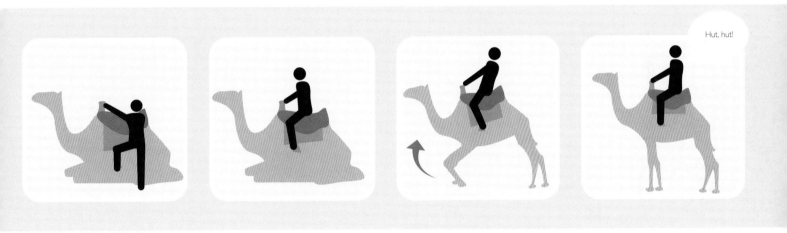

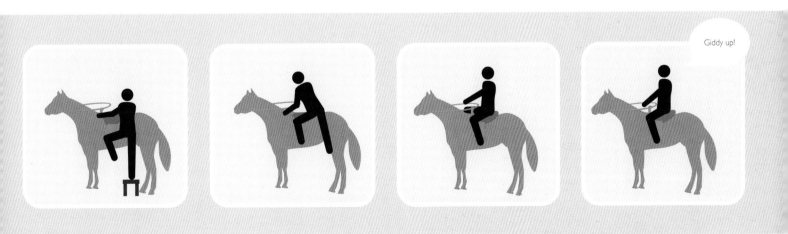

For optimum lighting, stand with the sun behind you and slightly to one side.

Pick out key elements that capture the location's essence.

The eye is drawn to bright areas—look for high contrast of light and dark.

Find lines that lead your eye toward your subject matter.

Keep an eye out for interesting repetitions of color, shape, or texture.

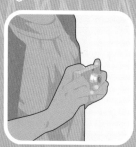

Grasp both sides.

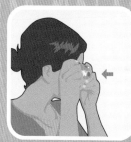

Brace against your face.

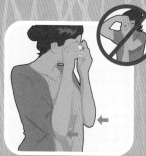

Tuck in your elbows.

Lean to keep steady.

Click while exhaling.

Use the rule of thirds to frame your shot:
keep the horizon on a horizontal third,
and your subject on a vertical third.

Vertical or horizontal
composition? Let
your subject's natural
shape decide.

Shoot at your subject's
eye level. (Always be
respectful—and safe!)

The best shots are of people
interacting with an environment, not
just posing in front of it.

Check the background
for distracting gaffes,
like a twig coming out
of someone's ear!

create professional effects 411

To freeze action, set your
shutter speed to 1/500th of a second.

To show vibrant, blurred motion, set your
shutter speed to 1/15th of a second.

Use f 2.8 to take a portrait with
a soft, unfocused background.

To get a greater depth of
field for landscapes, use f11.

To capture true colors at twilight, set up
a tripod and use a bulb setting to keep
the shutter open as long as you like.

412 ▸ parade in rio's carnaval

In late January or early February, Carnaval is celebrated in Rio de Janeiro, Brazil, with an amazing parade. But don't just watch!

Choose a samba school and order your costume.

Practice your school's song.

Easy on the cachaça!

Arrive in costume on time. Warm up with your school and "hop along" samba-style.

Party! Judges look for enthusiasm.

413 ▸ drench myself in holi's color

India celebrates the festival of Holi in late February or early March. It gets most colorful on its second day, called Dhulhendi.

Buy powdered color.

Drink thandai.

Toss the powder.

Mix the color with water, then splash bucketfuls.

Arm yourself! Shoot the color from water guns called pichkaris.

414 ▸ run with the bulls in pamplona

Every July, adrenaline junkies visit Pamplona, Spain, to run in "el encierro." The Fiesta de San Fermin honors the city's patron saint.

Dress appropriately.

Totally nuts? Start at Plaza Santo Domingo and toast with a shot of Pacharan.

Hug the corners. (The bulls go wide.)

Slightly less nuts? Start beyond "dead man's corner" and toast later—to having survived!

If you fall, stay down and cover your head.

The bull ring is the finish line.

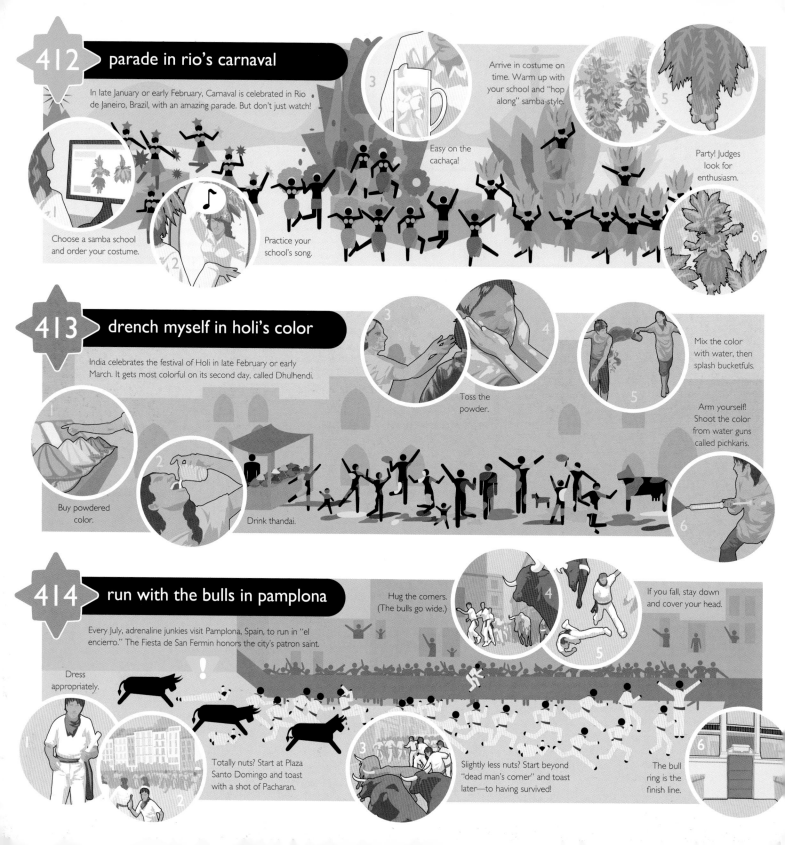

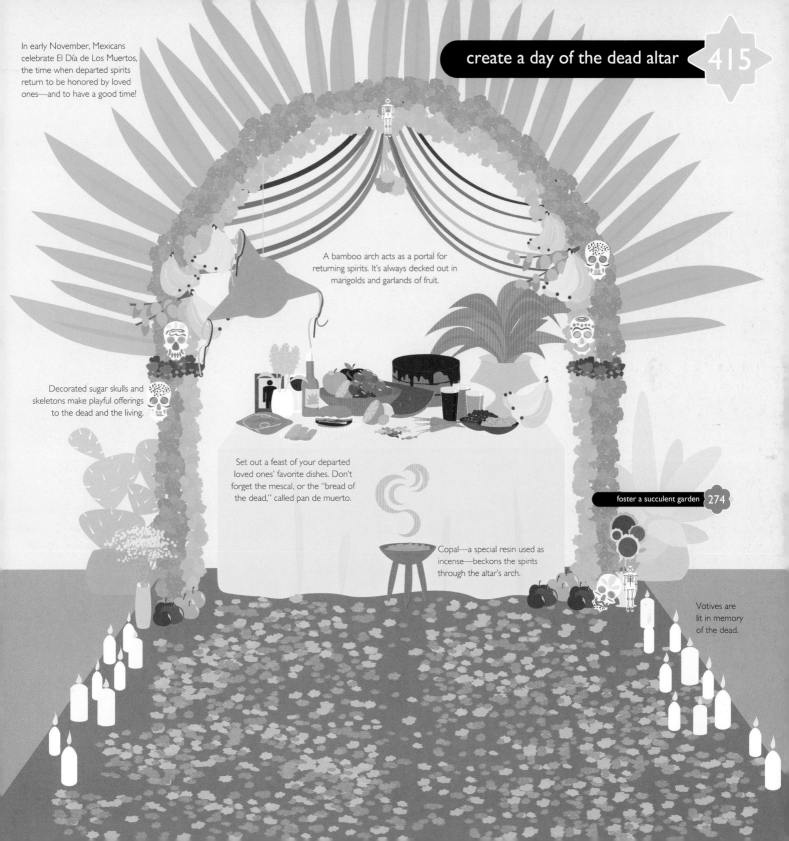

In early November, Mexicans celebrate El Día de Los Muertos, the time when departed spirits return to be honored by loved ones—and to have a good time!

A bamboo arch acts as a portal for returning spirits. It's always decked out in marigolds and garlands of fruit.

Decorated sugar skulls and skeletons make playful offerings to the dead and the living.

Set out a feast of your departed loved ones' favorite dishes. Don't forget the mescal, or the "bread of the dead," called pan de muerto.

foster a succulent garden 274

Copal—a special resin used as incense—beckons the spirits through the altar's arch.

Votives are lit in memory of the dead.

orient myself by the north star

Finding the north star, Polaris, is a snap. First, locate the famous pattern of stars called the Big Dipper (also known as the Plough) in the constellation Ursa Major. Then, mentally draw a line connecting the stars at the end of the Big Dipper's "bowl." Lengthen that line five times to arrive at Polaris, which is the brightest star in Ursa Minor, or the Little Dipper.

ursa major

big dipper (plough)

ursa minor (little dipper)

polaris

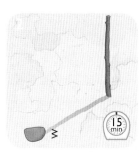

417 make a sun compass

W

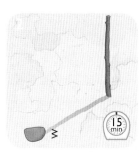

15 min

Mark the shadow's end; wait.

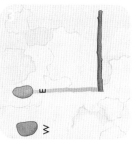

E

W

Mark the shadow's end again.

N

E

S

W

*

 Just a tip: the accuracy of this trick improves the closer you are to the equator, and around the time of the equinoxes.

418 navigate using my watch

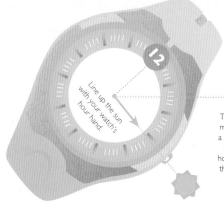

12

Line up the sun with your watch's hour hand

S

To find south, mentally draw a bisecting line between the hour hand and the 12 o'clock position.

northern hemisphere temperate zones

Make a wind-proof puddle.

×50
Magnetize your needle.

Place on a leaf in the puddle.

N S
Let the leaf align itself.

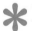 The needle always aligns with the north-south axis. Use other signs—like the sun's position in the sky—to define east and west, then find north.

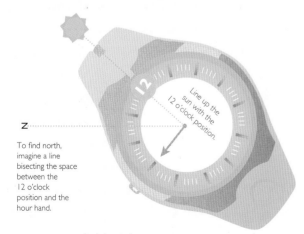

Line up the sun with the 12 o'clock position.

To find north, imagine a line bisecting the space between the 12 o'clock position and the hour hand.

southern hemisphere temperate zones

Searching for the south pole? First find the long axis of the Southern Cross (which is also called Crux) and extend the length of the axis four and a half times. Meanwhile, locate the bright stars Rigil Kent and Hadar to the left of the Southern Cross. Figure the midpoint between them, and then imagine a line that extends from this midpoint to the end of the line drawn from the Southern Cross. This intersection marks the south pole.

rigil kent

hadar

south pole

southern cross (crux)

estimate remaining daylight

Is it time to stop and scrounge for shelter, or is it better to keep on trekking? Use this simple trick to measure the remaining daylight. Remember to allow yourself at least two hours to set up camp before the sun goes down.

Count the finger widths between the sun and the horizon. Each finger is equivalent to fifteen minutes, with each hand totaling an hour. When the sun dips low enough that only two hands fit, it's time to search for a suitable campsite and assemble a shelter. (A caveat: if you're near the poles, the sun will hover over the horizon for a longer period of time, giving you an inaccurate reading.)

207 read my date's love line

Extend your arm fully in front of you to ensure an accurate measurement.

assemble a debris hut 422

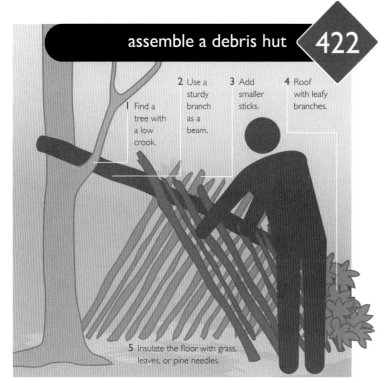

1 Find a tree with a low crook.

2 Use a sturdy branch as a beam.

3 Add smaller sticks.

4 Roof with leafy branches.

5 Insulate the floor with grass, leaves, or pine needles.

set up a shade shelter 423

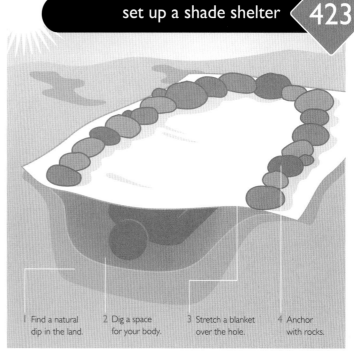

1 Find a natural dip in the land.

2 Dig a space for your body.

3 Stretch a blanket over the hole.

4 Anchor with rocks.

lash together a swamp bed 424

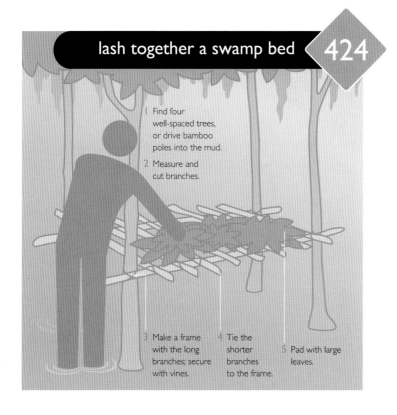

1 Find four well-spaced trees, or drive bamboo poles into the mud.

2 Measure and cut branches.

3 Make a frame with the long branches; secure with vines.

4 Tie the shorter branches to the frame.

5 Pad with large leaves.

dig a snow cave 425

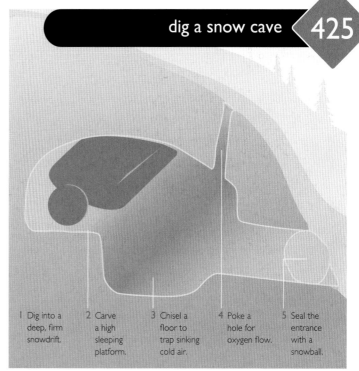

1 Dig into a deep, firm snowdrift.

2 Carve a high sleeping platform.

3 Chisel a floor to trap sinking cold air.

4 Poke a hole for oxygen flow.

5 Seal the entrance with a snowball.

426 catch a fish bare-handed

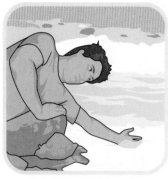
Lie with your arm in the water.

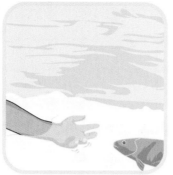
Wiggle your fingers.

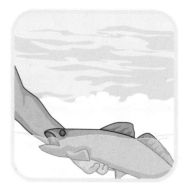

Fling to shore.

427 rig a soda-bottle fish trap

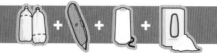

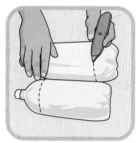
Cut two bottles.

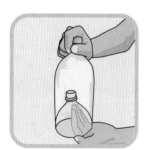

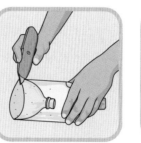
Cut holes in the bottles.

Stitch together.

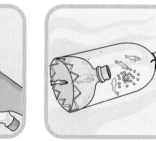
Bait; anchor and submerge.

428 fire-roast a tarantula

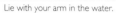

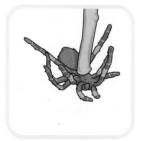
Flip the spider; press down.

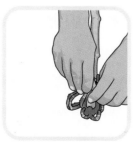
Gather the legs.

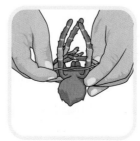
Secure the legs.

Wrap in a leaf.

Nestle in hot coals.

Find a path made by hares.

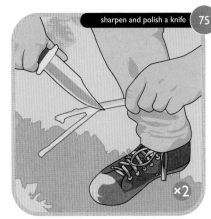

sharpen and polish a knife 75

×2

Trim two sticks to equal length; sharpen.

Stake on either side of the trail.

Secure your wire to a steady branch.

Make a noose with the other end.

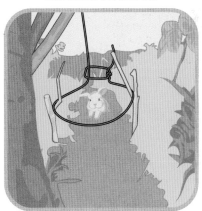

Drape the noose over the forked sticks.

Cut off the snake's head.

Slice along the belly.

Peel off the skin.

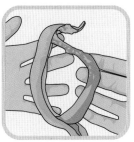

Remove the guts.

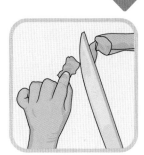

Cut the meat.

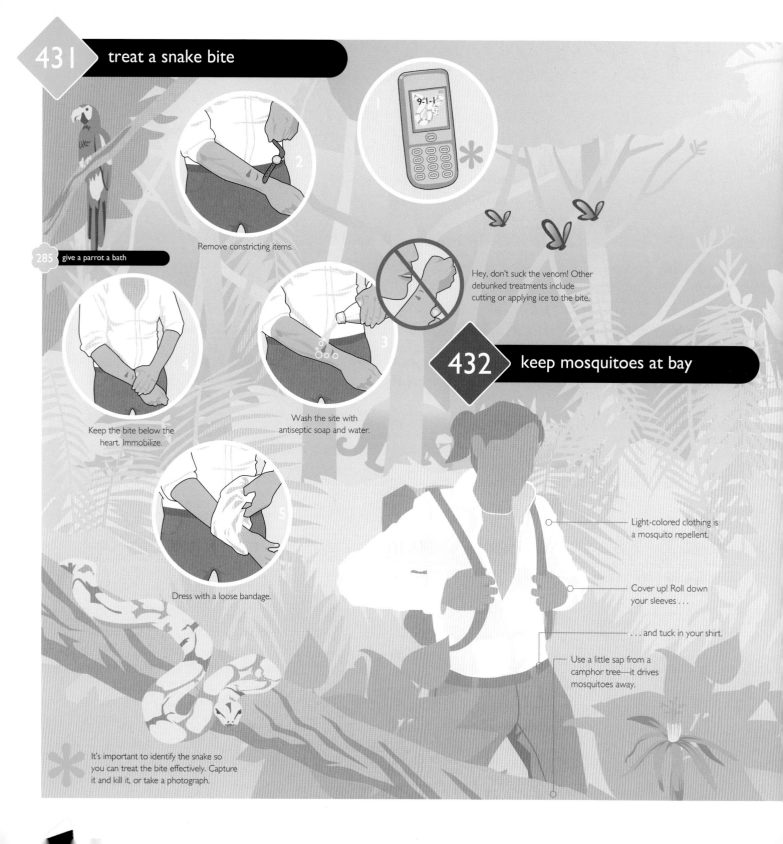

285 give a parrot a bath

431 › treat a snake bite

Remove constricting items.

Keep the bite below the heart. Immobilize.

Wash the site with antiseptic soap and water.

Hey, don't suck the venom! Other debunked treatments include cutting or applying ice to the bite.

Dress with a loose bandage.

It's important to identify the snake so you can treat the bite effectively. Capture it and kill it, or take a photograph.

432 › keep mosquitoes at bay

Light-colored clothing is a mosquito repellent.

Cover up! Roll down your sleeves . . .

. . . and tuck in your shirt.

Use a little sap from a camphor tree—it drives mosquitoes away.

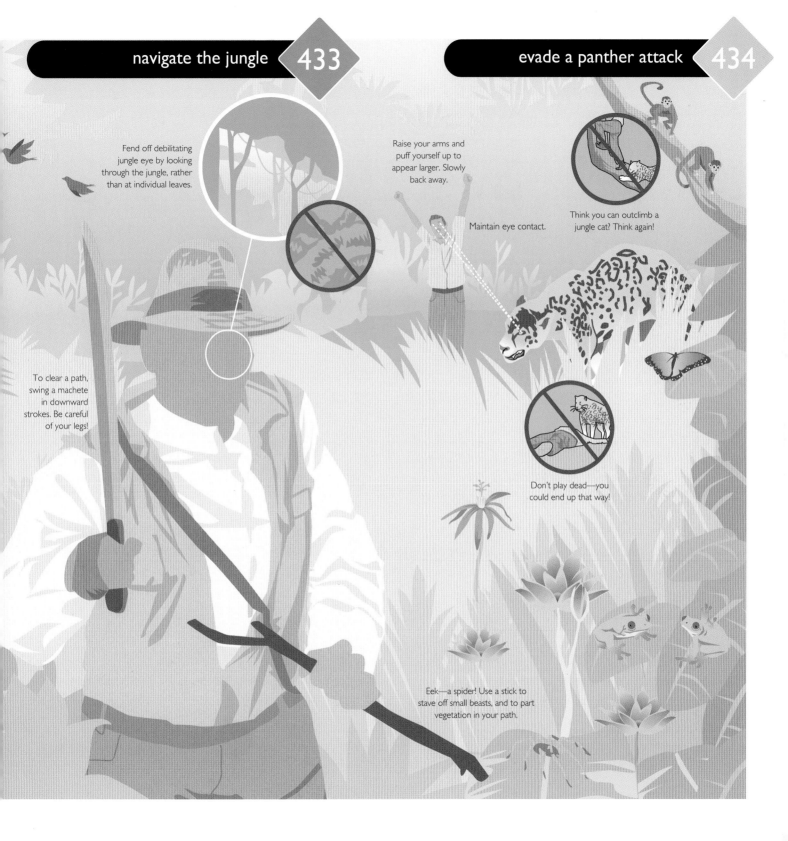

Fend off debilitating jungle eye by looking through the jungle, rather than at individual leaves.

To clear a path, swing a machete in downward strokes. Be careful of your legs!

Raise your arms and puff yourself up to appear larger. Slowly back away.

Maintain eye contact.

Think you can outclimb a jungle cat? Think again!

Don't play dead—you could end up that way!

Eek—a spider! Use a stick to stave off small beasts, and to part vegetation in your path.

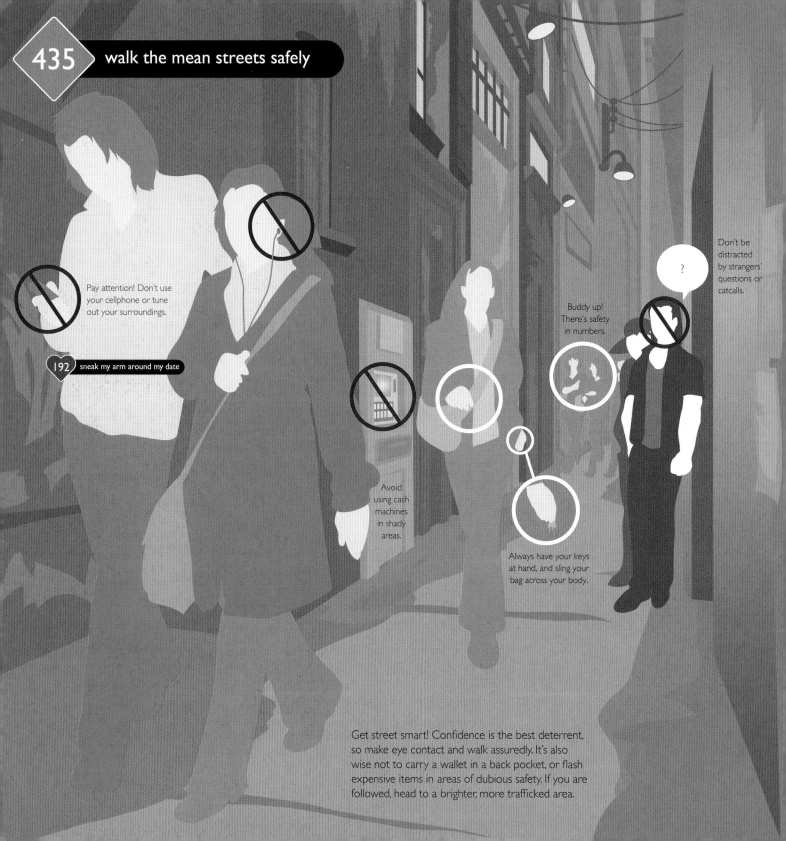

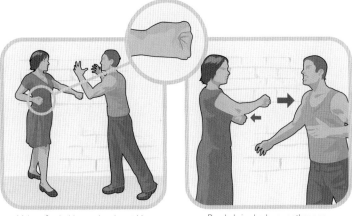
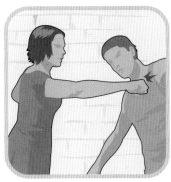
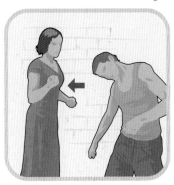

Make a fist; hold your thumb outside.

Punch; bring back your other arm.

Connect with the first two knuckles.

Pull back into a defensive position.

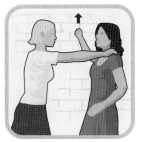
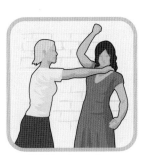
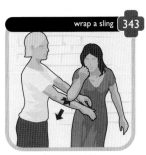
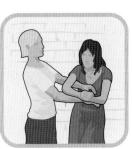

Lift your arm.

Twist; bend your elbow.

wrap a sling 343

Break the hold.

Join your hands.

Push your elbow.

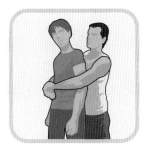
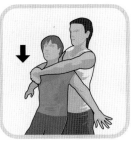
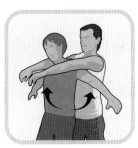
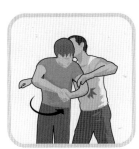

Keep your cool.

Bend your knees.

Raise your arms.

Spin; hit the attacker.

Run away.

439 clamber out of an ice hole

Stay calm; focus.

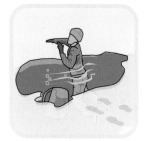
Drop any heavy items.

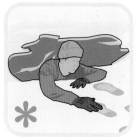
Turn back to strong ice.

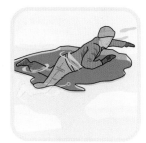
Kick to get horizontal.

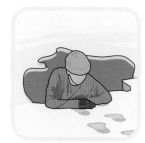
Lift with your elbows.

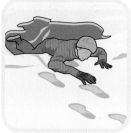
Kick to "swim" out.

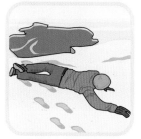
Roll away from the hole.

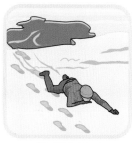
Crawl to firm land.

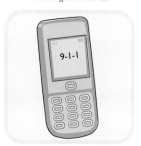

Get warm and dry.

As a general rule, the ice is stronger along the shore, where the water is shallowest and freezes over first. Assuming you're crossing a lake, the ice will be stronger behind you, so turn back in that direction before crawling out.

440 catch a fish in a frozen lake

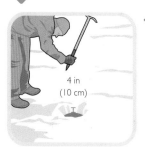
Chisel a hole in thick ice.

401 bait and cast my fishing hook
Tie the line to a branch.

Bait; place in the hole.

A stick supports the line.

Pack to prevent freezing.

Monitor body temperature.

Watch for severe shivering.

Remove from exposure.

Handle the victim gently.

Remove any wet clothing.

Insulate the victim.

Serve a hot beverage.

Share heat intermittently.

Keep flat until help arrives.

 Keep an eye out for other signs of hypothermia, like sluggishness, disorientation, and general fatigue. If a person suddenly stops violently shivering, the case is especially severe, and you should get help as soon as possible.

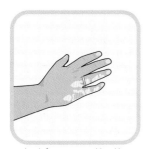

Look for waxy or white skin.

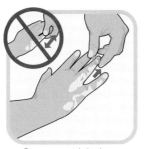

Remove constricting items.

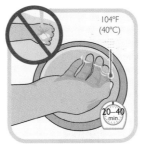

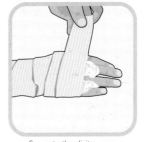

Separate the digits; wrap.

1 — Divide into parts; test each.

2 — Check for foul odors.

3 — Rub; monitor your reaction.

4 — Rub on your lips.

5 — Touch to your tongue.

6 — Chew; hold in your mouth. (3–4 min)

7 — Swallow. Wait and monitor. (8 hr)

8 — You can now eat a handful.

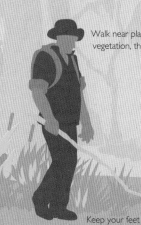

Walk near plants. Where there's vegetation, there's solid ground!

Probe suspicious areas with a stick.

Keep your feet close together.

 + + ◆ + ...

Polish with chocolate.

Focus sunlight on the can to ignite the tinder fungus.

402 — build a roaring campfire

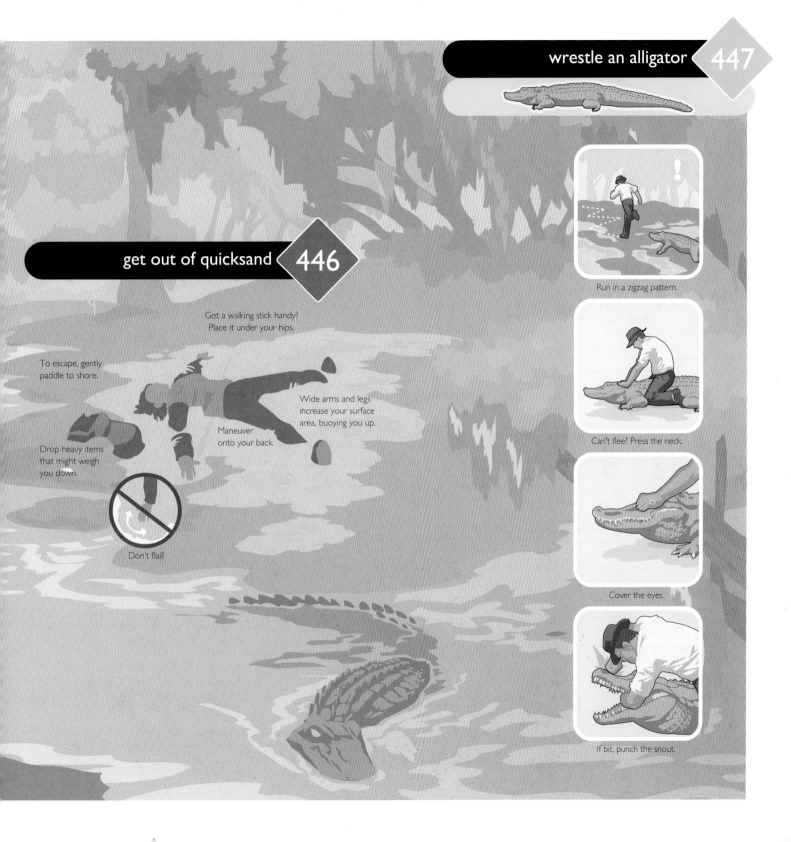

get out of quicksand 446

Got a walking stick handy?
Place it under your hips.

To escape, gently
paddle to shore.

Wide arms and legs
increase your surface
area, buoying you up.

Maneuver
onto your back.

Drop heavy items
that might weigh
you down.

Don't flail!

Run in a zigzag pattern.

Can't flee? Press the neck.

Cover the eyes.

If bit, punch the snout.

448 use my pants to stay afloat

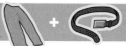

Remove your pants.

Knot the bottom of the leg. ×2

Pull down to fill with air.

Cinch the belt to trap air.

Hug; wait for rescue.

449 prevail with the dead man's float

Man overboard? Assume this tried-and-true survival position. It conserves crucial energy, while allowing you to periodically breathe until you're rescued.

Hold your head and shoulders slightly above the water.

When you need to take a breath, tread water by pumping your arms up and down and lightly kicking your feet.

Let your arms and legs dangle freely.

450 understand morse code

a • —
b — • • •
c — • — •
d — • •
e •
f • • — •
g — — •
h • • • •
i • •
j • — — —
k — • —
l • — • •
m — —

n — •
o — — —
p • — — •
q — — • —
r • — •
s • • •
t —
u • • —
v • • • —
w • — —
x — • • —
y — • — —
z — — • •

1 • — — — —
2 • • — — —
3 • • • — —
4 • • • • —
5 • • • • •

6 — • • • •
7 — — • • •
8 — — — • •
9 — — — — •
0 — — — — —

understood • • • — •
error • • • • • • • •
invite to transmit — • —
wait • — • • •
end of work • • • — • —
starting signal — • — • —

 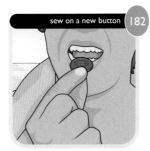
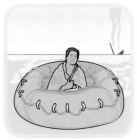

Get warm and dry.

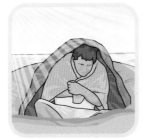

Shield yourself from the sun.

sew on a new button 182

Suck a button to ease thirst.

Collect rainwater in a tarp.

See land? Swim to it.

fend off a shark 452

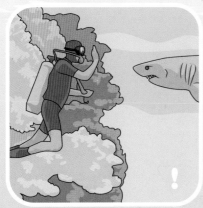

Defend your back from the shark.

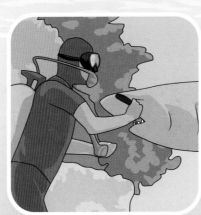

Hit on the side.

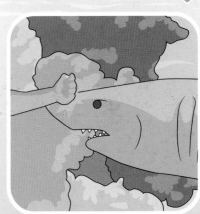

Hit the end of the nose.

Shove your hand in the gills.

Jab the shark in the eye.

Escape; treat any wounds immediately.

Any waterproof container will do.

The tubing should be at least 3 ft (90 cm) in length.

The plastic tarp must be clear.

Medium-sized rocks work best.

Finer sand is more airtight.

Dig with a shovel or a large flat stone.

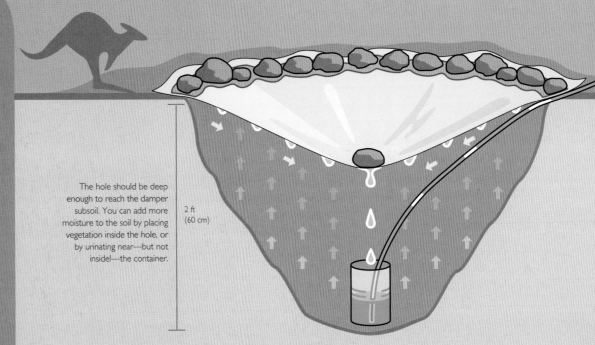

The hole should be deep enough to reach the damper subsoil. You can add more moisture to the soil by placing vegetation inside the hole, or by urinating near—but not inside!—the container.

2 ft (60 cm)

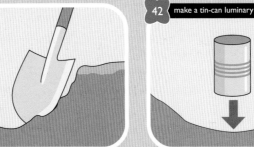

1 Make sure the hole is no wider than the tarp.

42 make a tin-can luminary

2 Add a container to collect water.

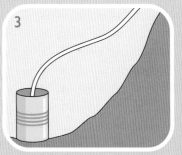

3 Insert the tubing to use as a straw.

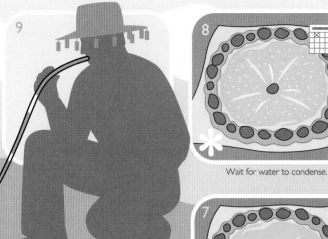

9

8

Wait for water to condense.

7

Place a rock in the center to draw drips.

6

Seal the airholes with sand.

During daylight hours, water vapor will naturally condense beneath the tarp and drip from its lowest point. It takes 24 hours for 17–35 fl oz (0.5–1 l) of water to gather in the container, depending on the air temperature and the moisture content of the soil. Three holes are recommended to meet daily water requirements.

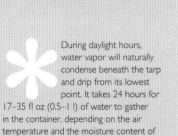

4

Cover the hole with the tarp.

5

Add rocks to anchor the tarp in place.

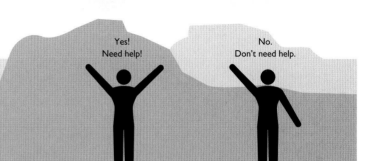

Yes!
Need help!

No.
Don't need help.

Make symbols on the ground large enough to be seen from above.

I
serious injury

LL
all is well

O
need compass and map

△
believe safe to land here

K
indicate direction to proceed

↑
am going this way

F
need food and water

Make symbols using branches, footprints, or any other readily available material.

Tighten the left loop.

Make the noose.

84 identify beef cuts

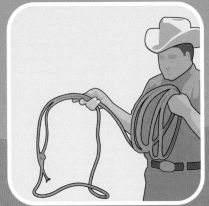

Hold above the knot; coil the excess.

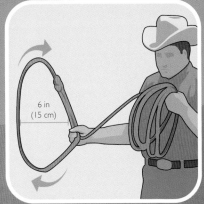

6 in (15 cm)

Rotate the lasso clockwise.

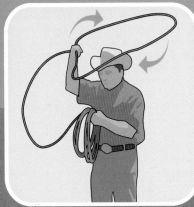

Lift over your head.

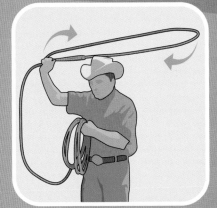

The lasso should flatten out and expand.

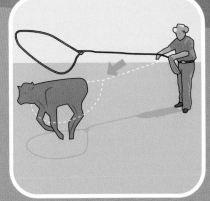

Step forward and toss.

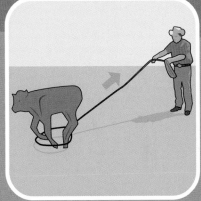

Cinch closed.

do the texas skip 457

Can't get your vertical loop big enough to jump through? Buy a metal honda knot and attach it to your rope. The added weight pulls the rope downward, expanding the loop.

Move your arm across your chest when the knot reaches the 12 o'clock position.

⭐ **458** — rip a phone book in half

Grasp the end; brace against your body.

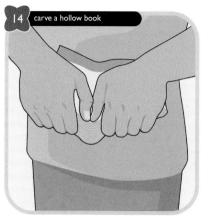

14 carve a hollow book

Pinch the middle; fold in half.

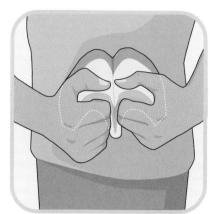

Keep pinched; pull at the edges.

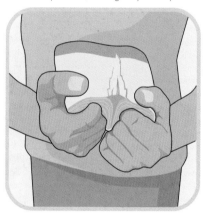

Begin the tear.

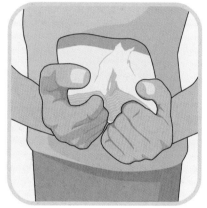

Tear more!

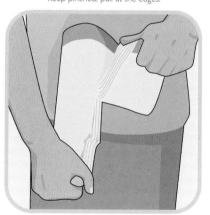

Pull in half with great might.

⭐ **459** — shoot a stealthy spitball

Insert into the straw; blow.

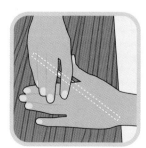

Conceal your weapon.

 ## spin a basketball on my finger ⭐460

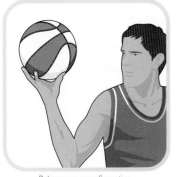 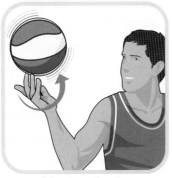 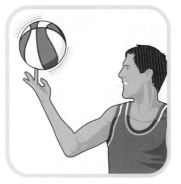

Balance on your fingertips. Spin onto one fingertip. Transfer; lightly brush to keep spinning.

skip a stone across water ⭐461

 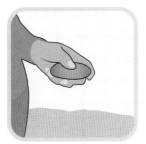 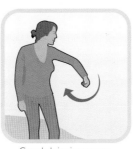 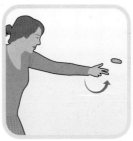 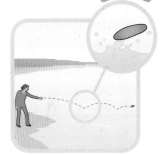

Pick a flat, smooth rock. Curl a finger around it. Crouch; bring in your arm. Release, flicking your wrist.

walk the dog ⭐462

Loop the string. Make a fist. Snap your wrist. Gently lower to the floor. Let the yo-yo "walk." Jerk back to your hand.

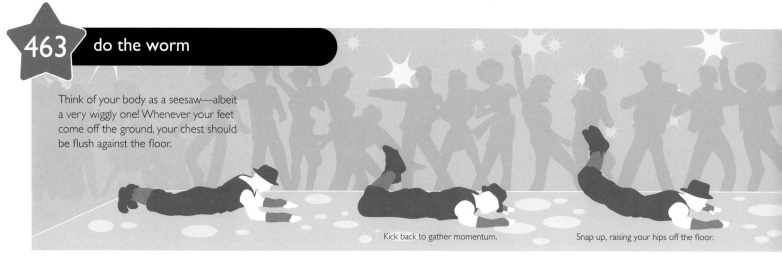

463 do the worm

Think of your body as a seesaw—albeit a very wiggly one! Whenever your feet come off the ground, your chest should be flush against the floor.

Kick back to gather momentum.

Snap up, raising your hips off the floor.

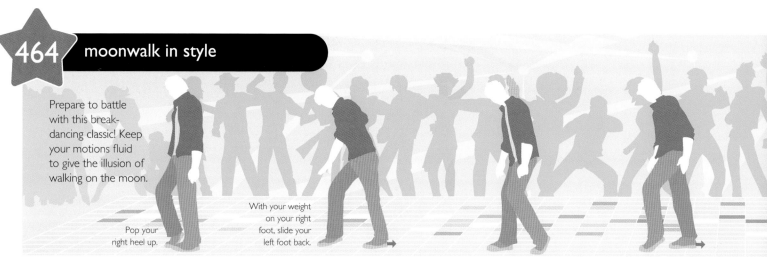

464 moonwalk in style

Prepare to battle with this break-dancing classic! Keep your motions fluid to give the illusion of walking on the moon.

Pop your right heel up.

With your weight on your right foot, slide your left foot back.

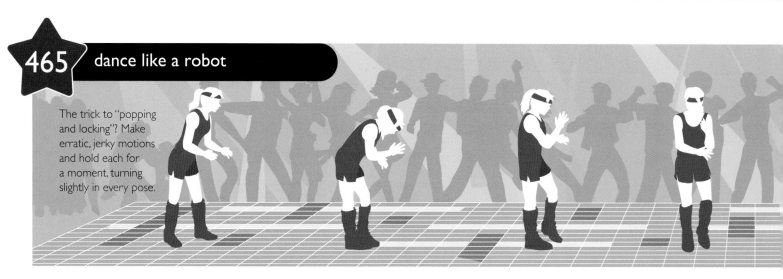

465 dance like a robot

The trick to "popping and locking"? Make erratic, jerky motions and hold each for a moment, turning slightly in every pose.

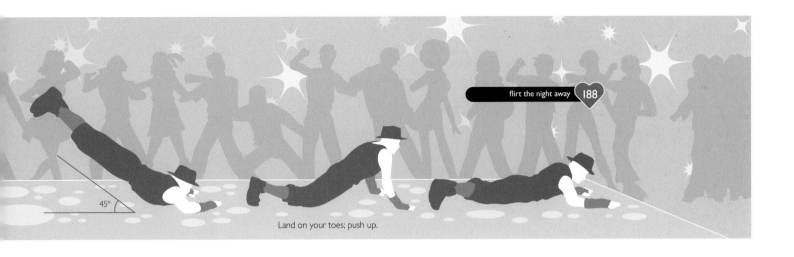

45°

Land on your toes; push up.

Pivot, and show off your skills on the other side.

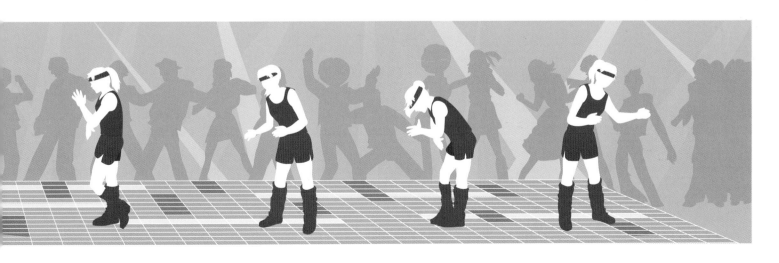

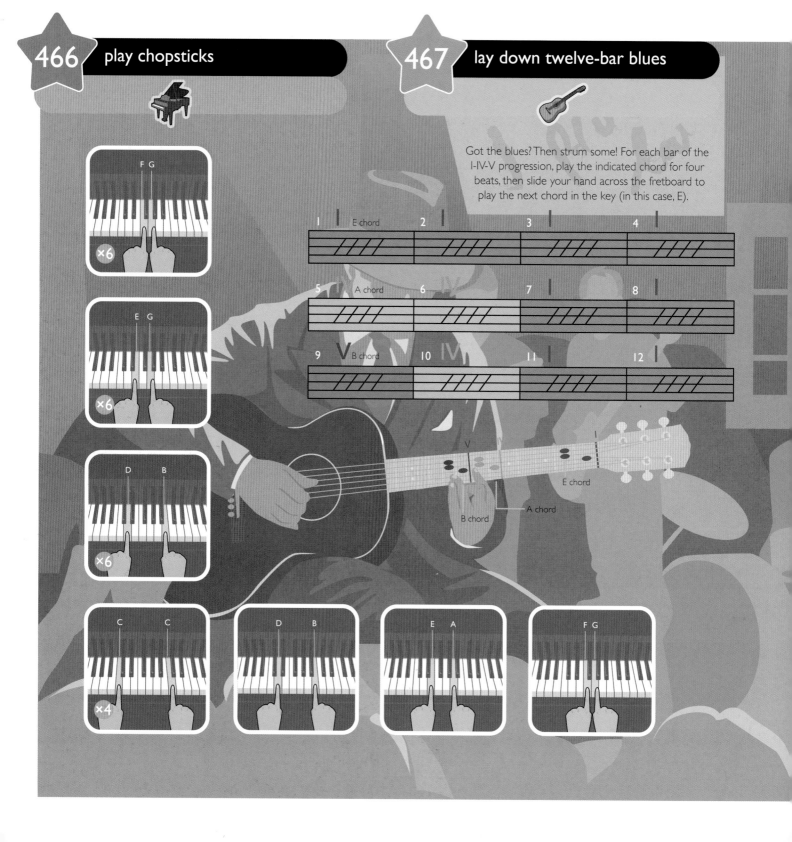

466 play chopsticks

467 lay down twelve-bar blues

Got the blues? Then strum some! For each bar of the I-IV-V progression, play the indicated chord for four beats, then slide your hand across the fretboard to play the next chord in the key (in this case, E).

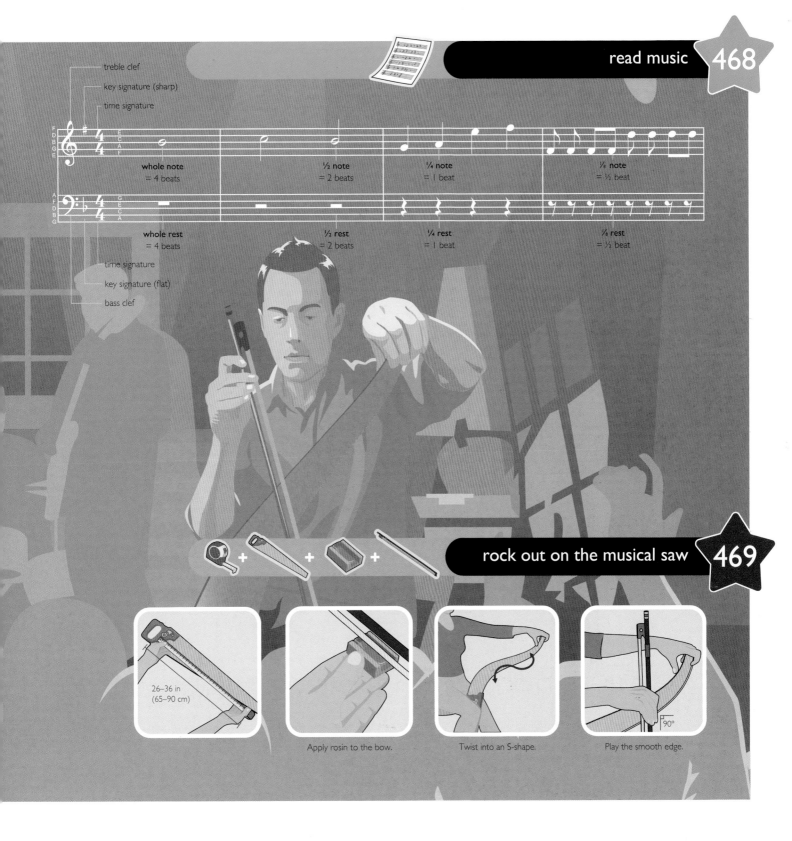

treble clef
key signature (sharp)
time signature

F D B G E

whole note
= 4 beats

½ note
= 2 beats

¼ note
= 1 beat

⅛ note
= ½ beat

A F D B G

whole rest
= 4 beats

½ rest
= 2 beats

¼ rest
= 1 beat

⅛ rest
= ½ beat

time signature
key signature (flat)
bass clef

26–36 in
(65–90 cm)

Apply rosin to the bow.

Twist into an S-shape.

Play the smooth edge.

90°

tie a cigarette in a knot

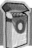

Remove the plastic wrap.

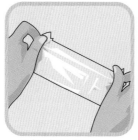

Unfold; flatten the wrapper.

Roll in the wrapper.

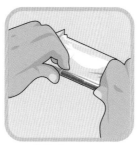

Knot the wrapper.

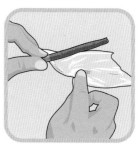

Untie; unveil the cigarette.

guzzle from a beer hat

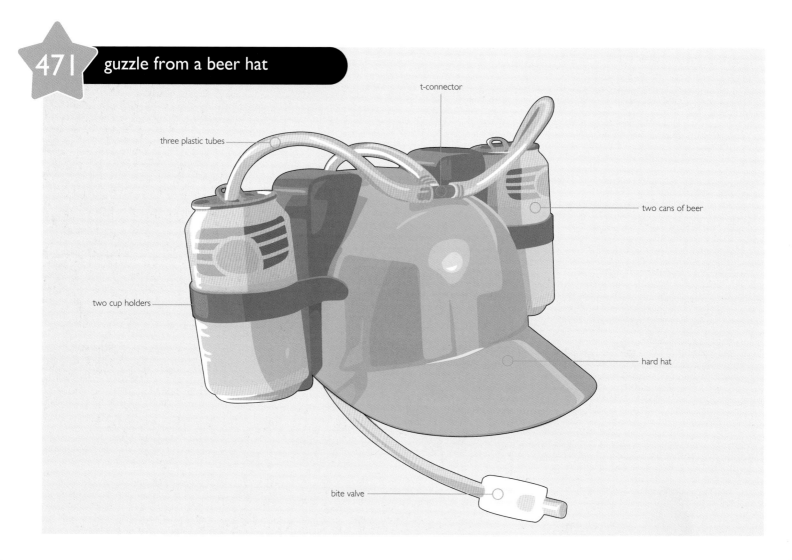

t-connector

three plastic tubes

two cans of beer

two cup holders

hard hat

bite valve

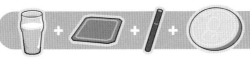

win bar bets with the coin drop 472

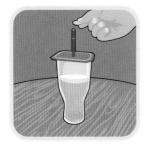

Bet your mark.

Blow on the glass.

Collect your winnings.

perform an awesome keg stand 473

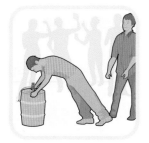 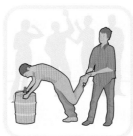 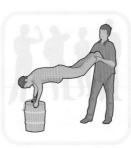 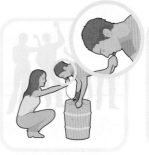 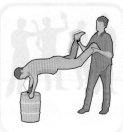

Grasp the keg's rim.

Lift one leg.

Kick up your second leg.

Drink from the nozzle.

Shake your leg when full.

vanquish a case of hiccups 474

Plug your ears.

Squeeze your nostrils shut.

Gulp down a glass of water.

Chew and swallow sugar.

Sip more water.

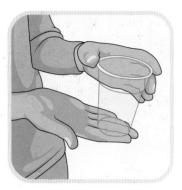

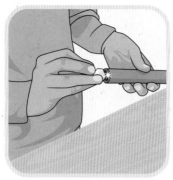

Insert the crystal into the copper pipe.

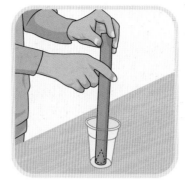

Use foil to hold in place.

Fill the cup with resin.

Let cure.

Revel in your powers.

 A zany cult favorite among pseudoscience enthusiasts, the cloudbuster is rumored to equalize unbalanced weather by changing atmospheric energy. While it's usually a big device, you can use this tiny one to clear up cloudy skies—or to make it pour!

Inflate helium balloons.

Crumple aluminum foil.

Fill a trash bag.

Close; set aloft.

Shh! Noise and light attract attention.

Drop off your gear first. Park far, far away and hike in.

Walk only on pre-existing tracks.

The plant stalks should bend, not break.

A wooden plank uniformly presses down the stalks as you scoot along, lifting one side of the plank at a time.

Follow plans that you've drawn ahead of time.

Use a partner or a stake to keep a constant center point.

Remember to take all tools and trash with you when you're done. Anything you leave behind could give you away—even a footprint!

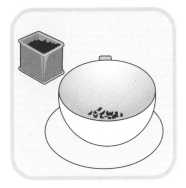 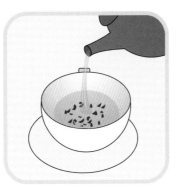

Inhale; contemplate a question.

★ 479 predict the timing of life events

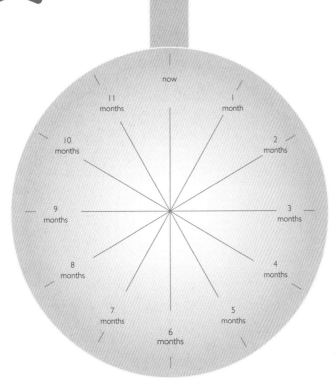

The cup is divided into monthly sections. Wherever a symbol appears, expect the corresponding event to occur in that amount of time.

★ 480 find symbols in tea leaves

Finding familiar shapes in tea leaves is an art, much like finding pictures in cloud formations. So meditate on a question that's important to you and watch the omens take shape in your cup.

 health

 fertility

 long life

 new romance

 false friend

 hard work

 message

 distraction

 advancement

 domestic situation

 disappointment

 psychic ability

 legal matter

 help from friends

 protection

 close call

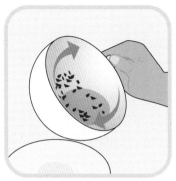

Swish the cup clockwise.

Drain the excess tea; retain the tea leaves.

Look for shapes.

man	woman	smooth journey	uncertain path	people's initials	days, months, years	right direction	wrong direction
reconsider plans	pay attention	good luck	protection	money	visitor	insight	love
good friend	untrustworthy friend	entanglement	possible theft	enemy nearby	long journey	busy	very good luck
challenge	trouble coming	startling event	future reward	big change	enlightenment	influence, power	natural cycle
correct path	secrecy	recognition	marriage	gift	beware!	violence	travel

cast handy shadow puppets

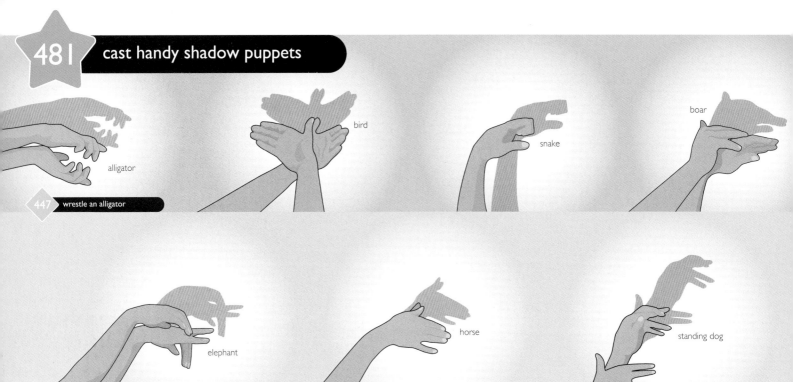

alligator

bird

snake

boar

447 wrestle an alligator

elephant

horse

standing dog

set the scene with sound effects

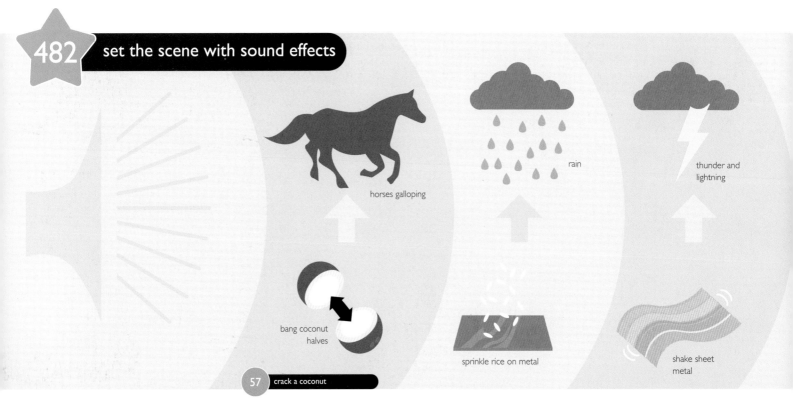

horses galloping

rain

thunder and lightning

bang coconut halves

sprinkle rice on metal

shake sheet metal

57 crack a coconut

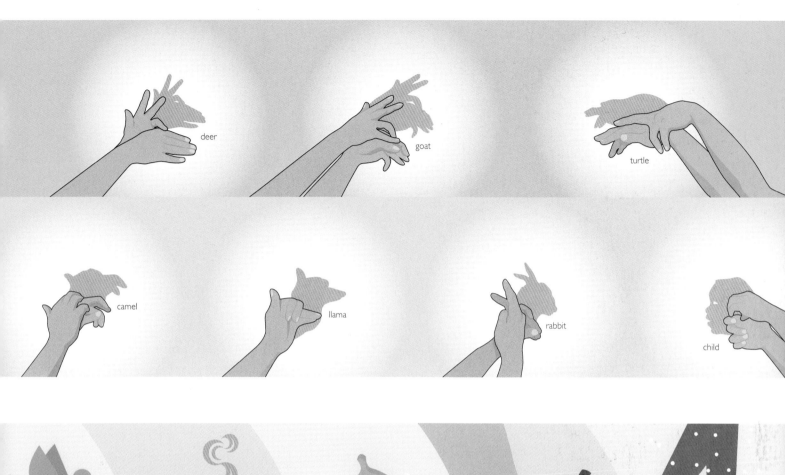

deer

goat

turtle

camel

llama

rabbit

child

flying bird

crackling campfire

ringing bell

stabbing

footfalls in snow

flap gloves

crumple cellophane

tap metal lids

stab a watermelon

crunch kitty litter

Present the coin theatrically.

Slide your thumb under.

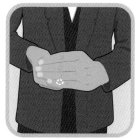

Close the hand over.

Drop into your right hand.

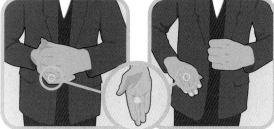

Place between your fingers.

Pull your right hand down.

Focus on your left hand.

Wear wide-legged pants.

Assemble a small audience.

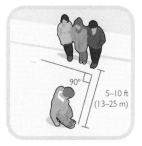

90°

5–10 ft
(13–25 m)

Distract your audience.

Rise on your right toe.

Cross your strong arm; inhale.

Exhale, making wiggle room.

Hang upside down.

Wiggle your elbows.

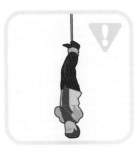

Push up your elbow.

Uncross and raise your arms.

Bite to undo the sleeve belt.

Undo the back belts.

Hook the sleeve belt; pull.

Pull off the jacket with flair.

 Want to pull a Houdini? When you're first wrangled into the straitjacket, place your strong (or dominant) arm under your opposite elbow and breathe deeply, expanding your chest and loosening the straitjacket. This way, you can later use great force to push your elbow over your head. Once your arms are uncrossed, undo the buckles—and dazzle the crowd with your escapologist skills!

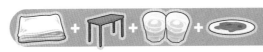

Place the cloth at the edge.

Smooth away wrinkles.

Add heavy items.

Grasp at the midpoint.

Pull down rapidly.

487 mold a false fingerprint

 +

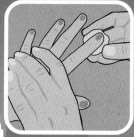
Mold someone else's print.

Fill with liquid gelatin.

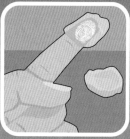
Refrigerate.

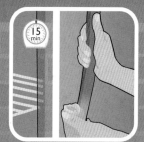
Peel; press to your finger.

488 pick a pin-and-tumbler lock

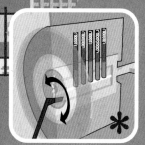
Test with the wrench.

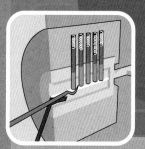
Insert the pick.

Click!
Push up the first pair of pins.

Click!
Turn; lift the next pin pairs.

Click!
Lift the last pair of pins.

Turn; open the door.

138 look dapper in a suit

Test the lock first to see which way it turns. Then apply slight torque in that direction and push the pin pairs up so that each upper pin is outside the cylinder.

There's something shady going on with this locked briefcase—and you need some illuminating answers! But how can you know if she's telling the truth? Look for these clues to catch a liar in the act.

Are her eyes darting to the right? The right side of her brain is cooking up a lie.

If her lips are smiling but the rest of her face is frowning, then she's hiding something.

Excessive fidgeting— especially touching the hair, neck, or nose—is mighty suspicious.

Is it hot in here? Sweating gives away the coolest of cucumbers.

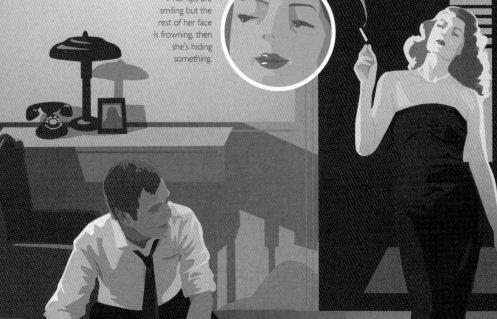

A graceful dame with a stiff, awkward body posture? Something's amiss!

Sudden exits betray discomfort.

Is she tapping like Fred Astaire? Then you'd better beware!

490 slide into a bootlegger turn

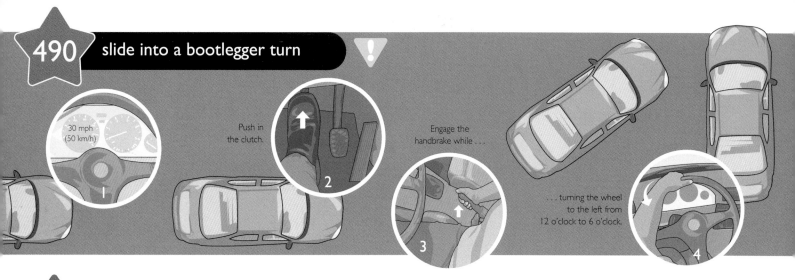

1 30 mph (50 km/h)

2 Push in the clutch.

3 Engage the handbrake while . . .

. . . turning the wheel to the left from 12 o'clock to 6 o'clock.

4

491 pop a sweet wheelie

Shift into first gear.

Rev to two-thirds capacity.

Pull in the clutch; rev fully.

Shift back in the saddle.

Open the throttle; release the clutch.

Cover the rear brake, just in case.

Pull up. Keep the front wheel straight.

Ease off the throttle; come down.

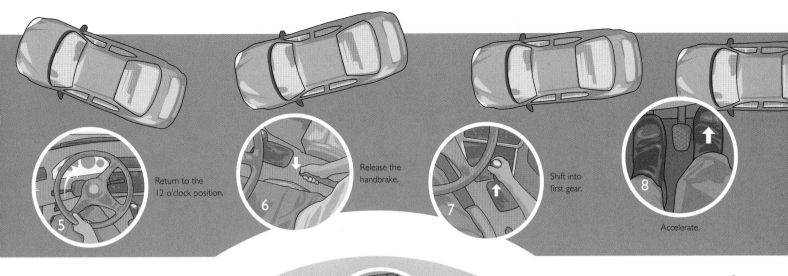

Return to the 12 o'clock position.

Release the handbrake.

Shift into first gear.

Accelerate.

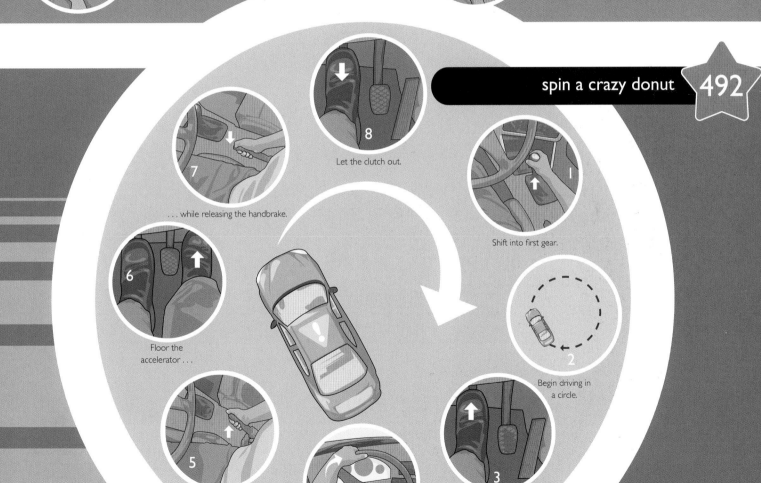

Let the clutch out.

. . . while releasing the handbrake.

Floor the accelerator . . .

. . . and pulling up the handbrake.

. . . while turning into a tight circle . . .

Push in the clutch . . .

Begin driving in a circle.

Shift into first gear.

 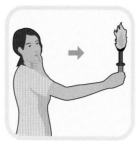 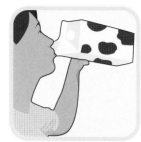

Always have a friend nearby. | Practice spraying mist. | Check the wind. | Milk neutralizes kerosene. | Hold in your mouth.

I tsp

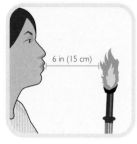 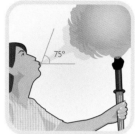

6 in (15 cm) | Spray a mist of kerosene. | Move the torch down. | Wipe with a damp rag. | Bread soaks up the fuel.

75°

Lower the seat. | Place your lead foot on top. | Lean forward; add the other foot. | Switch feet as the wheel rolls.

deliver a killer tennis serve 317

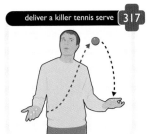

Practice with one ball.

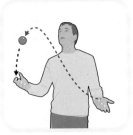

Keep your eye on the ball!

Add a second ball.

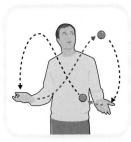

Toss at the first ball's peak.

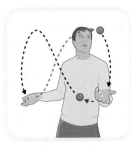

Repeat—a lot!

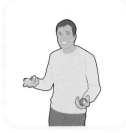

Add a third ball.

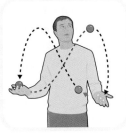

Toss at the first ball's peak.

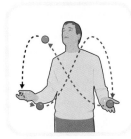

Toss at the second's peak.

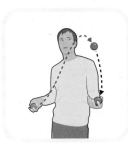

How do you keep all those balls in the air? First, practice tossing a ball from hand to hand in a figure-eight pattern, using a scooping gesture. It also helps to number each ball as you throw it, calling out "one," "two," "three," and so on.

be a human cannonball 496

Climb inside the cannon.

Lie down in the canister.

497 ollie like a pro

1 Put one foot at the board's center and one foot at its tail. Bend your knees.

2 Kick the tail down to pop the nose up. Drag the outside of your front foot against the board to guide it higher.

3 Lift both knees to your chest while soaring over the gap.

4 Land and shred away.

498 bust a feeble grind

1 Ollie up onto a gnarly ramp.

2 With the back truck straddling the ramp's edge, point the nose to the ramp's far side.

3 Grind down the ramp's edge and ollie off.

4 Land with both feet over the trucks.

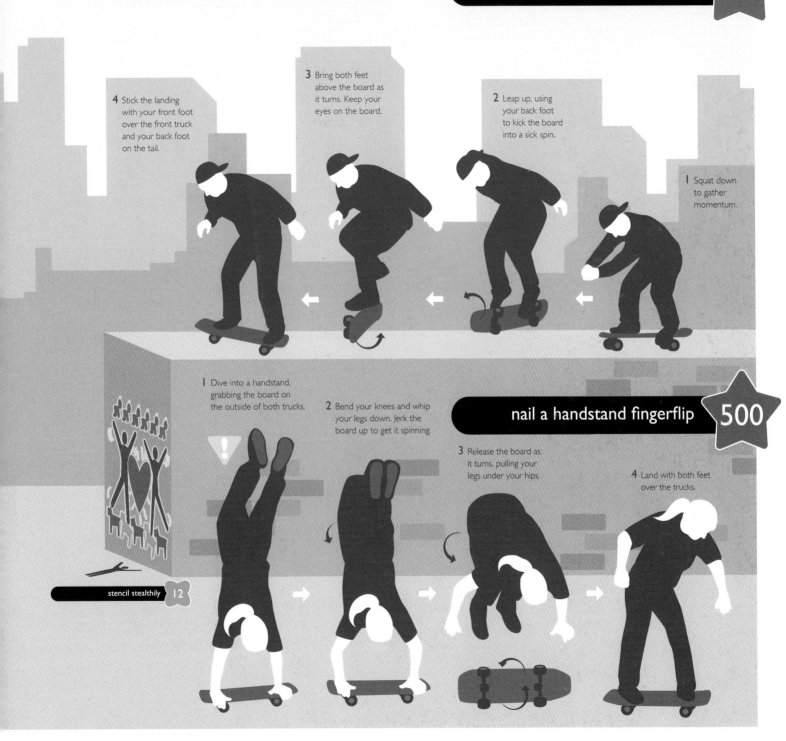

4 Stick the landing with your front foot over the front truck and your back foot on the tail.

3 Bring both feet above the board as it turns. Keep your eyes on the board.

2 Leap up, using your back foot to kick the board into a sick spin.

1 Squat down to gather momentum.

1 Dive into a handstand, grabbing the board on the outside of both trucks.

2 Bend your knees and whip your legs down. Jerk the board up to get it spinning.

nail a handstand fingerflip **500**

3 Release the board as it turns, pulling your legs under your hips.

4 Land with both feet over the trucks.

stencil stealthily 12

tools

seedlings	book	leaf	evergreen bough
herbs	florist ribbon	datejime (kimono belt)	crème de menthe
towel	chicken broth	koshi himo (kimono belt)	

aquarium greenery	crayon	sage bundle	tree
hookah	florist wire	skin toner	ribbon
painter's tape	bowl	ice water	

cricket	soda can	banana leaf	alligator
cleaning fluid	avocado	patch kit	dog toothpaste
vermouth	art knife	car	

olive	wasabi	artichoke	beans (haricots)
bicycle tire glue	henna	hat	screen
bubble fluid	electrical wire	snowboard	

olive oil	citrus trees	house paint	houseplant
decorative greenery	nori seaweed	shisha (tobacco)	paper money
water	bandage shears	sponge	

nail polish remover	cilantro (coriander)	plant-rooting hormone	bamboo
fern	red wine	felt pen	moisturizer
cornmeal	bucket	oats	

absinthe	mint	plants	couch
rosebush	florist wire	breath mint	shaving brush
deck chair	electrical tape	toothbrush	

lime	tennis ball	scarf	spray bottle
lederhosen	photo emulsion	ginger ale	watering can
blued razorblade	aquarium chemicals	screw anchor	

kerosene	lettuce	comb	gin
fabric	cucumber	gardening tape	setting lotion
fine mesh bag	fish	spackle	

chile pepper	modeling clay	vihta (birch whisk)	soda bottles
stage makeup	abalone shell	alligator clips	massage oil
tarp	paint roller	juggling balls	

gardening clippers	hammock	apple	wallpaper seam roller
helium balloons	lip gloss	yearbook	tuna
grocery bags	turkey	sweater	
rock anchor	thick paintbrush	salsa	pipe wrench
scissors	lipstick	espresso cup	steak
balloon	marinade	button	
snowboarding boots	aquarium rock	nail polish	lobster
fabric	lip liner	coaster	flowers
kneepads	wrapped candy	plastic beads	
rappel device	pastry brush	food coloring	crab
lip balm	seam ripper	brandy	rose
toilet plunger	staple gun	ladder	
flippers	wallpaper	cherries	wallpaper scoring tool
swim trunks	palette knife	cigarette pack	berries
washcloth	hacksaw	ribbon	
bed	ink	popcorn	pet pill
grenadine	wire cutters	chopped meat	obi (kimono belt)
liquid latex makeup	kayak	wire strippers	
sparkling water	eyelash glue	tomato	scraper
fake worm	surfboard	nonstick cooking spray	corset
wedding program	flat sheet	gardening clippers	
jeans	ironing board	fire extinguisher	wire nuts
head scarf	shirt	radish	note
nail file	sleeping bag	diaper pins	
decorative tape	sewing pins	bell pepper (capsicum)	skinny balloon
corset lace	fake blood	jumper cables	yarn
blush	clay	screwdriver	
ice pack	thread	cherry	bobber (fishing float)
sexy shoes	tent	pomegranate	toe separator
cuticle oil	sleeping pad	cigarette lighter	
saline solution	crepe paper	sticky tape	plate of pasta
shoe polish applicator	white vinegar	hoof pick	kimono
chicken	paddle	training wheels	

carrots	metal honda knot	sealant	raisins
peat moss	potato	toy dinosaur	gingerroot
drying rack	dog treat	bamboo mat	
orange juice	stick	cloves	baseball mitt
muddler	coconut	safety net	credit card
peanut butter	baseball bat	soil	
salmon roe	torch	spices	rake
eye makeup applicator	sheet of wood	guitar	suede
fence posts	snake	sword	
orange	drinking gourd	straitjacket	hammer
hairpins	golf bag	firewood	sandpaper
body brush	paint roller extension	sealant applicator	
yo-yo	copper wire	pétanque jack	violin bow
wooden spoon	rubber cement	stake	cardboard box
dandy brush	window	wooden skewer	
koi	rosin	calf	bare-root tree
tinder	shopping bag	forked branch	plant pot
blanket	pinecone	stage gelatin	
grated cheese	treasure chest	walking stick	brick of tea
cutting board	stenciled cardboard	branch	adobe bricks
lamp kit	boards	bone tool	
glass beads	tinder fungus	beans	chocolate bar
water bucket	sledgehammer	graham cracker	fabric dye
teakettle	brown paper bag	toilet paper tube	
flower	tea chum	table	hat
wooden tongs	dovetail saw	tortellini filling	goat milking stand
rope	climbing chalk	wooden mallet	
basketball	hairbrush	cigarette	beer
thin paintbrush	twine	surf wax	bait fish
coffee tamper	lumber	dropcloth	
match	hoof oil	belt	chopsticks
picture frame	electric plug	shoe polish	samovar
cat treat	cardboard	coffee mug	

| squeegee | clothespin | baking soda | lemon | baby shampoo | lightbulb | bottle cap | sewing machine | cotton ball | pvc pipe | baby bath |

| lined pie tin | baseball | stud finder | phone book | bee | socks | paint roller | burn ointment | rice | paper | golf balls |

| rubber band | foam rubber | resin | butter | white wine | beeswax | sheet music | teapot | lime powder | mulch | napkin |

| stick | corn tortillas | straw | mango | champagne | dried straw | candle | teacup | cloth diaper | soap | miniskirt |

| flour tortillas | bread | aquarium thermometer | bath toy | crackers (biscuits) | pencil stub | obi makura (obi form) | moisturizer | canned beer | paper towels | white glue |

| brick mold | baby food | corn oil | lemon juice | hair bands | paper butterfly | acid-free paper | cotton swab | toilet paper | shaving cream | electric teakettle |

| flour | bread dough | pineapple | yak butter | corn syrup | tape measure | votive candle | roller bandage | pillow | first-aid tape | fabric glue |

| rolling pin | pastry dough | seasickness pill | banana | bell | silkscreen | gauze | marshmallow | salt shaker | basketball hoop | drinking straws |

| glass boot of beer | tea | yerba mate | box cutter | egg dye | toothpick | cricket food | onion | pepper shaker | eggs | baby soap |

| nylon stocking | fitted sheet | sand | rubber glove | embroidery floss | buttermilk | makeup sponge | cuticle stick | sugar cube | golf shoes | trisodium phosphate |

| scone | measuring tape | taxi | shoe brush | petroleum jelly | adhesive bandage | t-shirt | night light | melatonin | milk | coarse salt |

heavy acrylic sheets	fabric soap	gravy separator	measuring cup	wine glass	kitchen sprayer
boston shaker	ruler	machete	seafood fork	drywall sponge	
iron	under-wig cap	rubbing alcohol	plastic tub	absinthe glass	point-and-shoot camera
aluminum foil	pizza wheel	chisel	tweezers	tennis racquet	
measuring cup	pipe tape	clear tape	martini glass	beaker	sugar
dough scraper	spoon	carabiner	bar spoon	whisk	
playing cards	coffee filter	glass	plastic transparency	jar shaker	charms
compact disc	joist hanger	scuba knife	safety pins	carving fork	
epsom salts	sour cream	ice	nail polish	baby bottle	tire levers
skis	saw	wood file	can opener	vegetable peeler	
pebbles	lined baking tray	clear plastic tarp	top coat	sausage casings	florist pins
seafood cracker	absinthe spoon	wheel gauge	anchor bolts	string	
soaking basin	string	crystal	pitcher	plastic lid	clock
saucepan	screws	plastic adhesive	fish	nails	
permanent marker	newspaper	water bottle	light rum	beer pint glass	cannon
butter knife	golf tees	L-bracket	ballpoint pen	duct tape	
dimmer switch	styrofoam ball	plastic wrap	french press	grafting tape	steam pitcher
chef knife	eye bolts	needle	shelf brackets	hook	
suet	mattress	plastic pastry bag (carrot bag)	pousse-café glass	fishing line	podstakannik (russian tea glass)
paring knife	saber	glass drill bit	fork	unicycle	
wall glaze	box spring	yoga mat	champagne flute	scuba mask	wallpaper smoothing tool
paint	hunting knife	cold water pipe	whetstones	keg	

mobile phone	steel wool	joint tape	lug wrench
ski boots	lock pick	curling iron	computer
wire	fake eyelashes	piano	
clipping shears	tea strainer	hairbrush	cinder blocks
slotted spoon	level	hair clips	teakettle
bicycle	fishing pole	dress shoe	
ski poles	lamp	bombilla	nail clipper
fire pit	wood preservative	spade	makeup brush
tarantula	hair trimmer	charcoal	
ice axe	golf club	climbing shoes	pants
airplane seat	tension wrench	curry comb	climbing harness
wet suit	USB cable	SLR camera	
coin	pan drippings	pétanque boules	baking tray
screw	magnet	drink strainer	wristwatch
oxygen tank	power drill	geisha wig	
shovel	auto jack	cooking thermometer	claw clipper
crystal earphone	knitting needles	chair	electric teakettle
water safety vest	glue gun	record	
pumice stone	measuring spoon	oyster	ice scoop
palette knife	wire hanger	jump ring	helmet
car tire	wireless adapter	magical items	
needlenose pliers	sieve	tongs	sauté pan
foam insulation	thumbtack	espresso machine	eyeshadow
cable ties	toilet snake	stone	
shrimp	wine key	tea	laptop
tin can	screwdriver	hairdryer	limousine
car keys	o-ring		
showerhead	bevel gauge	bicycle inner tubes	ice bucket
razor	grafting knife	hairspray	hot coals
mascara	coffee beans		
flask	spray paint	food processor	coffee grinder
fish hook	curtain rings	large trash bags	eye pencil
battery	rubber tubing		

index

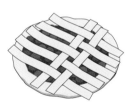

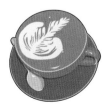

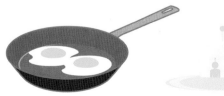

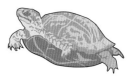

173

236

88

250

218

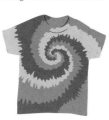

46

218

169

126

7

show me who

John Owen
High-Flying Executive Chairman

Terry Newell
Salty CEO and President

Dawn Low
Driven VP; Sales

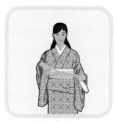

Amy Kaneko
Cosmopolitan VP; Sales

Stuart Laurence
Surfing Sr. VP; International Sales

Kristine Ravn
Animal-Loving Sales Manager

Roger Shaw
Mixological VP and Publisher

Mariah Bear
Hard-Hitting Executive Editor

Lucie Parker
Footloose Project Editor

Paula Rogers
Fire-Breathing Storyboard Editor

Sarah Gurman
Rock-Climbing Editorial Assistant

Mark Perrigo
Clever Director of Finance

Gaye Allen
Tasteful VP; Creative Director

Kelly Booth
Samba-Dancing Art Director

Britt Staebler
Chic Designer and Illustrator

Esy Casey
Cosmic Designer

William Mack
Tricky Designer

Delbarr Navai
Shutter-Snapping Designer

Lauren Smith
Crafty Spokesperson

Derek Fagerstrom
Saw-Bending Spokesperson

Show Me How: 500 Things You Should Know
Instructions for Life From the Everyday to the Exotic
Copyright © 2008 by Weldon Owen Inc.
All rights reserved. No part of this book may be used
or reproduced in any manner whatsoever without
written permission except in the case of
brief quotations embodied in critical articles and
reviews. For information, address Collins Design,
10 East 53rd Street, New York, NY 10022.

HarperCollins books may be purchased for
educational, business, or sales promotional use.
For information, please write: Special Markets
Department, HarperCollins Publishers, 10 East 53rd
Street, New York, NY 10022.

First published in the United States
and Canada in 2008 by:
Collins Design
An Imprint of HarperCollins Publishers

10 East 53rd Street
New York, NY 10022
Tel: (212) 207-7000
Fax: (212) 207-7654
collinsdesign@harpercollins.com
www.harpercollins.com

Distributed throughout the
United States and Canada by:
HarperCollins Publishers
10 East 53rd Street
New York, NY 10022
Fax: (212) 207-7654

Library of Congress
Control Number: 2008930025

ISBN: 978-0-06-166257-7

A Weldon Owen Production
415 Jackson Street
San Francisco CA 94111

Printed in Singapore by Tien Wah Press
First Printed in 2008

SHOW ME NOW™
A Show Me Now Book.
Show Me Now is a trademark
of Weldon Owen Inc.
www.showmenow.com

Chris Hemesath
B-Balling Production Director

Michelle Duggan
Slaloming Production Manager

Teri Bell
Artsy Color Manager

Charles Mathews
Engaging Production Coordinator

Hayden Foell
Pint-Lifting Illustration Specialist

Ross Sublett
Undead Illustration Specialist

Matthew Borgatti
Snazzy Illustration Specialist

Michael Alexander Eros
Intrepid Production Assistant

Brandi Valenza
Lucky Art Researcher

Juan Calle
Reanimated Illustrator

Joshua Kemble
Late-Night Illustrator

Vic Kulihin
Juggling Illustrator

Vincent Perea
Dog-Training Illustrator

Bryon Thompson
Adventuring Illustrator

Otis Thomson
Big Daddy Illustrator

Gabhor Utomo
Mysterious Illustrator

Tina Cash-Walsh
Mountain-Biking Illustrator

Mary Zins
Straight-Ahead Illustrator

ILLUSTRATION CREDITS The artwork in this book was a true team effort. We are happy to thank and acknowledge our illustrators.

Front Cover: Britt Staebler: dancers, shirt, martini, elephant
Kelly Booth: emoticons Gabhor Utomo: plant
Bryon Thompson: skateboarders

Back Cover: Gabhor Utomo: balloon animal Tina Cash-Walsh: sabrage, mohawk, baby Juan Calle: alligator

Key bg=background, bd=border, fr=frames, ex=extra art

Juan Calle: 16–18, 27, 28, 44, 81, 86, 150–156, 176, 187–188, 193–194, 258–259 fr, 277, 313–314, 317–318, 334, 347, 363–367, 387–391, 396–398, 412–414 fr, 435–438, 443–447, 460, 463–465, 470, 472
Esy Casey: 19 ex, 43, 126–127 bg, 241 bg, 256 bg, 258 bg, 354, 449

Hayden Foell: 210, 278 fr, 279 Joshua Kemble: 11fr, 122–125, 191, 236–238 fr, 256–257 fr, 269–270, 315–316, 331–333, 335, 337–339, 340–343, 426–430, 451–452, 475–476, 490, 492 Vic Kulihin: 25–26, 29, 82, 98–101, 231, 241 fr, 252, 260–261bg, 384–385, 448, 461–462, 459, 491, 494–496 William Mack: chapter openers Vincent Perea: 9 fr, 162–163, 180–182, 186, 280–281 fr, 283–284, 286, 289–290, 294, 296, 392, 394–395, 431–434, 439–42 Britt Staebler: 4, 9–11 bg, 10, 32, 35–38 bg, 39, 50, 55–56, 67, 68–69 bg, 76, 77, 77–79 bg, 84–85, 114, 116, 118–119, 120–121, 126–127, 133, 136–138, 171–174, 177, 184, 189–190, 197–200, 212–213, 218, 219–220, 233, 246–249, 250, 262, 268, 271–276, 278 bg, 303, 326–328, 336, 348, 353, 355–358, 370–371, 372, 375, 378–379, 386 fr, 406–408, 412–414 bg, 415, 455–457, 477, 478–480, 482 Bryon Thompson: 5–8, 59–62, 102–107, 140, 329–330, 359–362, 421–425, 453–454, 497–500 Otis Thomson: 113, 164, 226–228

Wil Tirion: 416, 420 Gabhor Utomo: 13, 15, 19, 20, 22, 24, 30–31, 33, 35–38 fr, 45–46, 51–53, 58, 73, 75, 87–89, 90, 92–93, 130, 142–143, 149, 185, 195, 224–225, 230, 234–235, 242, 244, 251, 263–264, 265–266, 280–282 bg, 282, 292, 295, 297, 307–311, 312, 319–325, 344–346, 351–352, 368, 373–374, 386 bg, 399–400, 409–411, 419, 458, 466–469 bg, 466, 471, 474, 483–486, 487–489 Brandy Valenza: 368–369 bg Tina Cash-Walsh: 2, 3, 12, 14, 21, 23, 34, 40–42, 47–49, 57, 63–66 fr, 68–72 fr, 74, 78–79 fr, 80, 83, 91, 94, 95–97, 108–112, 115, 117 fr, 128–129, 131–132, 134–135, 139, 141, 146–147, 157–161, 165–170, 175, 178–179, 183, 192, 203–206, 211, 216–217, 221–223, 236–238 ex, 239–240, 243, 253–255, 285, 287–288, 291, 298, 299–300, 302, 304–306, 349–350, 380–383, 401–405, 418 Mary Zins: 144–145, 148, 196, 214–215, 229, 232, 236 ex, 245, 260 fr, 265–267 ex, 267, 301, 393, 393 bd, 417, 467–469 fr, 473, 481, 493

how we did it

The illustrations in this book were created and edited in Adobe Illustrator. The typeface used throughout is Gill Sans, designed by Eric Gill in 1927. This versatile and readable font was inspired by Edward Johnston's Johnston typeface for the London Underground, which Gill had worked on while apprenticed to Johnston.

Research, verification, and fact-checking was performed by a host of experts and passionate practitioners. We are especially grateful to Jennifer Newens and Hannah Rahill for cooking expertise, Lou Bustamante for mixological advice, Elizabeth Dougherty for parenting input, Jay Wiseman for first-aid pointers, Ronda Slota for yoga instruction, Renée Myers for knitting demos, Khan "Samurai" Hasegawa at Café Abir for his mastery of the coffee arts, Jan Egan for midwifery know-how, Richard Trory for structural savoir faire, and Karen Perez for nautical notations. Many other experts, in everything from motorcycles to miniskirts, gave advice and input, to the great improvement of this book.

The majority of the Show Me Team is pictured on the preceding pages. Others who contributed to the production of this book are Christopher Davis, Stephanie Tang, Shelly Firth, Malin Westman, and Scott Erwert. Susan Jonaitis added copyediting expertise, and Mike Bass kept the computers running. Many thanks to all.

show us how

Do you think you have a way to do one of the things in this book better, faster, or smarter? If so, we want to hear about it! Send us an e-mail at info@showmenow.com, and your ideas could be featured in the next edition of this book. Send photos and/or a video, and we may even depict you showing us how.

join the team

Is there something that you think should have been in this book? Something you or your friends know how to do and want to show off? Our Show Me Team is looking for new members to share their expertise with the world. Please send us your best ideas* and, if we use them, you'll be credited as an official member of this exciting group of experts and enthusiasts.

***** and maybe some of your second-best ones too.